Harrison Fisher

Defining the American Beauty

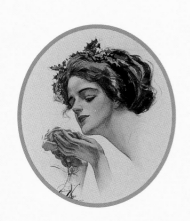

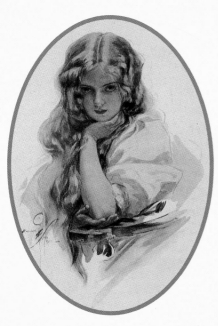

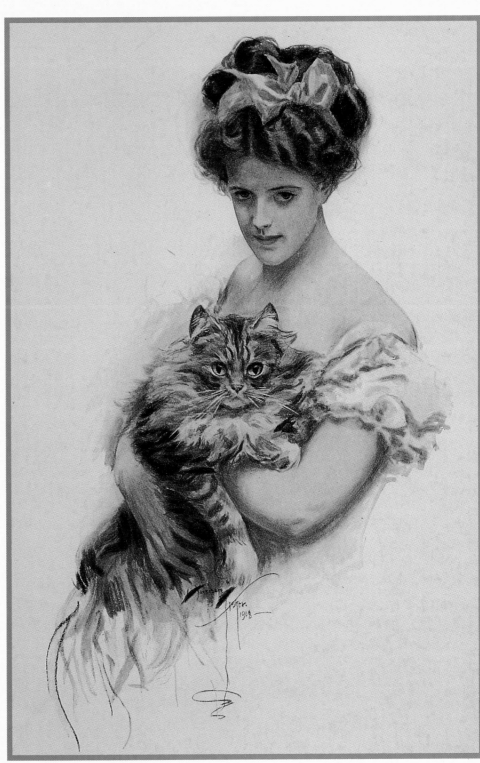

4880 Lower Valley Road, Atglen, PA 19310 USA

Tina Skinner

With Price Guide by Bruce Magnotti

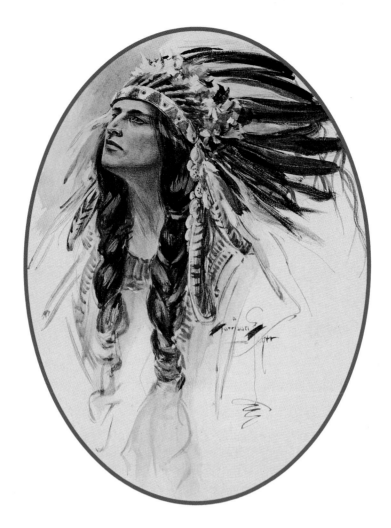

Designed by Bonnie M. Hensley
Typeset in English 157 BT/Goudy OISt

ISBN: 0-7643-0741-X
Printed in China
1 2 3 4

Published by Schiffer Publishing Ltd.
4880 Lower Valley Road
Atglen, PA 19310
Phone: (610) 593-1777; Fax: (610) 593-2002
E-mail: Schifferbk@aol.com

In Europe, Schiffer books are distributed by Bushwood Books
84 Bushwood Road Kew Gardens
Surrey TW9 3BQ England
Phone: 44 (0)181 948-8119; Fax: 44 (0)181 948-3232
E-mail: Bushwd@aol.com

Please visit our web site catalog at **www.schiffbooks.com** or write for a free catalog.
This book may be purchased from the publisher.
Please include $3.95 for shipping. Please try your bookstore first.
We are interested in hearing from authors with book ideas on related subjects.

Contents

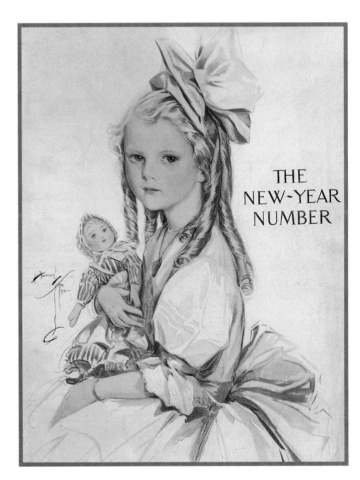

THE NEW-YEAR NUMBER

This book was made possible by the generosity of Marvin Mitchell of Balliol Corporation in Lancaster, Pennsylvania. He is a man commited to preservation, and these images would not be here were it not for him.

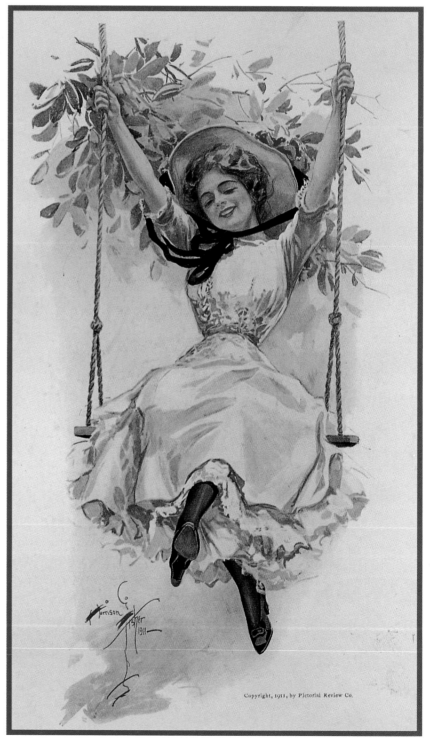

Harrison Fisher enjoyed a status comparable to today's movie stars. For a brief while, Fisher played the part of Homer's Paris, sitting in the center of an ongoing American beauty pageant. He engaged in publicity campaigns that made him the most sought-after bachelor in America, and he claimed to have turned away thousands of women who sought him out.

Fisher's fame came after the retirement of his black-and-white artistic successor, Charles Dana Gibson, at a time when new color printing technology opened the door for his talents. His fame fell briefly, during a golden era when color print technology offered the visual artist more latitude, and while the American public was still dependent on printed matter for weekly and monthly doses of news and entertainment. While he held sway, he was the king of magazine covers, in constant demand by such publications as *The Saturday Evening Post*, *Cosmopolitan*, and *The Ladies' Home Journal*. His work helped boost books to best-seller lists, and reprints of his work on postcards, calendars, and posters were wildly popular both in the United States and Europe.

Fisher's era extended for about a decade, from his leap into popularity in 1907, until pictures went motion and the Roaring '20s transformed the American beauty into an image antithetical to Fisher's ideal. When the spotlight faded, the ever market-savvy Fisher stepped gracefully into the wings, employing his artistic talents to portray those whose fame followed — the emerging movie stars, who bought his services as a mark of distinction.

An Artist from the Start

Harrison Fisher was born into his profession. He was one of two sons born to Bohemian immigrant Hugo Anton (or Antoine) Fisher, a third-generation artist, and Addie Pond of Brooklyn, New York. Hugo immigrated to the United States as a young man, and continued to further his studies

A photograph of the author published in *The Art Interchange*.

in painting. He worked in watercolor and the occasional oil, specializing in landscapes and pastoral scenes. His work was exhibited at the Columbian Exposition in Chicago in the 1890s, and he taught at the San Francisco Art Association.

The birth of Harrison Fisher has been reported both as July 27, 1875 or 1877. It is fairly certain that he was born in Brooklyn, and his family relocated to Alameda, California when he was six years old. He began to show promise as an artist at the time of the move, and in the 1890s took up formal studies at the San Francisco Art Association and the Mark Hopkins Institute of Art. He also traveled to art museums and schools in England and France.

Self portrait, black and white. This portrait ran in A *Garden of Girls*, published in 1910.

The artist's hallmark signature, published in *Fair Americans by Harrison Fisher*, 1911.

In his early career, he proved himself in all manner of mediums: oils, watercolors, pastels, pen and ink, and charcoal. All these were left behind with his rise to fame, however, when the Fisher look became a virtual trademark. Fisher said in a 1913 interview that "I know of nothing which hits (the American woman) off better than the crayon sketch, the pen and ink drawing, and the etching."

Fisher was in every sense a practical artist, and a commercial one. He put his talent to work at the ripe age of 16, selling sketches to *The San Francisco Call* newspaper, which employed him to draw accidents, prominent personalities, social affairs, street scenes, and other illustrations. He later earned himself promotions by landing a job with *The San Francisco Examiner* and, in 1897, by applying to be trans-

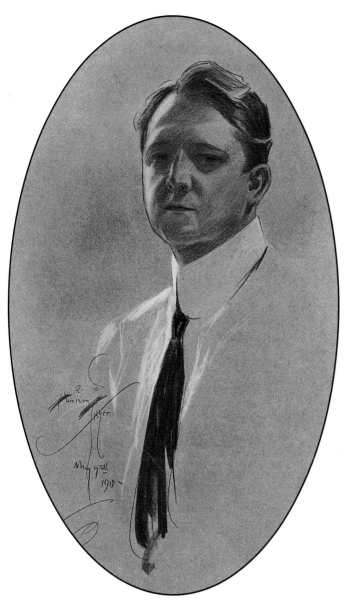

Self portrait, color, dated 1910.

Wheels. After these two success stories, Fisher became a regular for *The Saturday Evening Post*, producing covers and inside illustrations. As yet, however, Fisher was merely a successful working artist, with no foreshadowing of the celebrity soon to emerge.

Perhaps, though, his calling to portray women was foretold with his very first sale of a painting, back in his days as a student in California. As he related the story in a 1913 interview with *Holland's Magazine*, he sold his first painting while studying at the Mark Hopkins Institute of Art in San Francisco, 20 years of age and poor as the common artist. He was finishing up a sketch of a Western girl, complete with leggings, sombrero, and red handkerchief, when an old gentleman stopped to look and, without a word, handed the artist $15 in gold pieces and carried off the painting.

"I was so excited I couldn't work any more that day," Fisher recalled, adding that he went and had the three gold pieces "changed into silver so it would sound bigger" in his pocket.

Before long, Fisher would be making a widely reported $60,000 annual salary, a fortune for the times. He'd own his own car, and divide his time between New York and San Francisco, with occasional forays to Europe. Though his life was so much in the spotlight, much of the remaining publicity seems like just that: things said and done for publicity while masking a very private life.

Rise to Stardom

The Ladies' Home Journal helped to transform Fisher's career with commissions for cover work. The large format and excellent color reproduction of the magazine showed Fisher's work at its best, and soon the magazine was offering reprints for framing. In 1909, the magazine introduced the first of many serialized drawings by Fisher entitled *Harrison Fisher's American Girls Abroad*. This and other series—such as *The Girls I Like Best* and *The Greatest Moments of a Girl's Life*— were run at whim in order to encourage subscriptions. Indeed, subscriptions followed, as did orders for reprints, popular postcard series, and Fisher's own art books.

His old employer, William Randolph Hearst, was not to be left out. The Hearst magazine *Cosmopolitan* ran its first Fisher cover in 1907 and, from 1912 until his death in 1934, Fisher did nearly every cover for that publication.

Within a decade of his New York arrival, Fisher was in high demand among publishing houses. From 1900-1910, he was being pressed into service by magazines and book publishers alike, who recognized that Fisher illustrations spurred sales. In 1906, Fisher illustrated an edition of the classic Henry Wadsworth Longfellow poem, *A Song of Hiawatha.* The artist spent many months visiting tribes in the Rocky Mountains and Minnesota and researching his subject.

Fisher's fame was growing, and in 1907 he published his first book, *The Harrison Fisher Book*, which was an instant success. More than a dozen Fisher books in all were pub-

ferred within the Hearst newspaper chain to the *New York American* in New York City.

Whether driven by fame or fortune, as soon as Fisher hit the streets of New York he set out in search of other employers, knocking on editors' doors at magazines and attempting to sell illustrations. He made a friend in William Curtis Gibson, art director of *Puck*, who hired Fisher as a staff illustrator to produce cartoons and to illustrate poems and features. Fisher left the *New York American* only a few weeks after he arrived. And he continued to search out freelance work. He was asked to illustrate articles for *The Saturday Evening Post*, and he received wide notice for his work illustrating Harold Frederic's serialized book *The Market-Place* in 1899 and Jerome K. Jerome's *Three Men on Four*

lished, either strictly devoted to his art, or fluffed with assorted verse interspersed with his images.

Defining the American Beauty

Harrison Fisher didn't set out to become an authority on beauty, though he was unofficially crowned with that job description by 1907.

In some interviews, he seemed to almost lament the job. In fact, the chance to illustrate American Indians must have felt like a breath of fresh air to the artist, who frequently complained of the monotony of his subjects. Fisher time and again stated that he only portrayed women because he was forced to. "The public cries for them," he told *Vogue* magazine in November, 1909. "Someday I am going to give to the world, that has been too kind to me for the good of my art, a chance to show whether it is my work or the subject which appeals. I am going to paint some dear old women and men. That is what I really wish to do."

Another time he told the *Los Angeles Evening Herald and Express* that he was tired of drawing women, saying he'd

THE CREATOR OF THE HARRISON FISHER GIRL

ILLUSTRATIONS FROM ORIGINAL DRAWINGS BY MR. FISHER, AND PHOTOGRAPHS BY BYRON TAKEN ESPECIALLY FOR THE JOURNAL.

THE AMERICAN GIRL has found no more facile pencil to portray her charms than that wielded by Mr. Harrison Fisher. He has succeeded in creating a beautiful type distinctly his own. Readers of THE JOURNAL have voiced their warm appreciation of his art, and it is therefore a pleasure to present these pictures of him in his New York studio, with one of his young lady models.

Mr. Fisher was born in Brooklyn, but he lived most of the time in San Francisco until the age of twenty-one, when he went to New York and soon found himself busily engaged in illustrative work for the great magazines. Talent and an abounding enthusiasm have been the chief factors in his success. As he himself says, "I love to draw," and as he is young and ambitious we may reasonably look for even greater refinement and charm as his art develops.

Singing the artist's praises in *The Ladies' Home Journal*, undated.

prefer to put cows, or maybe sea lions on magazine covers for a change."

Still, as *Cosmopolitan* wrote in 1910, "There is no more enviable position in the world of art to-day than that of the successful illustrator. ...Every illustrator wants to be a painter. To be courted by publishers, to have one's name upon the lips of a nation, to be pointed out in public places as a familiar figure. ...At the top of the heap stands Harrison Fisher—creator of the Fisher girl and most popular of all Americans who ply brush and pencil for reproduction. By reason of his industry and because of the uniform soundness of his drawing and color-sense he is the acknowledged master of the pretty-girl picture."

Cosmopolitan, which made a lucrative business selling reprints, compared Fisher's work with that of Whistler, Rembrandt, Halls, and Valasquez. "From the masters Fisher has taken his cue and pinned to paper lastingly the beauties of our day and generation with a maximum effect and a minimum expenditure of visible effort. ...whatever the future holds for Harrison Fisher he will always be known as the real depictor of the healthy, well-poised, clear-eyed girl of the period, the American girl who is neither slob nor sloven, who may or may not be in or of society." Fisher's work, *Cosmopolitan* speculated, is "the work of the true art historian, and as the historian of the American girl, Harrison Fisher has neither peer nor superior."

In actuality, however, Fisher managed to idealize the American woman, painting a fantasy image that the common reader of the time reveled in.

It was his talent for depicting high society that maintained his popularity," wrote Barbara Andrews in *The Antique Trader Weekly*. "His girls are products of wealth and leisure with all the trappings of the very rich. Fisher captured the clothes, furnishing, drawing rooms, balls, country clubs, horses, and dogs of the upper class in the settings for his girls. His drawings were romantic, focusing on the fantasies of the nation's women, on what women wanted to be, not what they were."

This was a time, after all, when American women were at the height of their popularity worldwide, or thought they were, according to the authors of *Harrison Fisher*. "His was the era of the Gay Nineties...when rich families such as the Vanderbilts and the Belmonts were bidding to outdo each other on the social scene...Foreign princes, dukes, and earls, well-titled but often penniless, courted American girls and won many of them. These situations inspired many novels on the theme, several of which were illustrated by Fisher. The brush and pencil of the artist could create a romantic setting in a way that a camera could never do."

During his reign as definer of what women should be, Fisher professed that "femininity, grace, personality, and intelligence," were more important than physical beauty. And he dictated five characteristics to be emulated by ladies of the day: 1. Individuality; 2. Proper use of cosmetics; 3. Harmony in colors; 4. Emphasizing one's good points; and 5. Avoiding extremes.

Now commanding $300-800 per illustration, and swamped with orders, Fisher said his search for perfect models was relentless. Only one in a hundred was worthy to be an ideal American girl, he said, though it seemed he must have had ample candidates for a surplus. He claimed to have painted thousands of women during his career. And *The New York Herald Tribune* reported that women were applying in droves, sending letters and photographs.

In newspaper and magazine interviews, Fisher said all the right things to spur hope in the candidates:

"Models are hard to find, for nine out of ten of them lack beauty, and their faces, if faithfully reproduced by the painter, would be dull, flat, and unattractive. No matter how near perfect a girl's features, figure and complexion may be, the quality that makes her beautiful lies beneath them and uses them only as a mirror with which to reflect her charm...It is character, innate refinement, and beauty of mind that make the difference between the flat, wooden face and the radiant one that the artist seeks. But for all that, American girls are the most beautiful and the best dressed in the world. I could not find in Europe a single model that my American public would accept."

Fisher always emphasized the importance of inner beauty, a quality all women could hope to posses. Further, he became that one, legendary man who could pick out this inner beauty from amongst a hundred stranger's faces. Fisher publicity implied that the artist was always on the hunt, that not enough women were measuring up, that ever more candidates were needed.

If the desperate public need for role models of inner beauty wasn't enough motivation, there was the fact that selection alone was enough to launch a woman to stardom. Like Mary Elizabeth Forbes, who recalled her few days spent modeling for Fisher in an account printed for readers of *Pictorial Review*. Forbes, feeling that "I might be more useful in Mr. Fisher's studio than in any other" pursuit, looked up Fisher's address and showed up at his door. He asked her back the next morning and employed her to pose for several illustrations over the course of several days. She published an account of her experience as Fisher's model that read much like a teen's account of a dream date with a movie idol.

Later, in what seems to have been a well-orchestrated celebrity stunt, Fisher stated for headline news stories that he was tired of the "goo-goo eyes and fluffy hair and little noses and pouty lips" of his previous creations and wanted to head out West and find "the real American beauty." *The San Francisco Examiner* stated that Fisher would return to visit his family in Alameda and then take a leisurely return East while searching out the proper model. "Highways and byways, nooks and crannies, he will explore if necessary until

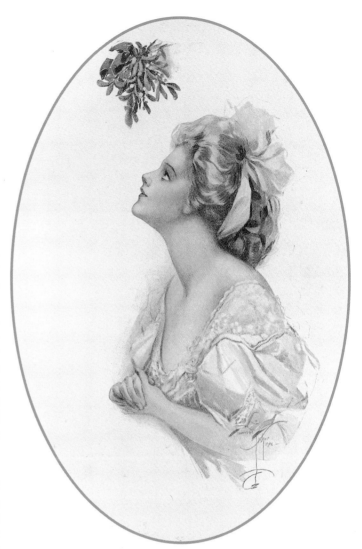

Mary Elizabeth Forbes, in recounting her week's work as a model for Harrison Fisher, discussed the stiff neck she developed while posing for a picture with mistletoe. The result was undoubtedly this piece, titled *Anticipation*.

the ideal face he seeks is discovered," the newspaper reported on July 23.

His eventual find created an incredible flurry of newspaper stories. The news dominated a full page in *The New York Times* on January 22, 1911, with an article titled "Harrison Fisher Discovered a New Type of Beauty." The Times reported that the winner was a Rita Maurine Rasmussen, who defied her parents and walked 25 miles (a distance that varies wildly in its many accounts) from her family ranch to catch a train to go to San Francisco to meet the artist. Since his discovery, Fisher had been eagerly awaiting her arrival in New York, and talking about her so much that vaudeville agents were hot to sign her up.

In the ensuing publicity extravaganza, Fisher gave interviews about this amazing "Girl of the Golden West ...everything about her suggested great space and silent mountains...there was a dash, a fire, a spirit about her that was wonderful. The set of her shoulders, the poise of her

head, the quiver of her nostrils, everything breathed of life and spirit."

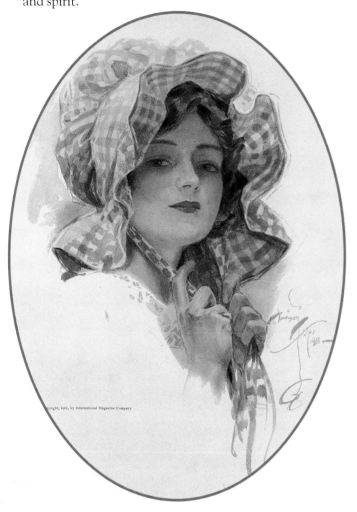

Copyright, 1911, by International Magazine Company

Sunbonnet Girl was one of the most famous pieces to result from the much publicized discovery of "The Girl of the Golden West," Rita Maurine Rasmussen, and her short and turbulent career as a model for Harrison Fisher. This image also ran in *Maidens Fair.*

Other newspapers helped stoke a growing fire of envy, and sniping between the coasts ensued over the virtue of the resident women.

Now the pride of California, Rasmussen was celebrated in West Coast and the Midwest newspapers while New York women were slurred. Newspaper articles reported "the fury of envious women. Every day since it was announced that Fisher had chosen his ideal girl, Miss Rasmussen has received from one to a score of letters from women. Are they letters of congratulation that a California girl had been awarded the apple in the modern judgment of Paris? They are not...every missive is a missile." Another paper reported Rasmussen as saying "New York girls look as if there was a $5 fine here for smiling" and saying that the New York girls "are beautiful but there's no use looking like a plaster cast" and asking "why don't their faces wake up once in a while."

Meanwhile, another Fisher model, Miss Lucy Cotton, left and moved to a competing artist's camp, going to work for Howard Chandler Christy, another fallout in the "heart burning and angry model's war in New York." Cotton was

reported as saying that "Miss Rasmussen is not beautiful, but that the lines of her face make a good picture."

The working relationship between Rasmussen and Fisher was short-lived. The model claims she met with another critic in Fisher's studio, a Katherine Clements who "was so rude to me that that was one of the reasons I left him." One of Fisher's favorite models, Clements also worked as his secretary for many years. Later biographers have speculated about a love interest between the two, and Clements was named in Fisher's will.

Rasmussen isn't the only one who quit the studio. Fisher was quoted as saying that Rasmussen was "simply too dazzling," and that he was unable to portray her and was leaving for Europe only a few weeks after the Golden Girl's arrival.

Rasmussen claimed that she left him for a better offer to work on the stage, a career she dropped out of early for love and a marriage that failed.

In any case, Rasmussen is the subject of several well-received works by Fisher, including the *Sunbonnet Girl*, which graced the cover of *Cosmopolitan* and her most famous pose, *The Girl of the Golden West*. She also claimed to have provided the inspiration for pictures copyrighted before her celebrated discovery. Further, pictures Rasmussen claims were made from her image were also claimed by other models, proving that Fisher relied little upon the girl actually sitting in front of him to create his romantic ideals and that many women could claim to mirror the image.

Most Eligible Bachelor

Later in his life, Fisher claimed to have painted no fewer than 15,000 women. Surrounded by so many models of inner and outer beauty, Fisher was only lured by one.

A celebrity, it was only natural that newspaper reporters badgered Fisher for an account of his love life. And very little was offered. He'd offer teasers to the effect that he'd seen too much of girls, or that he'd been too busy to marry. Then, in 1928, he held out a carrot, telling *The Los Angeles Examiner* that he "had fallen hard" and that, "in spite of the fact that a wife may produce any number of complications into the profession, he has determined to take a chance." He stated further that "I've been proposed to, but this is the first time I've ever done the proposing."

Keeping the woman's identity a secret, Fisher told various newspapers that he'd proposed and was eagerly awaiting an answer. None was forthcoming and Fisher remained single until his death following what some newspapers reported as emergency appendectomy surgery on January 19, 1934.

Fisher's brother, Hugo Melville, older by one year, survived him. While his brother earned fame for his portrayal of the American girl, Hugo studied abroad, living in Paris most of his adult life and studying with Whistler, Laurens, and others. He held successful exhibitions in London and Paris before returning to Alameda in 1938 and dying of a brain tumor in 1946. He, likewise, never married.

Serialized Magazine Stories

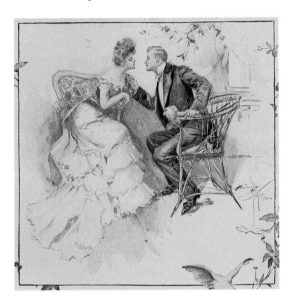

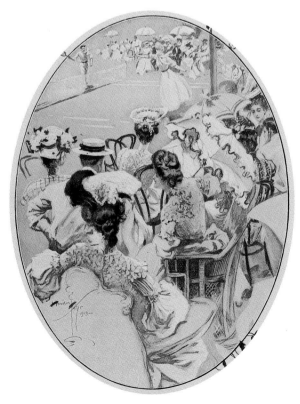

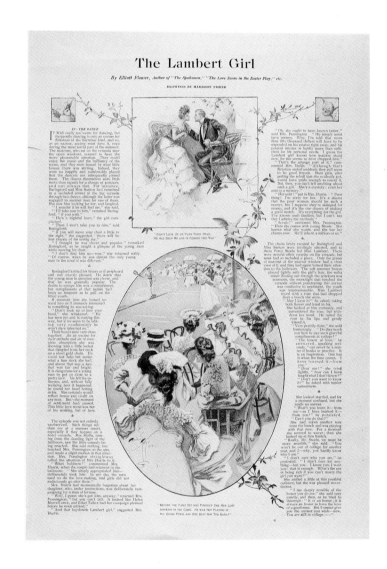

Illustrations for *The Lambert Girl*, a short story by Elliott Flower, published in *The Ladies' Home Journal*, July 1903

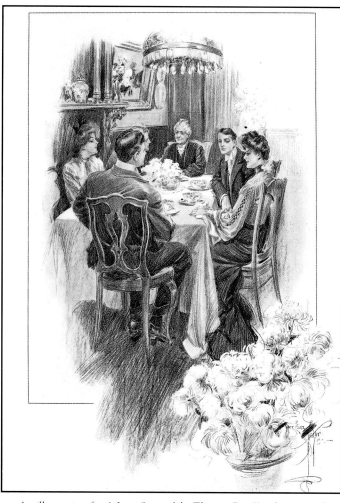

An illustration for *A Love Story of the Theatre, Part II* a short story by Hamlin Garland, published in *The Ladies' Home Journal*, February 1904.

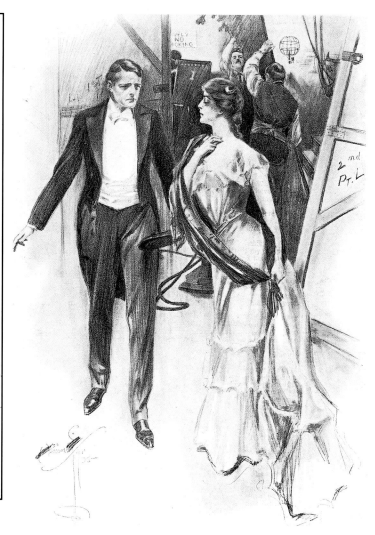

An illustration for *A Love Story of the Theatre, Part IV*, a short story by Hamlin Garland, published in *The Ladies' Home Journal*, April 1904.

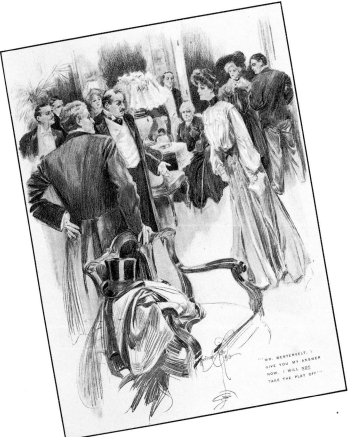

"MR. WESTERVELT, I GIVE YOU MY ANSWER NOW. I WILL NOT TAKE THE PLAY OFF!"

An illustration for *A Love Story of the Theatre, Part III,* a serialized story by Hamlin Garland, published in *The Ladies' Home Journal*, March 1904.

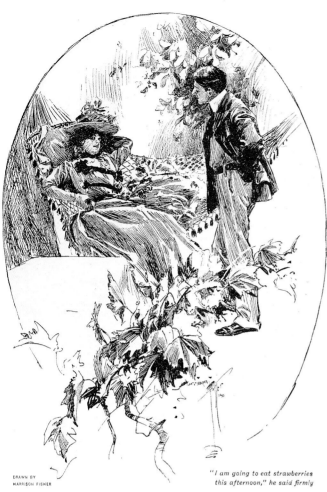

*"I am going to eat strawberries
this afternoon," he said firmly*

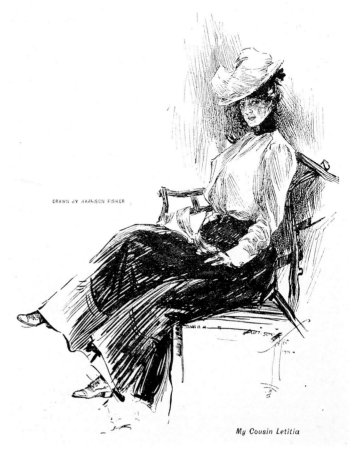

My Cousin Letitia

Illustrations for *The Love Affairs of Patricia—I try to Amuse Cousin George*,
by Lilian Quiller-Couch, published in *The Saturday Evening Post*, 1901.

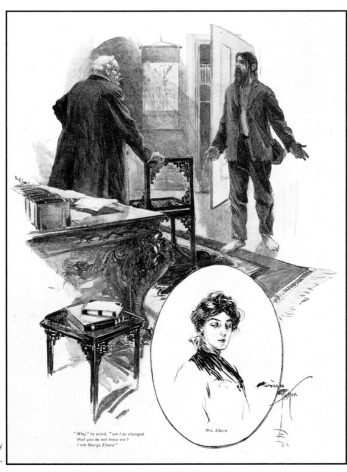

*"Why," he cried, "am I so changed
that you do not know me?
I am George Elbers"*

Mrs. Elbers

Illustration in *The Saturday
Evening Post*, 1901.

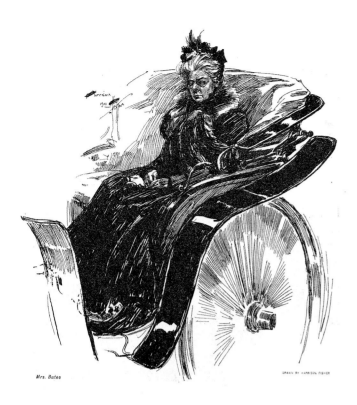

Mrs. Bates

DRAWN BY HARRISON FISHER

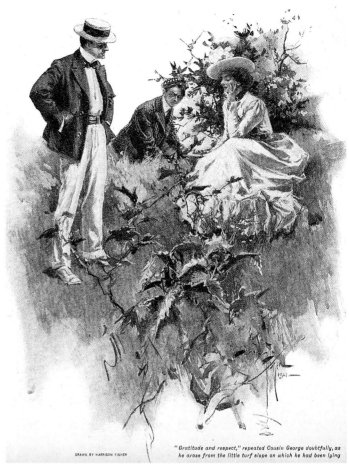

DRAWN BY HARRISON FISHER

"Gratitude and respect," repeated Cousin George doubtfully, as
he arose from the little turf slope on which he had been lying

Illustration published in *The Saturday Evening Post*, 1901.

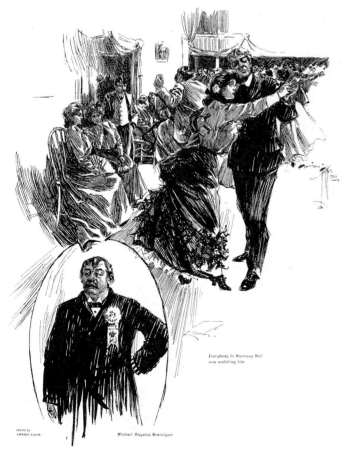

Everybody in Harmony Hall
was watching him

DRAWN BY
HARRISON FISHER

Michael Aloysius Brannigan

Illustrations for *Striking an* Average, a short story by B. Fuller, published
in *The Saturday Evening Post*, 1901.

Illustration published in *The Saturday Evening Post*, 1901.

DRAWN BY HARRISON FISHER

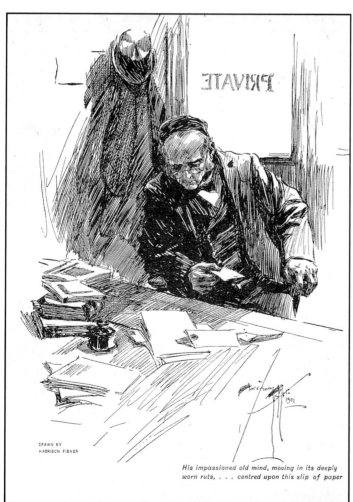

PRIVATE

DRAWN BY
HARRISON FISHER

His impassioned old mind, moving in its deeply worn ruts, . . . centred upon this slip of paper

Illustrations for *The End of the Deal*, a short story by Will Payne, published in *The Saturday Evening Post*, 1901.

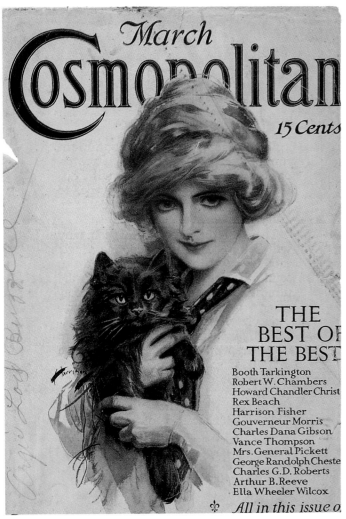

A cover illustration for *Cosmopolitan.* Harrison Fisher did his first cover for this Hearst magazine in 1907. From 1912 until his death in 1934, Fisher did nearly every cover for that publication.

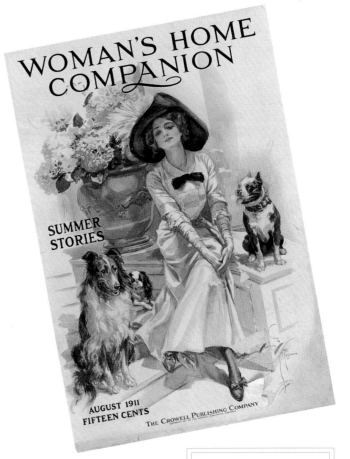

Woman's Home Companion covers by Harrison Fisher.

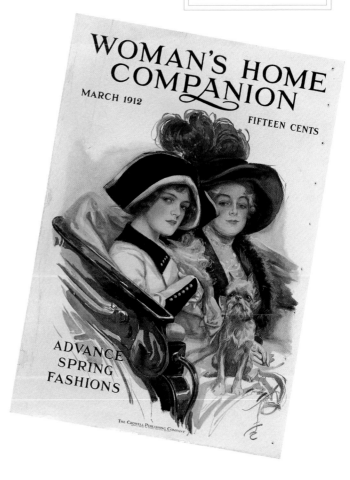

Following five photos: Cover art for *American Sunday Monthly Magazine.*

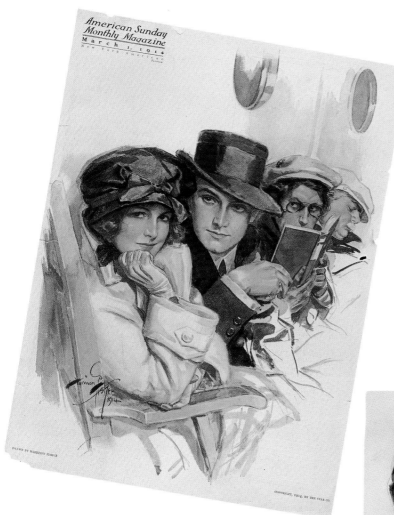

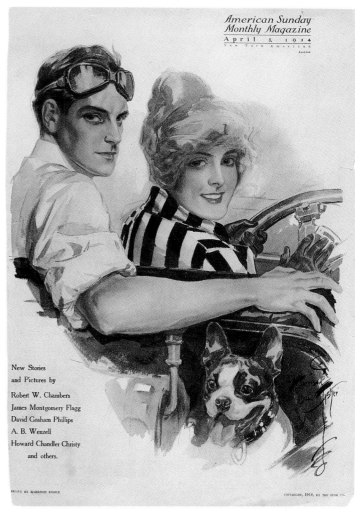

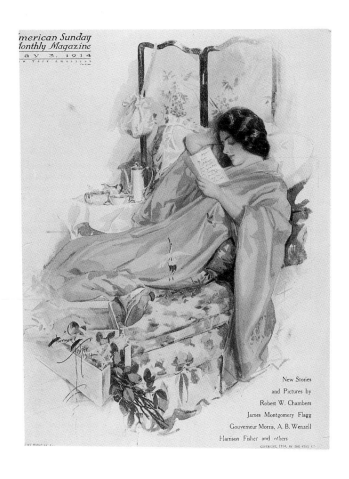

New Stories
and Pictures by
Robert W. Chambers
James Montgomery Flagg
Gouverneur Morris, A. B. Wenzell
Harrison Fisher and others

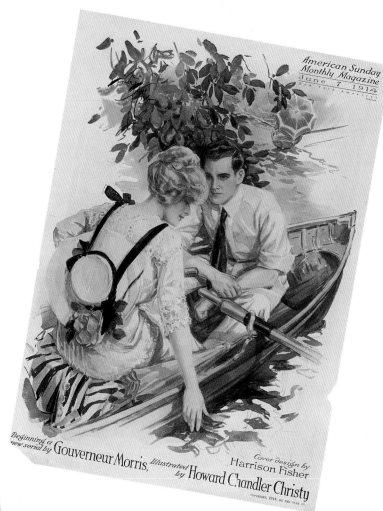

Beginning a
new serial by Gouverneur Morris, Illustrated
by Howard Chandler Christy.

Cover design by
Harrison Fisher

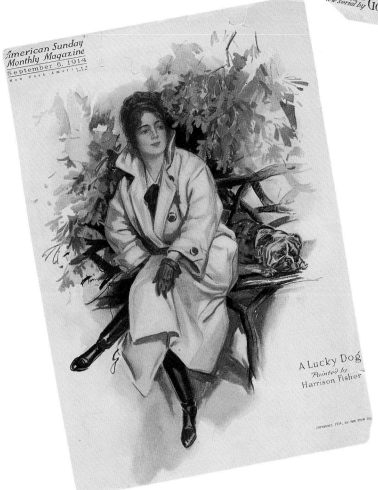

A Lucky Dog
Painted by
Harrison Fisher

Following twenty-two photos: Cover art for *The Ladies' Home Journel.*

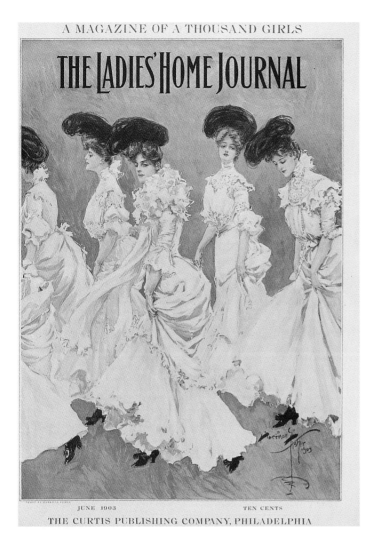

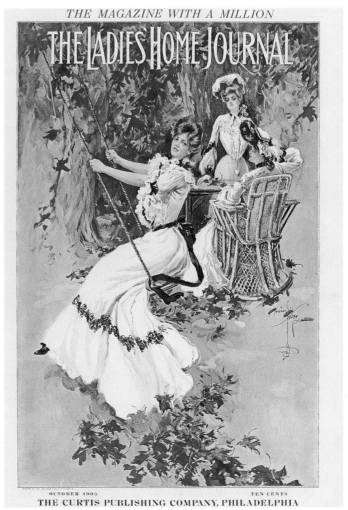

THE MAGAZINE WITH A MILLION

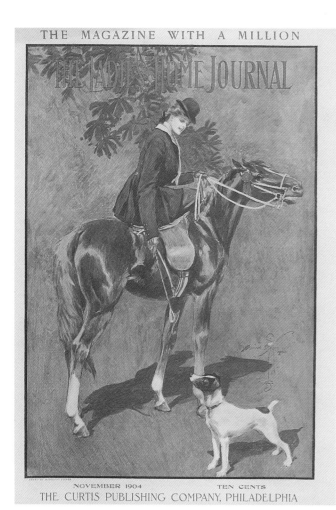

THE LADIES' HOME JOURNAL

NOVEMBER 1904 TEN CENTS

THE CURTIS PUBLISHING COMPANY, PHILADELPHIA

THE SPRING FASHION NUMBER
THE LADIES' HOME JOURNAL

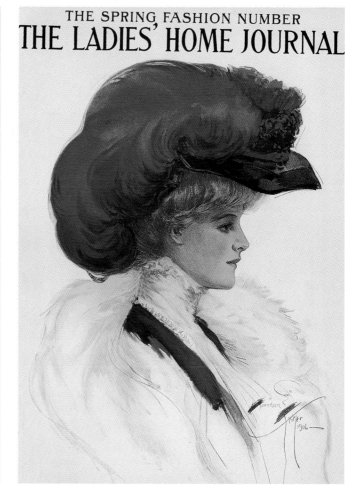

BEGINNING F. HOPKINSON SMITH'S GREAT ARTICLES

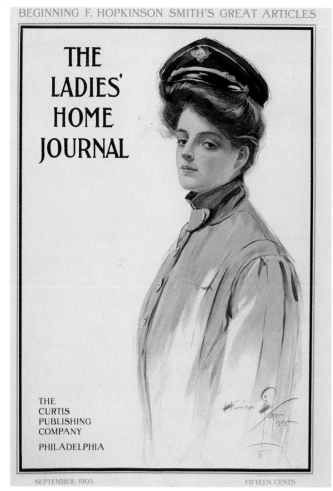

THE LADIES' HOME JOURNAL

THE
CURTIS
PUBLISHING
COMPANY

PHILADELPHIA

SEPTEMBER, 1905 FIFTEEN CENTS

THE LADIES' HOME JOURNAL

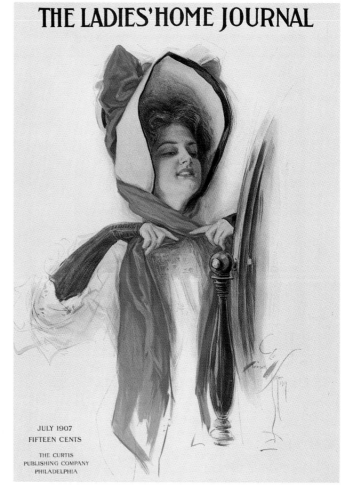

JULY 1907
FIFTEEN CENTS

THE CURTIS
PUBLISHING COMPANY
PHILADELPHIA

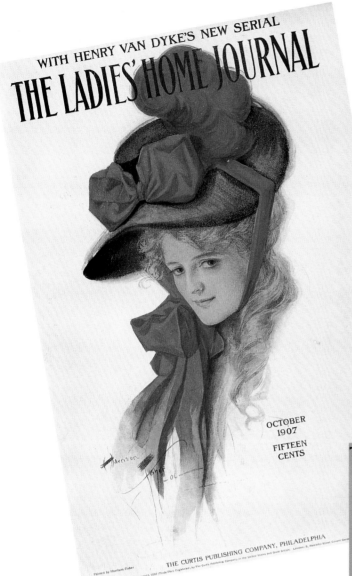

WITH HENRY VAN DYKE'S NEW SERIAL

THE LADIES' HOME JOURNAL

OCTOBER
1907

FIFTEEN
CENTS

THE CURTIS PUBLISHING COMPANY, PHILADELPHIA

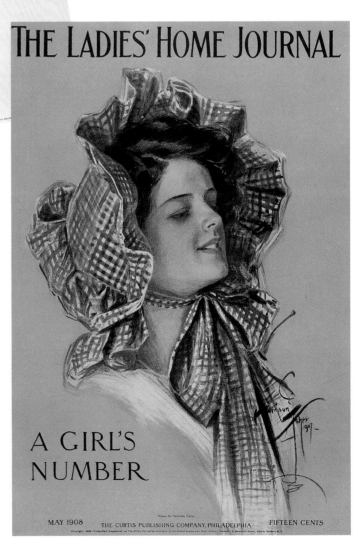

THE LADIES' HOME JOURNAL

A GIRL'S
NUMBER

MAY 1908 THE CURTIS PUBLISHING COMPANY, PHILADELPHIA FIFTEEN CENTS

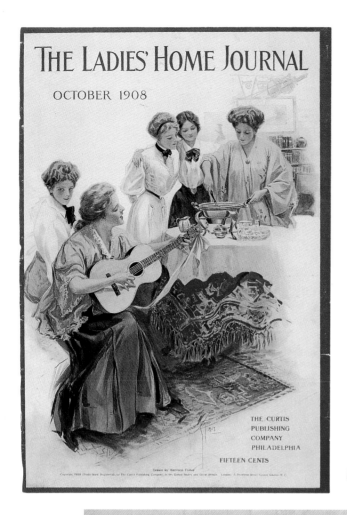

The Ladies' Home Journal

OCTOBER 1908

THE CURTIS
PUBLISHING
COMPANY
PHILADELPHIA

FIFTEEN CENTS

Drawn by Harrison Fisher

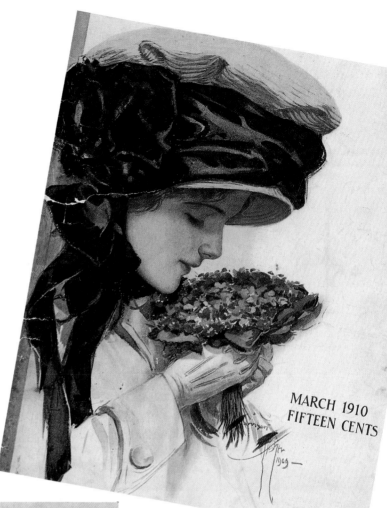

MARCH 1910
FIFTEEN CENTS

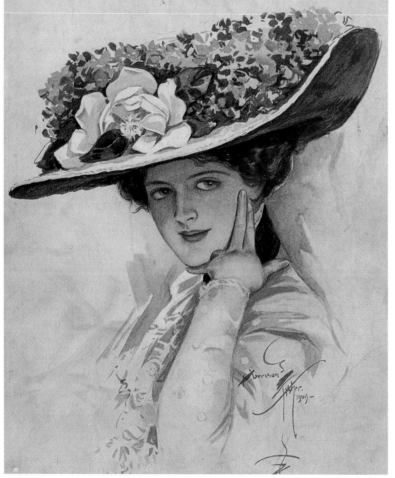

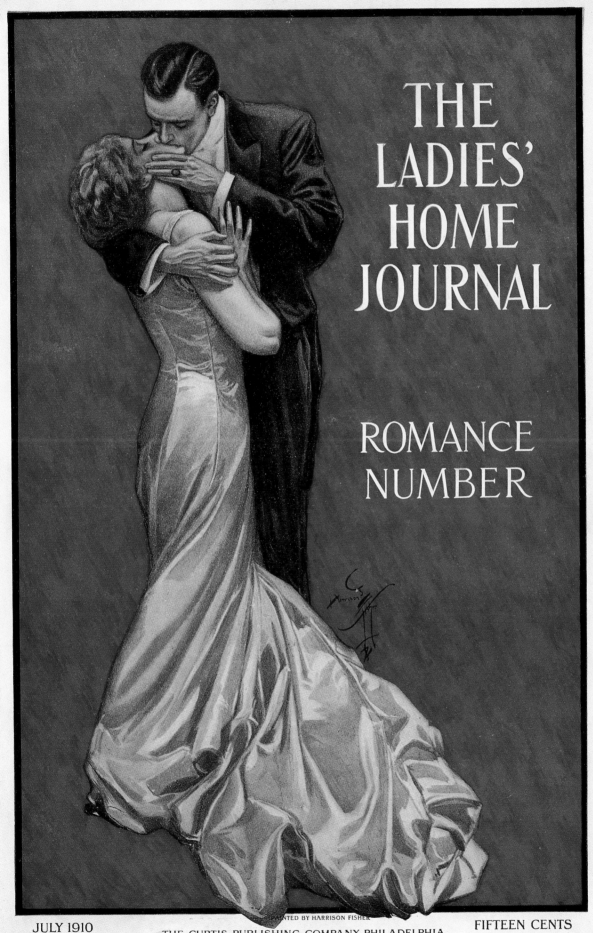

THE
LADIES'
HOME
JOURNAL

ROMANCE
NUMBER

PAINTED BY HARRISON FISHER

JULY 1910 THE CURTIS PUBLISHING COMPANY, PHILADELPHIA FIFTEEN CENTS

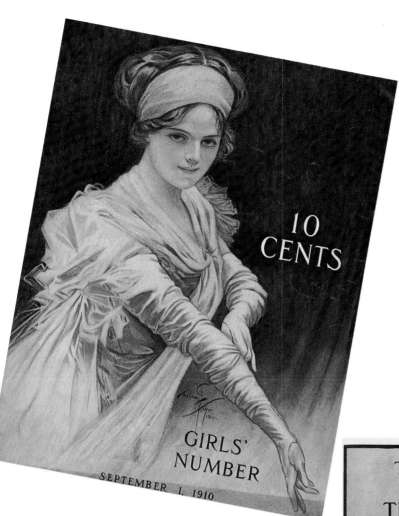

10
CENTS

GIRLS'
NUMBER
SEPTEMBER 1, 1910

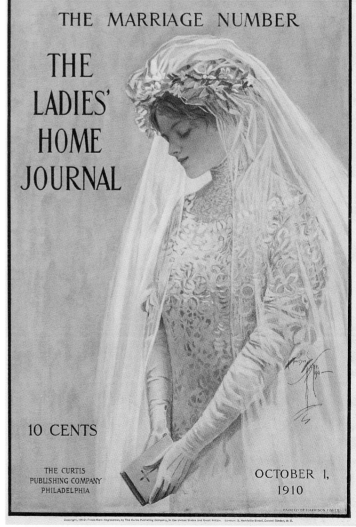

THE MARRIAGE NUMBER

THE
LADIES'
HOME
JOURNAL

10 CENTS

THE CURTIS
PUBLISHING COMPANY
PHILADELPHIA

OCTOBER 1,
1910

PAINTED BY HARRISON FISHER

Copyright, 1910. Trade-Mark Registered, by The Curtis Publishing Company, in the United States and Great Britain. London: 6, Henrietta Street, Covent Garden, W. C.

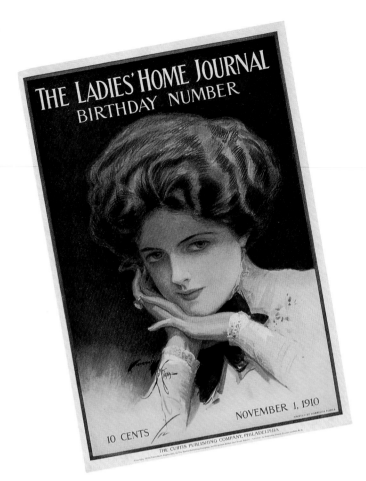

THE LADIES' HOME JOURNAL
BIRTHDAY NUMBER

10 CENTS

NOVEMBER 1, 1910

THE CURTIS PUBLISHING COMPANY, PHILADELPHIA

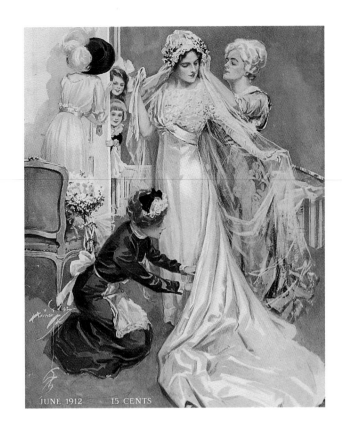

JUNE 1912 15 CENTS

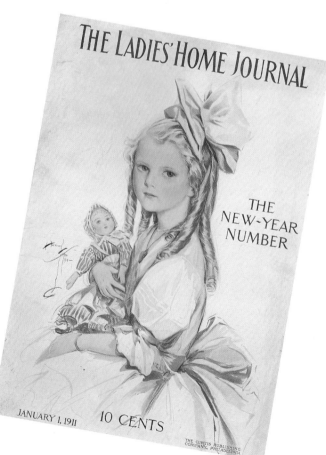

THE LADIES' HOME JOURNAL

THE
NEW-YEAR
NUMBER

JANUARY 1, 1911 10 CENTS

THE CURTIS PUBLISHING
COMPANY, PHILADELPHIA

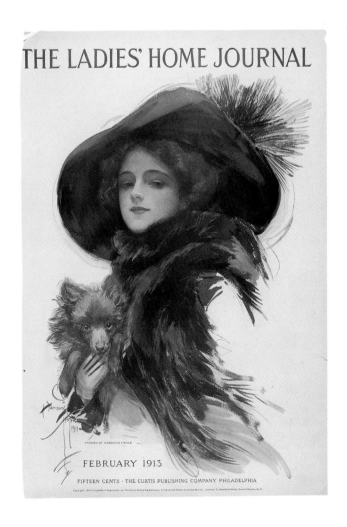

THE LADIES' HOME JOURNAL

FEBRUARY 1913

FIFTEEN CENTS - THE CURTIS PUBLISHING COMPANY PHILADELPHIA

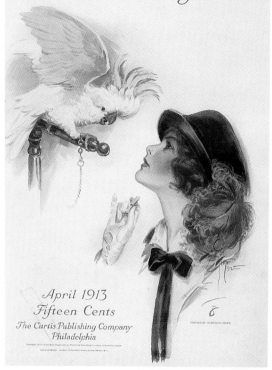

The Ladies' Home Journal

April 1913
Fifteen Cents
The Curtis Publishing Company
Philadelphia

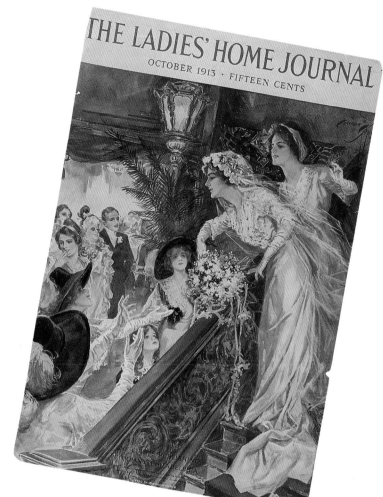

THE LADIES' HOME JOURNAL
OCTOBER 1913 · FIFTEEN CENTS

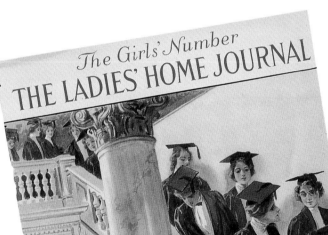

The Girls' Number
THE LADIES' HOME JOURNAL

JUNE 1913 THE CURTIS PUBLISHING COMPANY PHILADELPHIA 15 CENTS

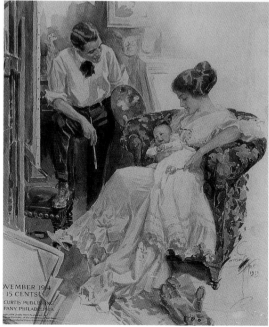

NOVEMBER 1914
15 CENTS
CURTIS PUBLISHING
PANY PHILADELPHIA

Following six photos: Harrison Fisher was commissioned to produce a number of series for various publications, such as these, which made up *Harrison Fisher's College Girls*, a six-part series run in 1908 issues of *The Ladies' Home Journal*, May, 1908.

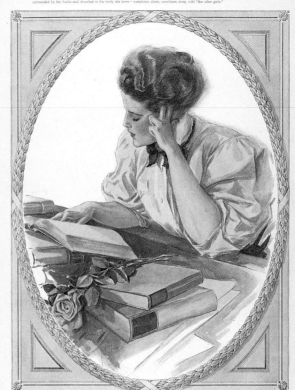

Harrison Fisher's College Girls

The College Girl at Her Studies
By Harrison Fisher

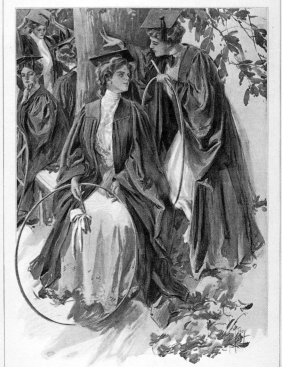

Harrison Fisher's College Girls

The College Girl at Basket-Ball
By Harrison Fisher

The College Girl After the May-Day Hoop-Rolling
By Harrison Fisher

Harrison Fisher's College Girls

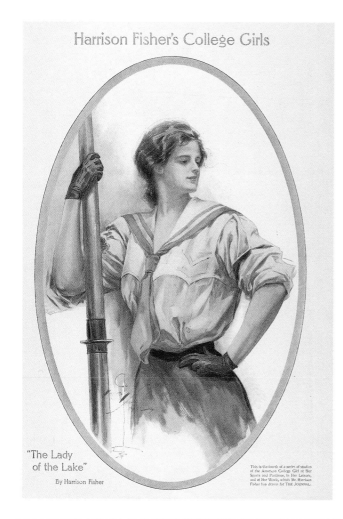

"The Lady
of the Lake"

By Harrison Fisher

This is the fourth of a series of studies
of the American College Girl at Her
Sports and Pastimes, in Her Leisure,
and at Her Work, which Mr. Harrison
Fisher has drawn for THE JOURNAL.

Harrison Fisher's College Girls

A Fudge Party
By Harrison Fisher

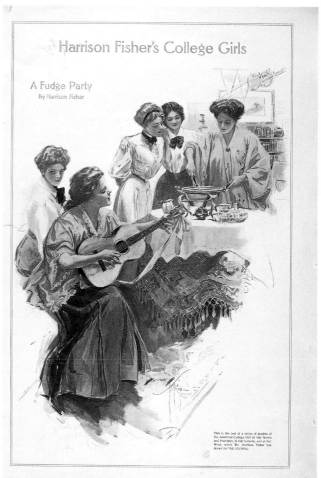

This is the last of a series of studies of
the American College Girl at Her Sports
and Pastimes, in Her Leisure, and at Her
Work, which Mr. Harrison Fisher has
drawn for THE JOURNAL.

Harrison Fisher's College Girls

JUNE days are days of farewell
among college girls, but to the
"grand old Seniors" the good-bys are
tinged with sadness. Never again
shall they meet together in that free
and inspiring companionship which
has ennobled their college life and
will follow them into "the wide, wide
world." So in the hours that yet re-
main they make merry. Class Day
has come and is almost gone. The
gay supper has ended in gayer
speeches—eyes are wet though lips
smile—and then with one accord every
girl springs to her feet and in the
words of "Auld Lang Syne" pledges
loyalty to her college memories.

This is the fifth of a series of studies of
the American College Girl at Her Sports
and Pastimes, in Her Leisure, and at Her
Work, which Mr. Harrison Fisher has
drawn for THE JOURNAL.

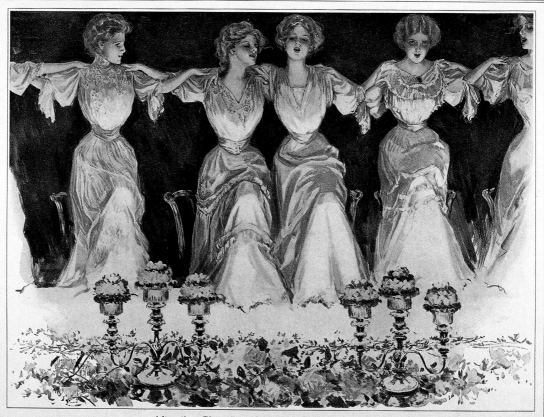

After the Class-Day Supper: By Harrison Fisher

The Girls I Like Best: By Harrison Fisher

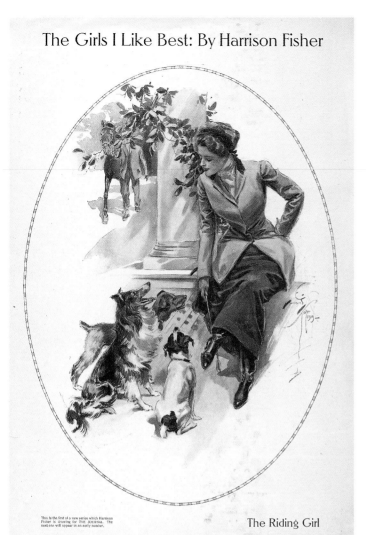

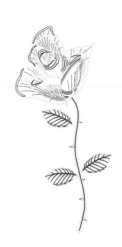

This is the first of a new series which Harrison Fisher is drawing for THE JOURNAL. The next one will appear in an early number.

The Riding Girl

Serialized illustrations — such as *The Girls I Like Best: By Harrison Fisher* published in 1910 issues of *The Ladies' Home* Journal — were run in random issues to keep customers coming back.

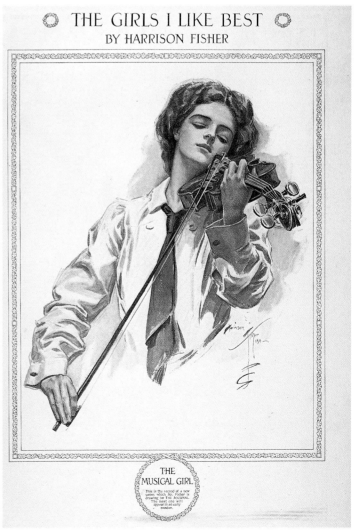

THE GIRLS I LIKE BEST
BY HARRISON FISHER

THE MUSICAL GIRL

This is the second of a new series which Mr. Fisher is drawing for THE JOURNAL. The next one will appear in an early number.

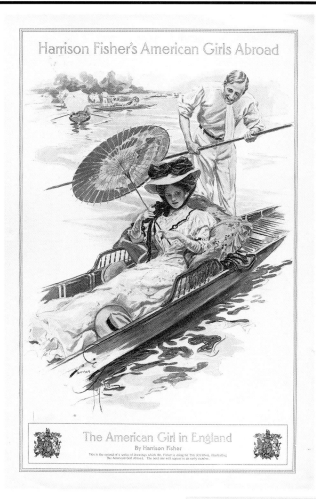

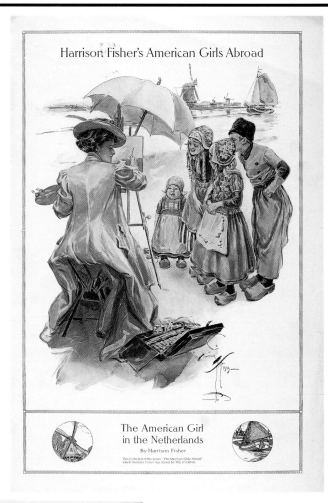

One popular series by Harrison Fisher was his *American Girls Abroad*, run in 1909 issues of *The Ladies' Home Journal* and later reproduced in books and on postcards.

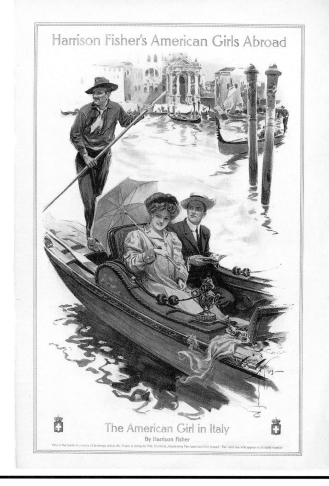

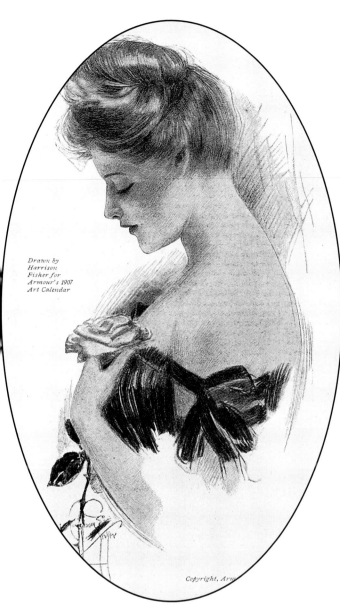

Drawn by
Harrison
Fisher for
Armour's 1907
Art Calendar

Copyright, Arm

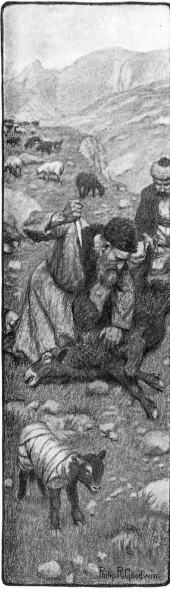

Harrison Fisher's work also helped sell products other than publications. This illustration was used to publicize a 1907 calendar for Armour and Company food products, shown here in an advertisement from *The Ladies' Home Journal*, January 1907.

Harrison Fisher pitched in for the war effort, producing posters for World War I. He also teamed up with artist Philip R. Goodwin to create *A Picture Parable* with the following message for fashionable ladies: "To obtain the 'broadtail' fur, which women are now wearing so much, the mother is slaughtered and the unborn lamb is taken from her. This gives a more glossy fur. If fashionable women knew the cruel price which is paid for the lamb skins thus obtained but few of them would find pleasure in wearing the 'broadtail' fur."

Harrison Fisher's name took on brand appeal. It sold. His illustrations could turn novels into bestsellers, so publishers clamored for his work. They pasted it on the covers and dust jackets of books illustrated by other artists, and sometimes they plastered popular artist's name above the author's on the cover. Following are a number of his more popular illustrated works, run in chronological order acccording to publication dates.

Beverly of Graustark

Following five photos: Illustrations for *Beverly of Graustark* by George Barr McCutcheon, published by Grosset & Dunlap, New York, 1904.

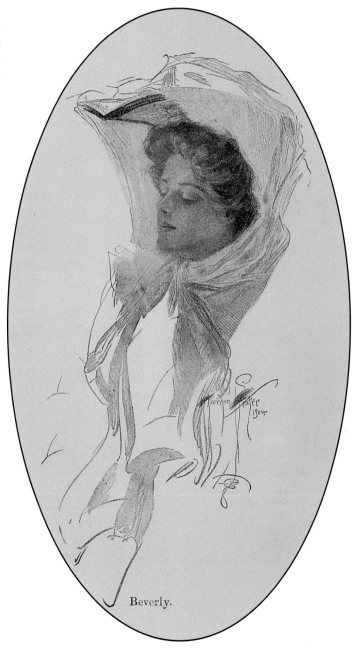

Beverly.

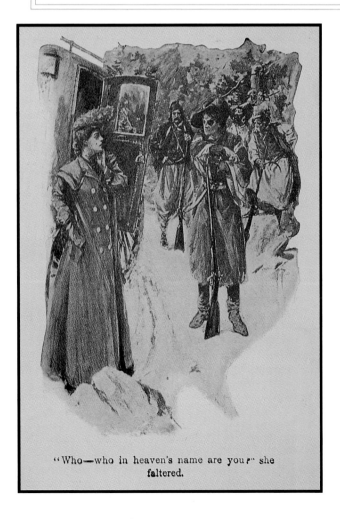

"Who—who in heaven's name are you?" she faltered.

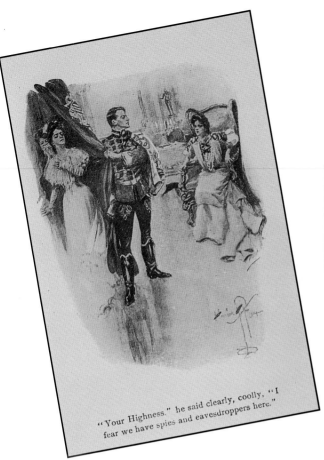

"Your Highness," he said clearly, coolly, "I fear we have spies and eavesdroppers here."

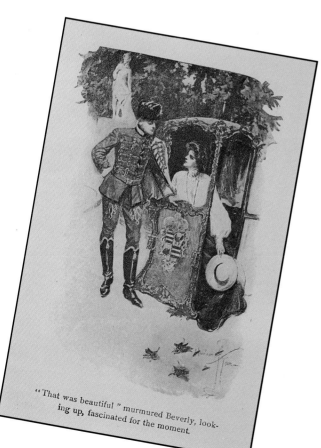

"That was beautiful" murmured Beverly, looking up, fascinated for the moment.

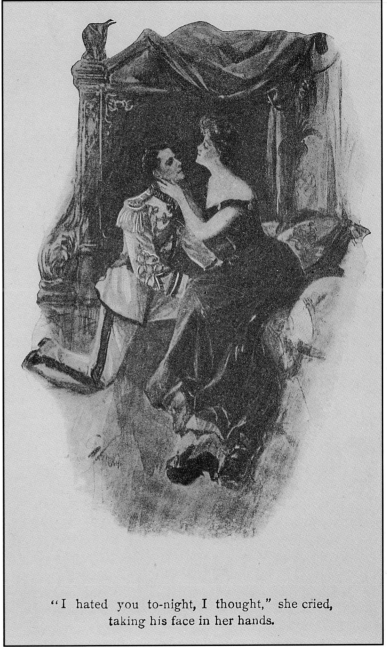

"I hated you to-night, I thought," she cried, taking his face in her hands.

Following five photos: *The Day of the Dog: A Love Story* by George Barr McCutcheon, Grosset & Dunlap, New York, 1905.

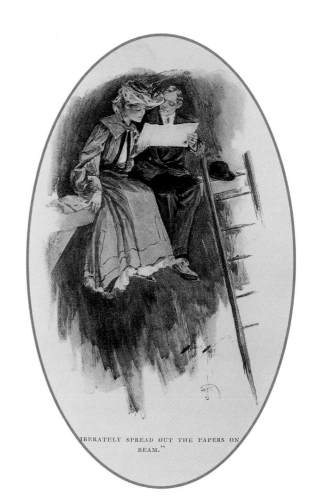

"IBERATELY SPREAD OUT THE PAPERS ON BEAM."

SWALLOW.

CHUBBY BODY SHOT SQUARELY THROUGH THE OPENING."

SPLASHING THROUGH THE SHALLOW BRO

VENS!' 'WHAT IS IT?' HE CRIED.

OT MARRIED, ARE YOU?'"

Following five photos: *Nedra* by George Barr
McCutcheon, Dodd, Mead & Company, New York, 1905.

LADY TENNYS

GRACE VERNON

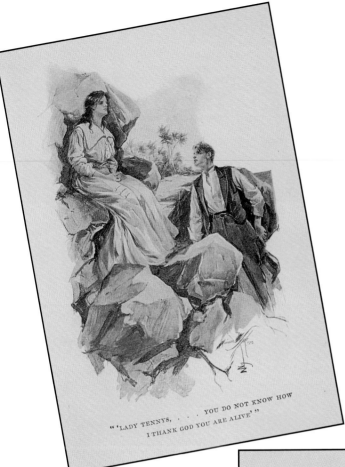

"'LADY TENNYS, YOU DO NOT KNOW HOW
I THANK GOD YOU ARE ALIVE'"

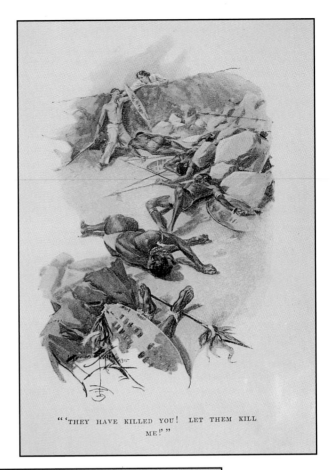

"'THEY HAVE KILLED YOU! LET THEM KILL
ME!'"

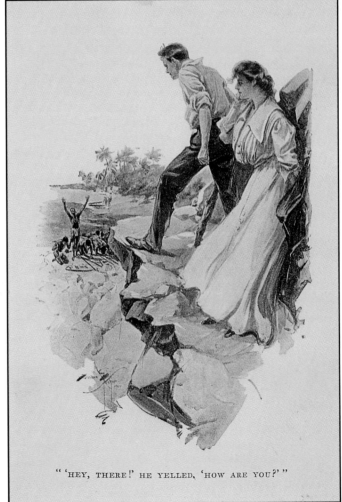

"'HEY, THERE!' HE YELLED, 'HOW ARE YOU?'"

Following five photos: *Cowardice Court* by
George Barr McCutcheon, Grosset & Dunlap,
New York, 1906.

tting me off your place? Oh, ho

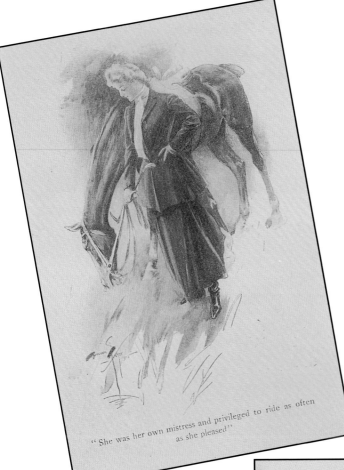

"She was her own mistress and privileged to ride as often
as she pleased"

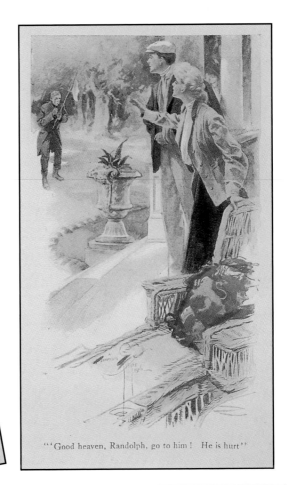

"'Good heaven, Randolph, go to him! He is hurt'"

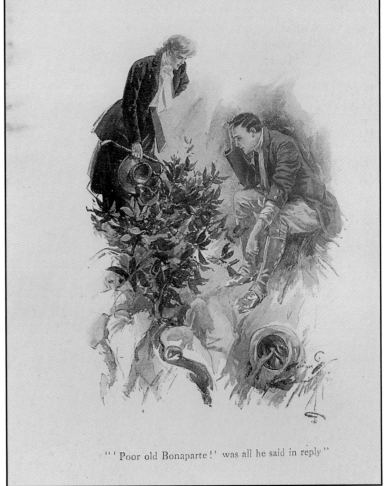

"'Poor old Bonaparte!' was all he said in reply"

Following twenty-six photos: Harrison Fisher put extraordinary effort into a commission to illustrate the classic poem *Hiawatha* by Henry Wadsworth Longfellow. In all, he had 68 illustrations included in the book, which was published by the Bobbs-Merrill Company of Indianapolis in 1906. Fifty-two of these were black and white illustrations, and we have weeded out 42 of these for the sake of space.

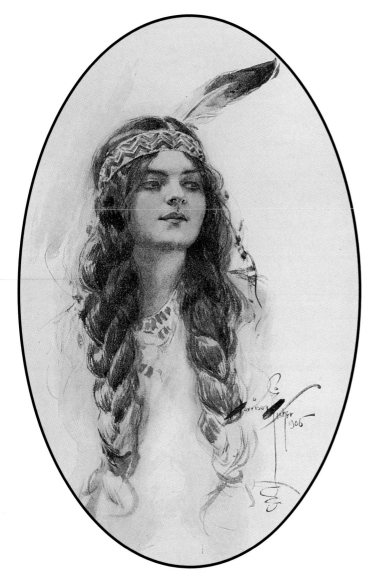

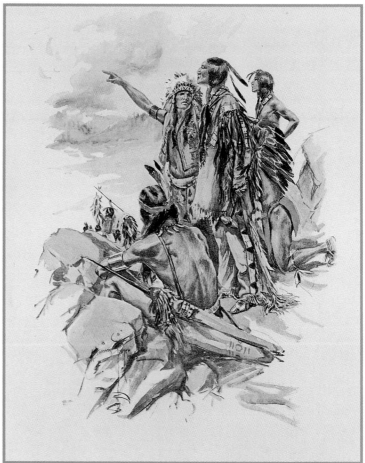

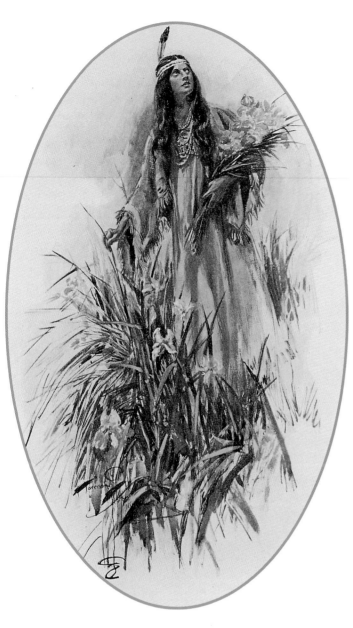

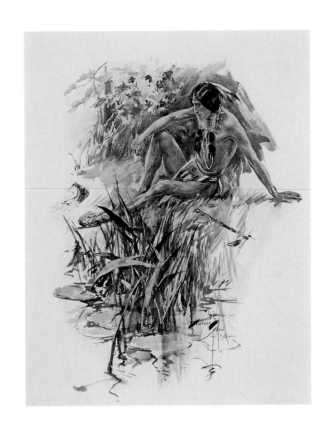

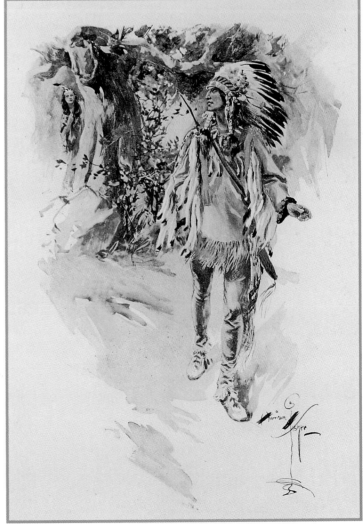

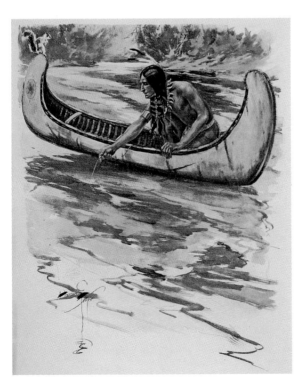

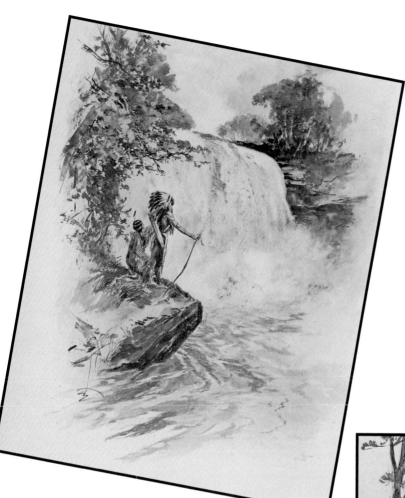

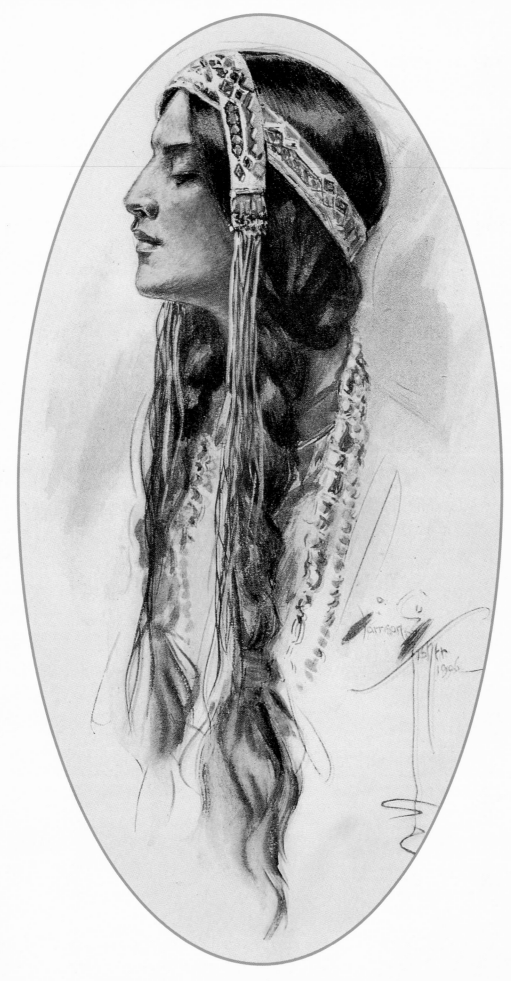

43

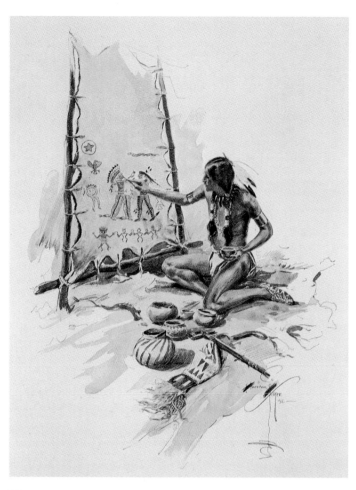

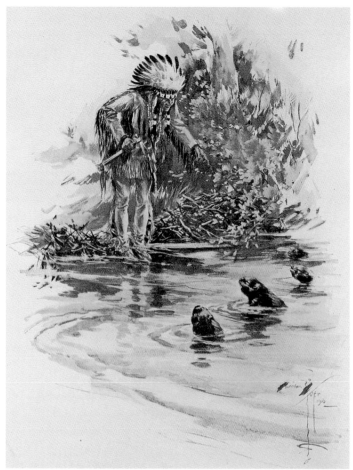

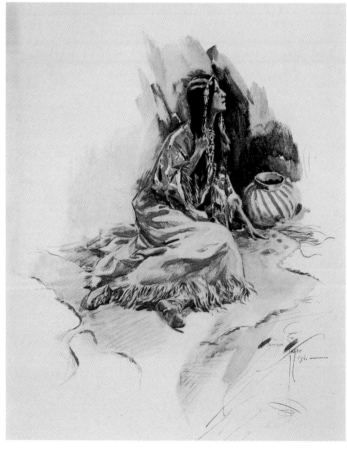

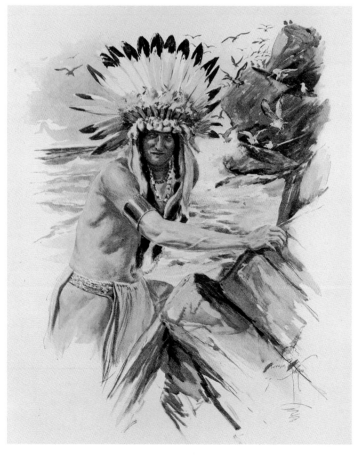

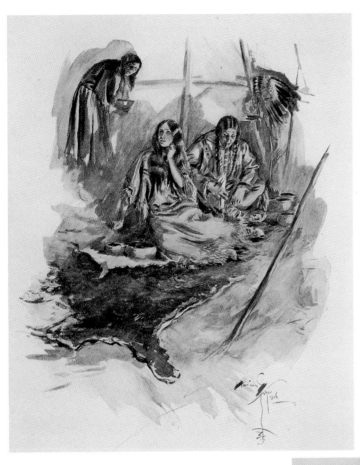

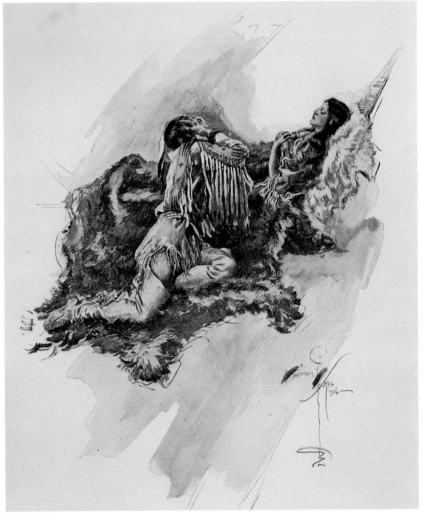

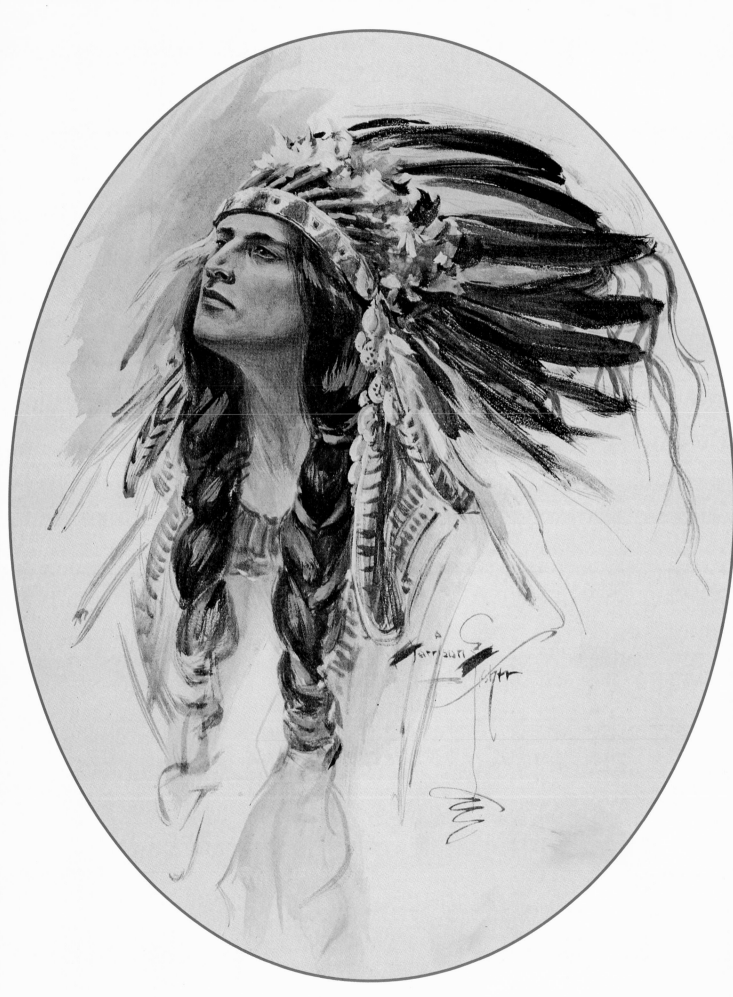

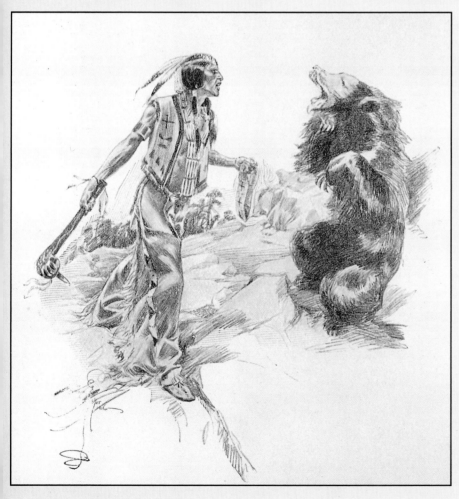

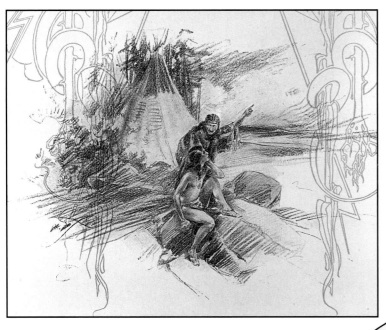

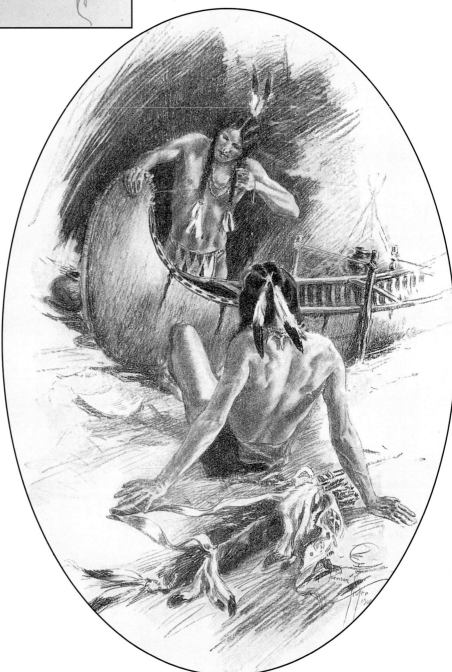

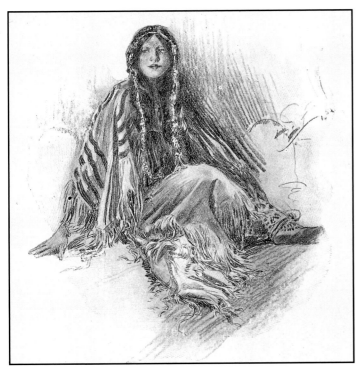

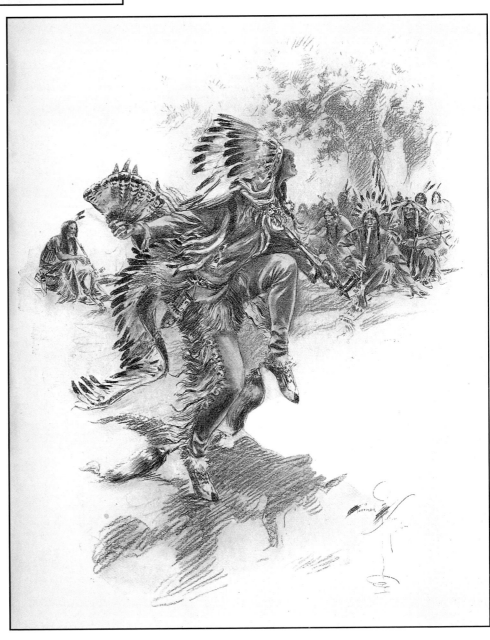

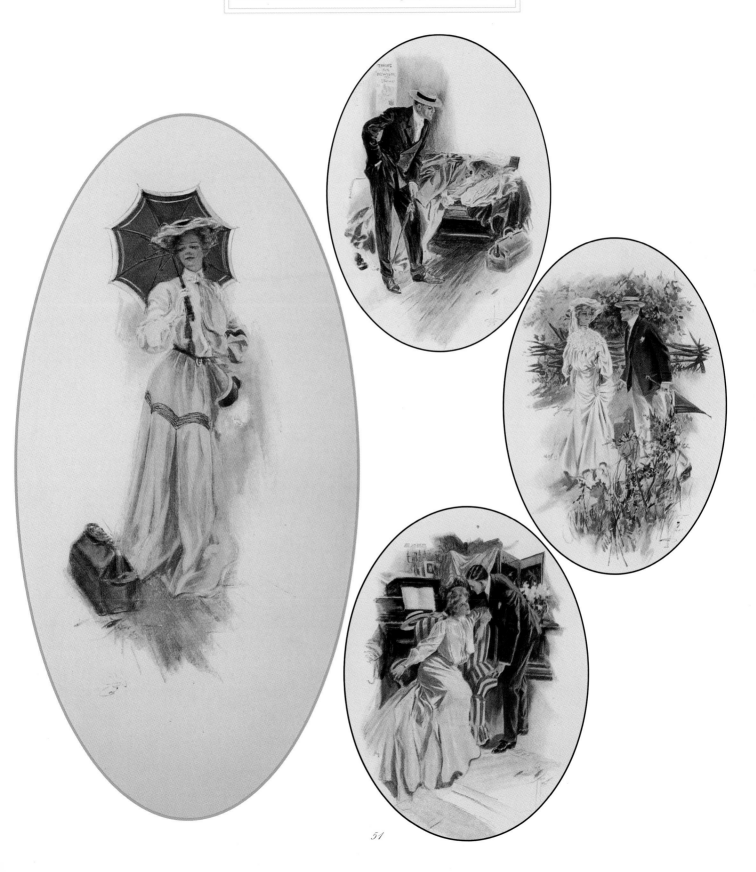

Following four photos: *The Purple Parasol* by George Barr McCutcheon, Dodd, Mead & Company, New York, 1907.

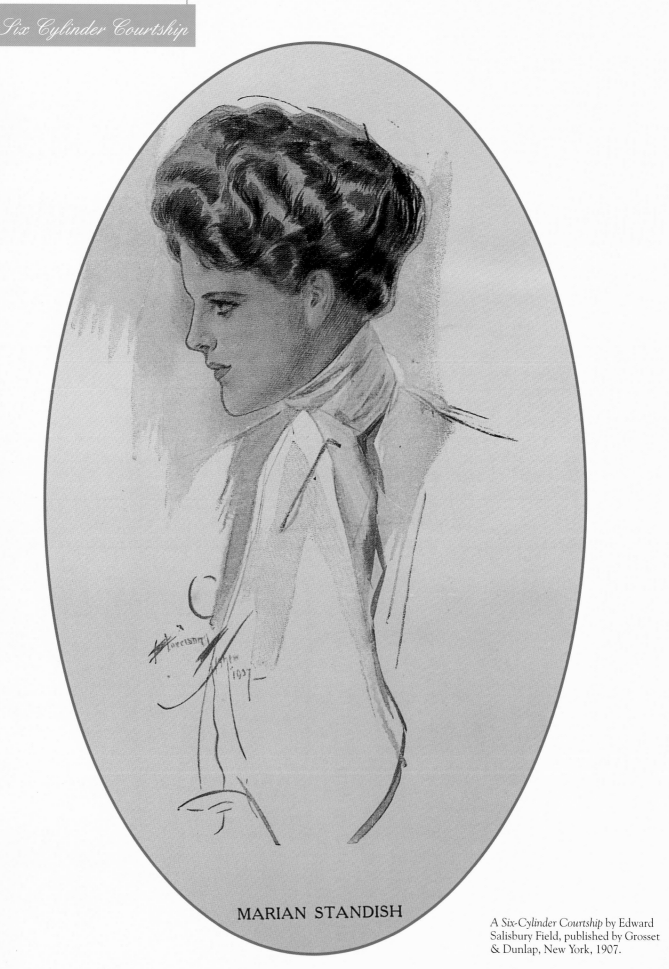

MARIAN STANDISH

A *Six-Cylinder Courtship* by Edward
Salisbury Field, published by Grosset
& Dunlap, New York, 1907.

The Men from Brodneys, by George Barr McCutcheon,
published by Grosset & Dunlap, New York, 1908.

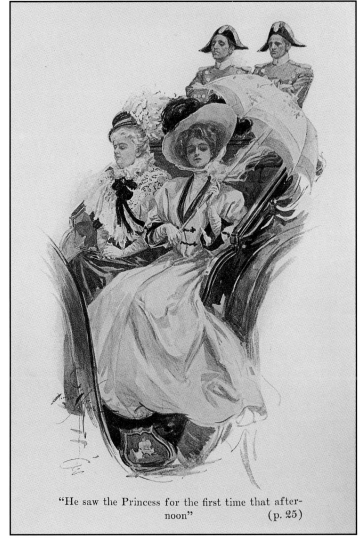

"He saw the Princess for the first time that after-
noon" (p. 25)

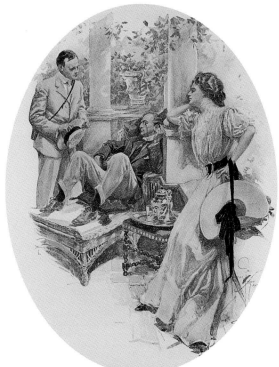

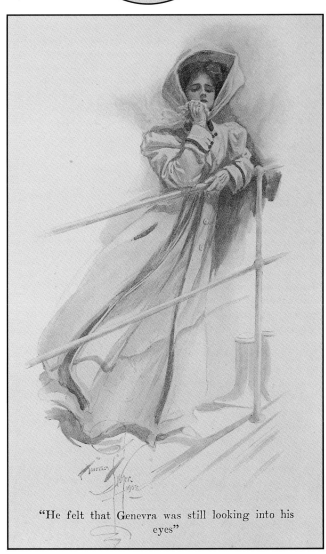

"He felt that Genevra was still looking into his
eyes"

Following five photos: *Their Hearts' Desire* by Frances Foster Perry, published by Dodd, Mead & Company, New York, 1909.

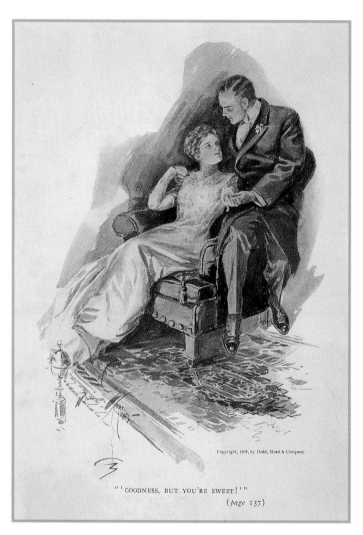

Copyright, 1909, by Dodd, Mead & Company

"'GOODNESS, BUT YOU'RE SWEET!'"

(*page* 137)

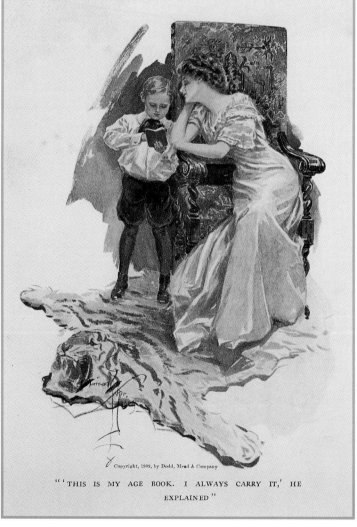

Copyright, 1909, by Dodd, Mead & Company

"'THIS IS MY AGE BOOK. I ALWAYS CARRY IT,' HE EXPLAINED"

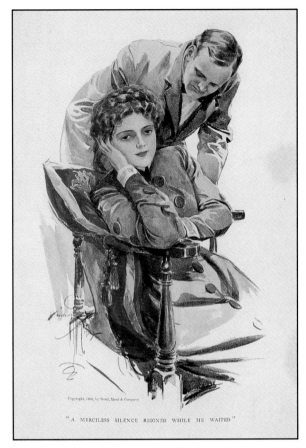

"A MERCILESS SILENCE REIGNED WHILE HE WAITED"

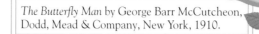

The Butterfly Man by George Barr McCutcheon, Dodd, Mead & Company, New York, 1910.

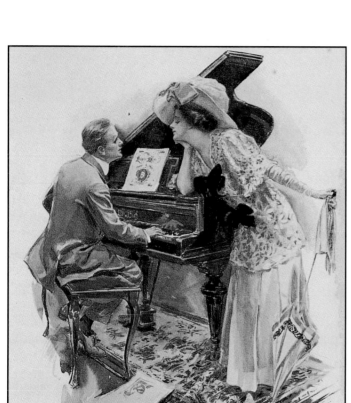

The following are books published either exclusively as albums of Harrison Fisher's work, or as works thinly disguised as literature using his illustrations as the main selling point. The latter were often compilations of poetry, often not attributed to any author, interspersed with Fisher's work, which bore no relation to the words running next to it.

A Dream of Fair Women

Following twenty photos: *A Dream of Fair Women*, a compilation of poetry published by The Bobbs-Merrill Company, Indianapolis, 1907.

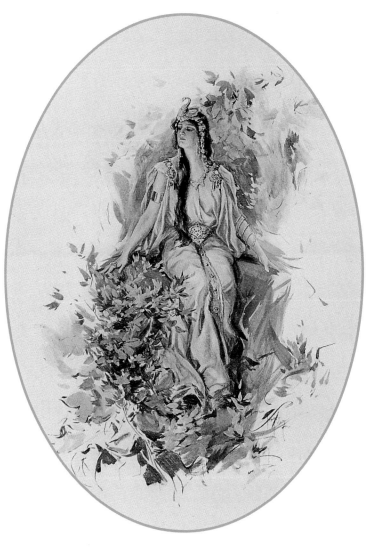

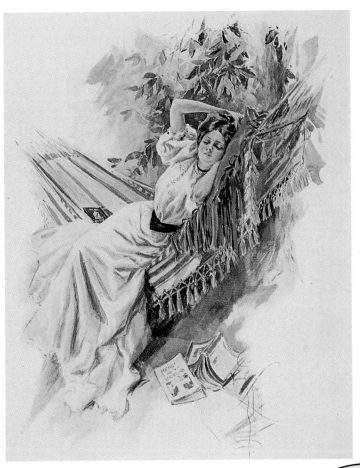

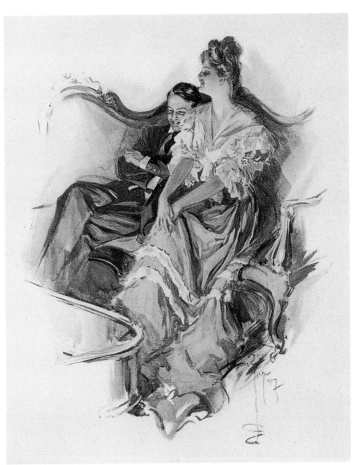

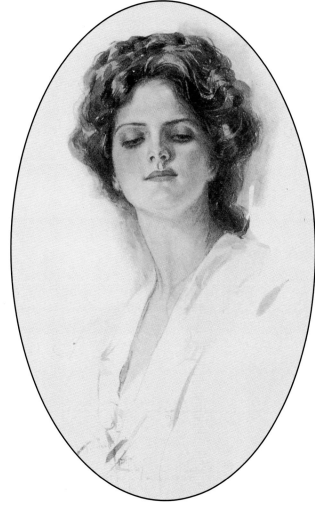

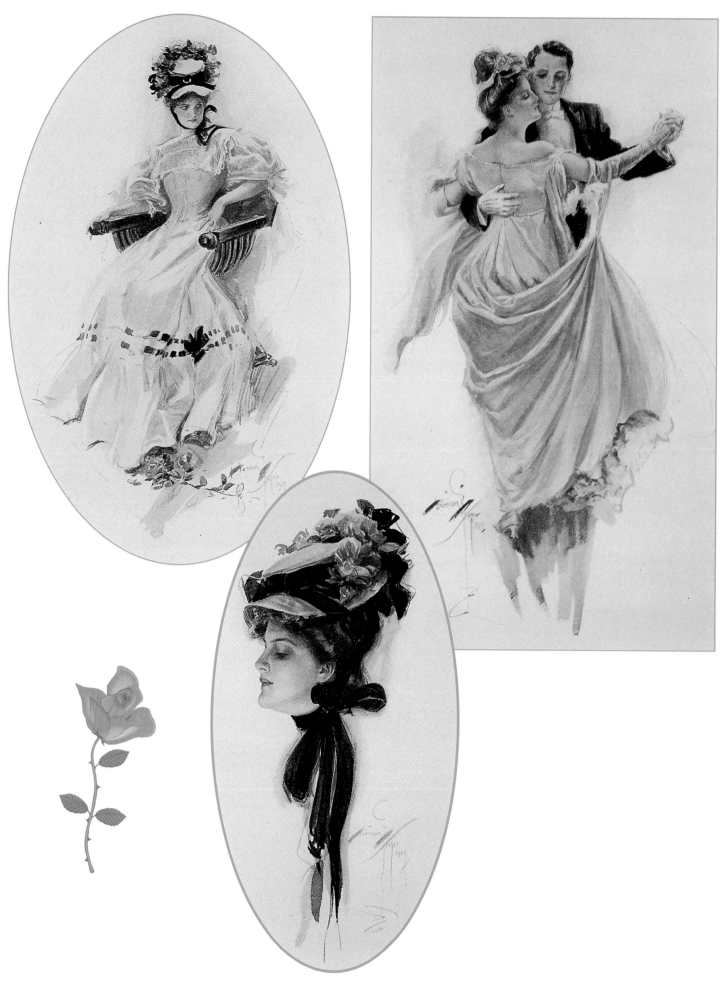

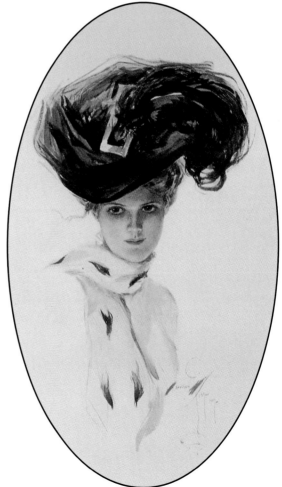

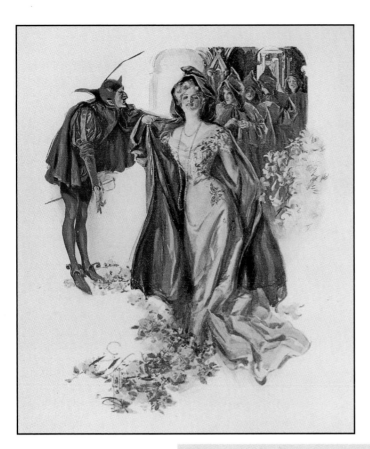

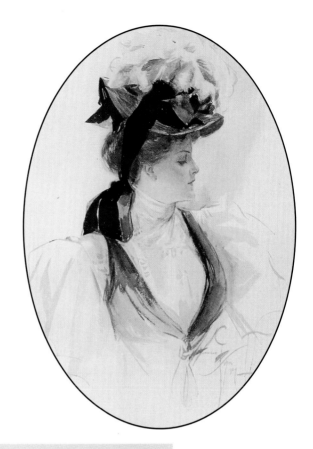

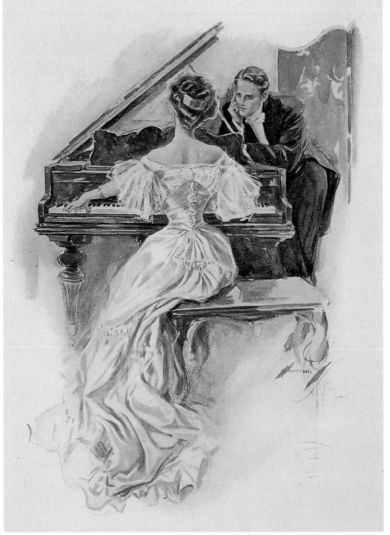

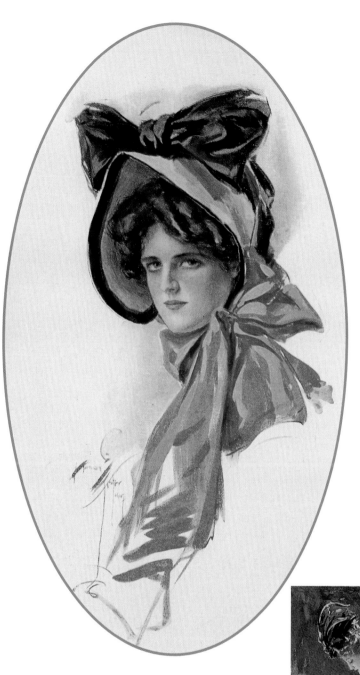

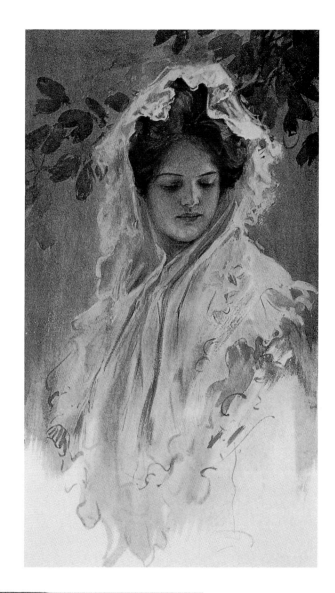

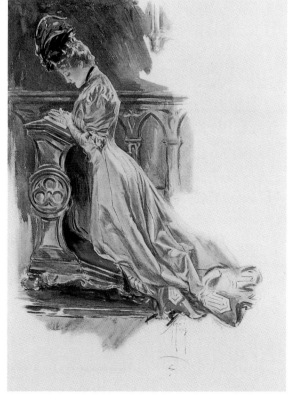

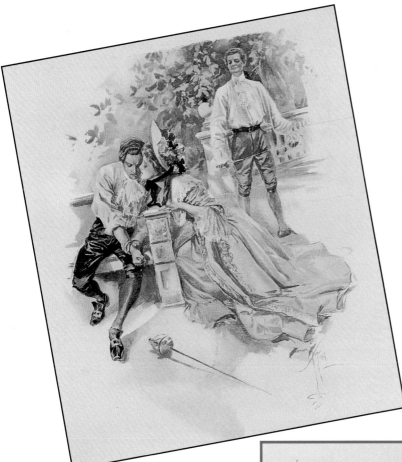

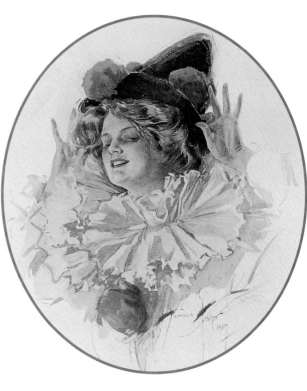

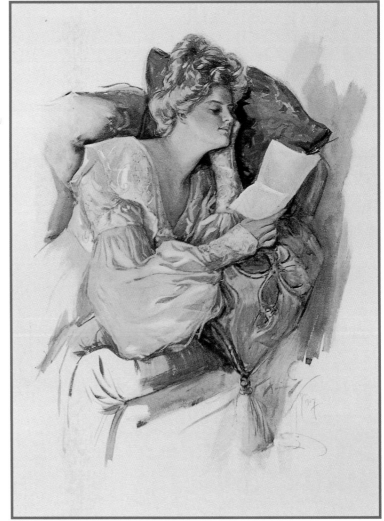

The Harrison Fisher Book: A Collection of Drawings in Colors and Black and White, published by Charles Scribner's Sons, New York, 1907. The first book devoted solely to the art of Harrison Fisher, this publication was an instant success. It incorporated a number of new sketches, primarily in black and white, as well as reprints of popular drawings from magazine serials and book illustrations. The following illustrations are run in approximately the order that they appear in the book. Some have been omitted as they are to be found elsewhere in this book.

Portrait of the author.

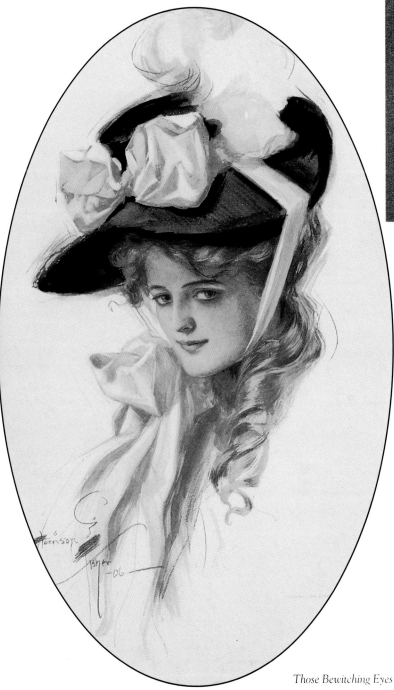

Those Bewitching Eyes

Ready for the Run

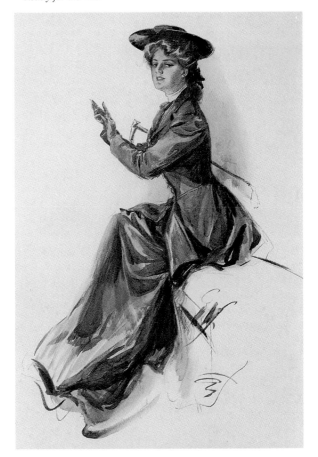

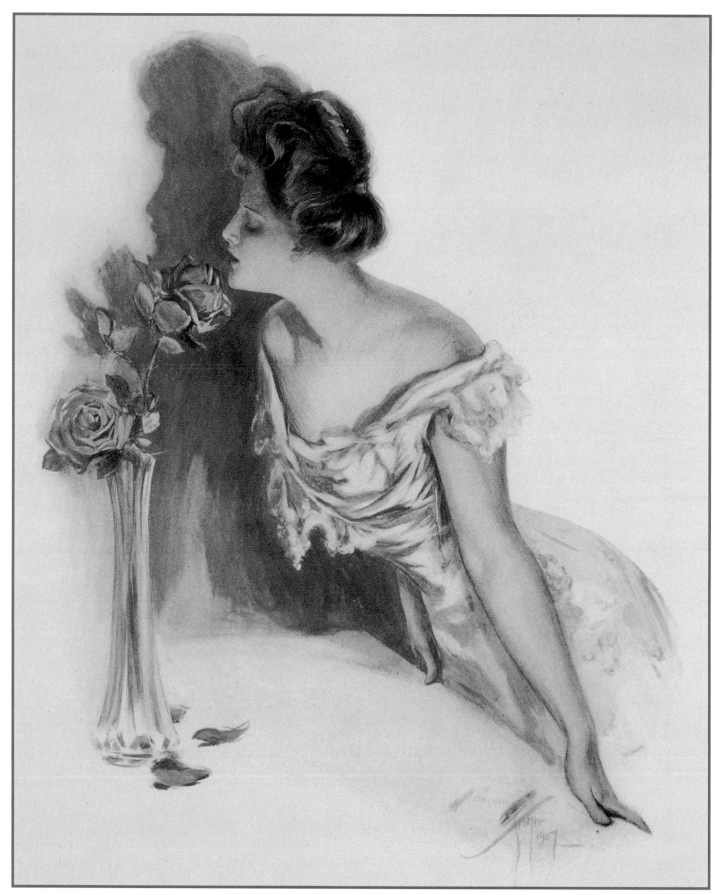

American Beauties

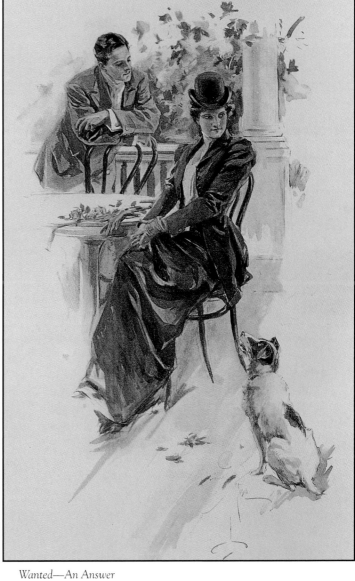

Wanted—An Answer

Fore!

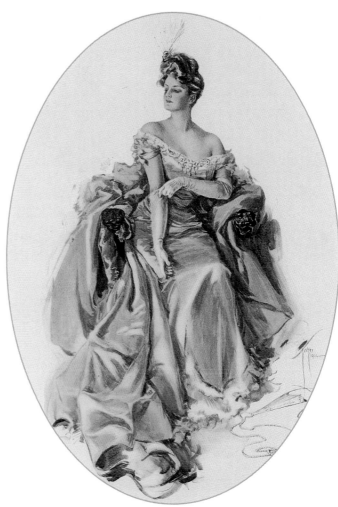

Fisherman's Luck

After the Dance

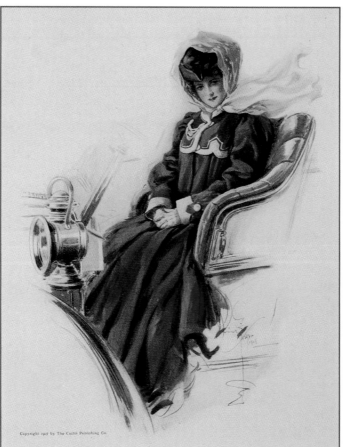

The Automobile Girl

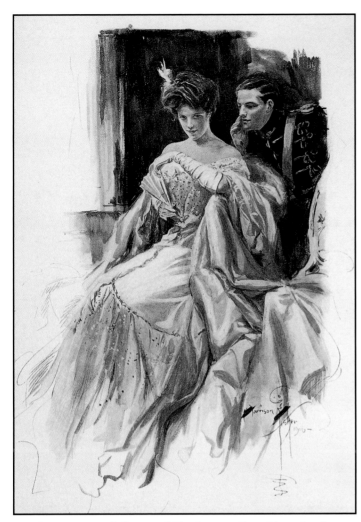

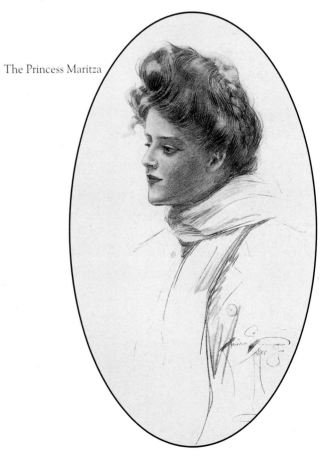

The Champion

Above: Desmond Ellerey and The Countess Frina Mavrodin, from
The Princess Maritza
Below: *One of the Pleasures of the Game*

The Princess Maritza

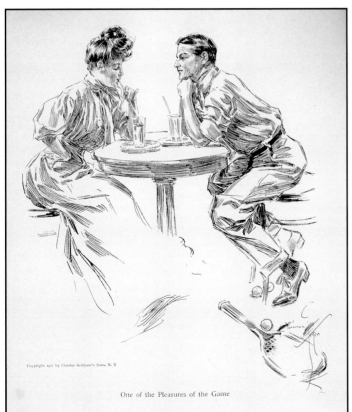

Copyright 1907 by Charles Scribner's Sons, N. Y

One of the Pleasures of the Game

The Critical Moment

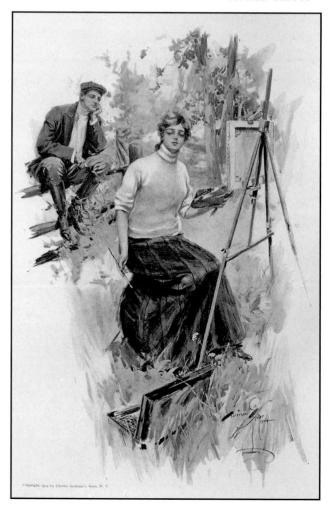

Which?

Which?

An Hour with Art

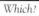

A Portrait Sketch

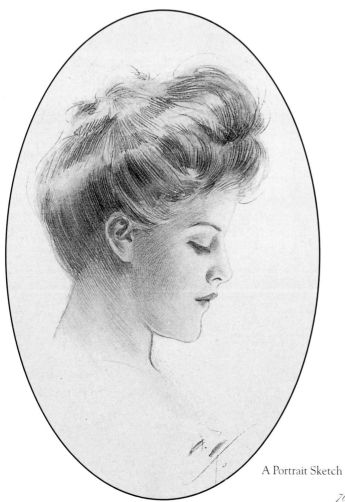

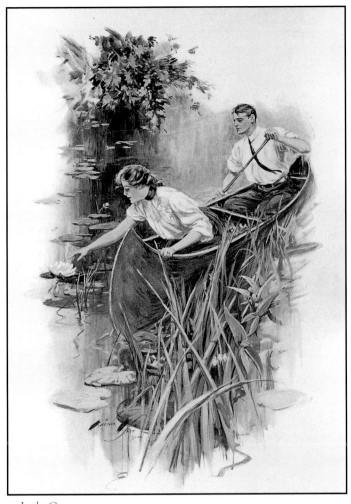

In the Canoe

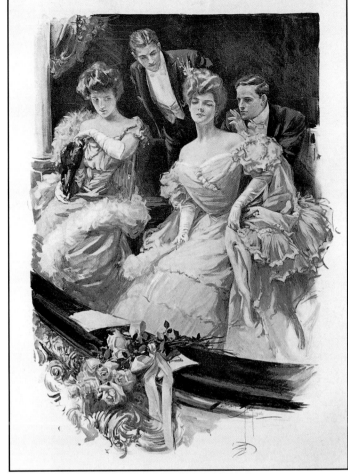

Rivals

A Sketch

A Sketch

71

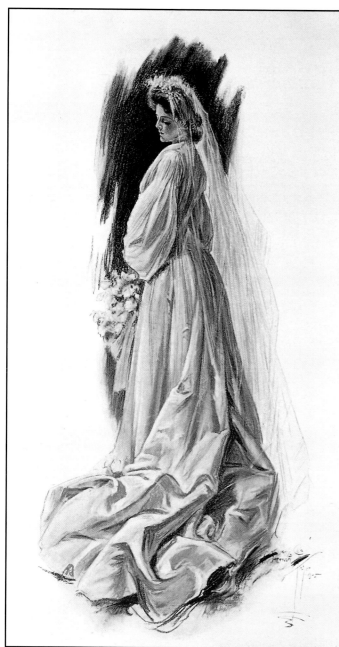

The Bride

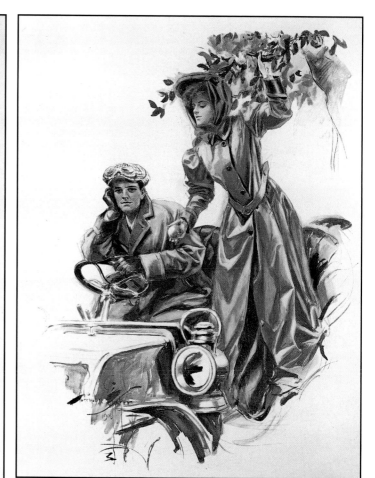

A Modern Eve

Final Instructions

A Sketch

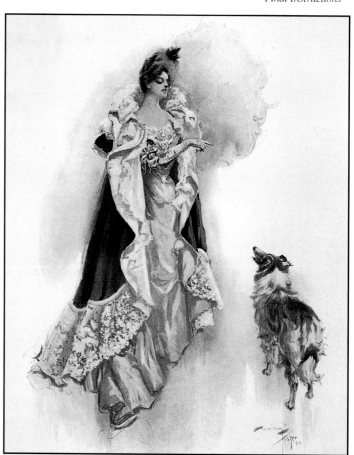

In the Country

Lady Bazelhurst, from *Cowardice Court*. See Page 38.
Penelope Drake, from *Cowardice Court*. See Page 38.

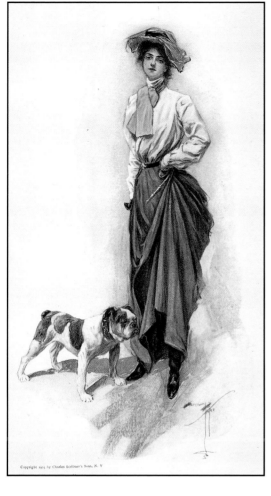

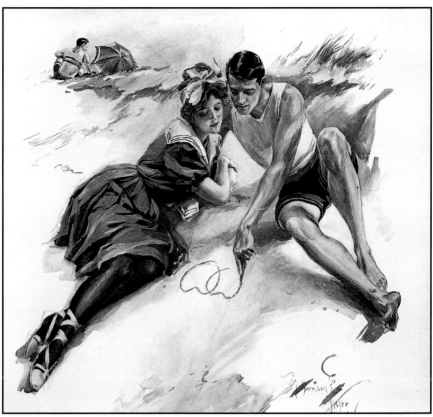

The Shifting Sands

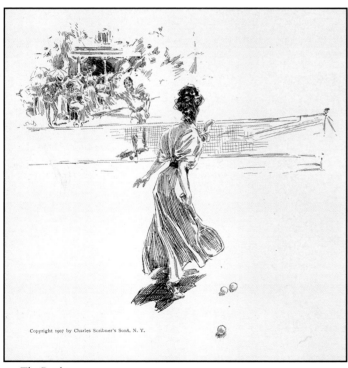

The Battle

An Incident of the Ride

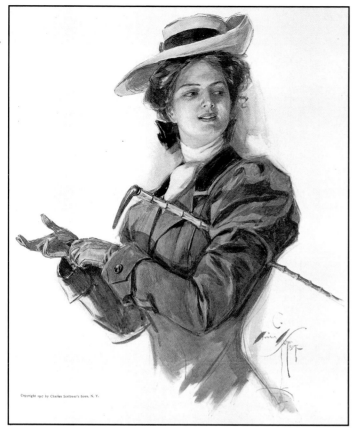

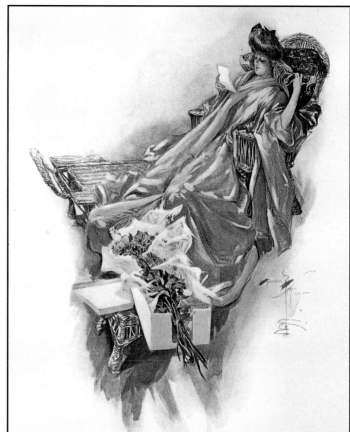

A Blue Ribbon Winner

Beginning the Day

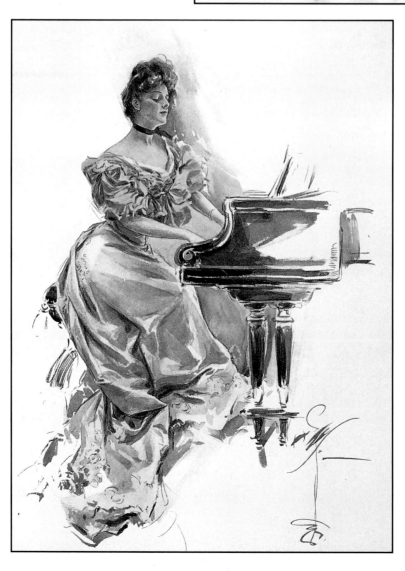

An Old Song

Rosamond

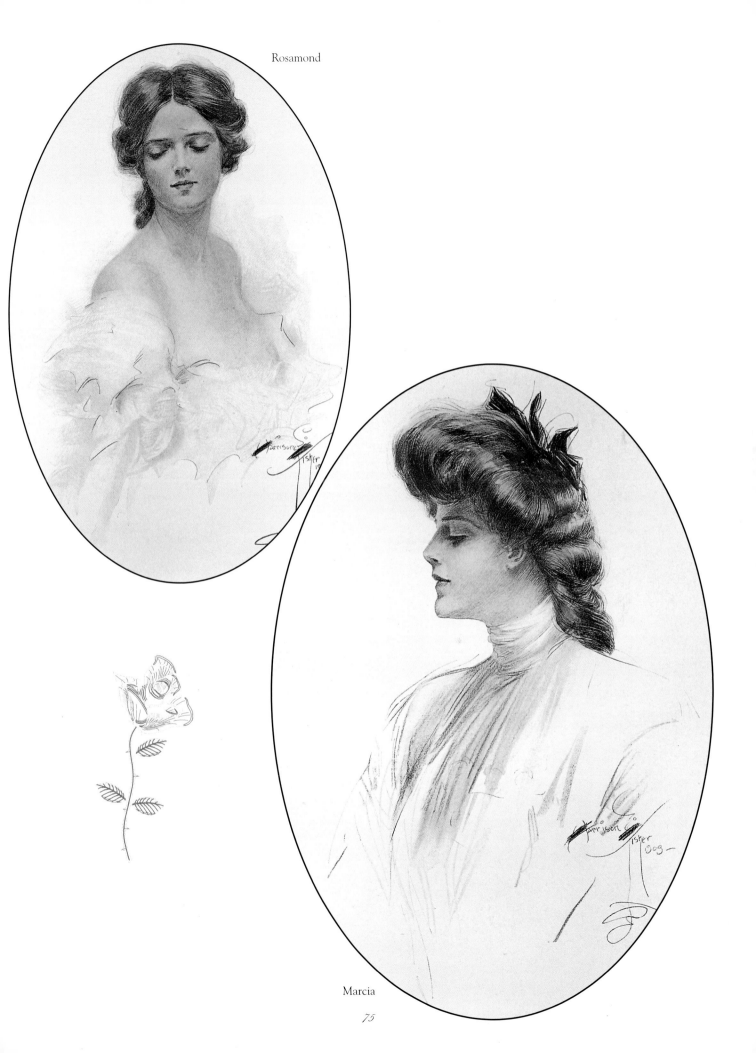

Marcia

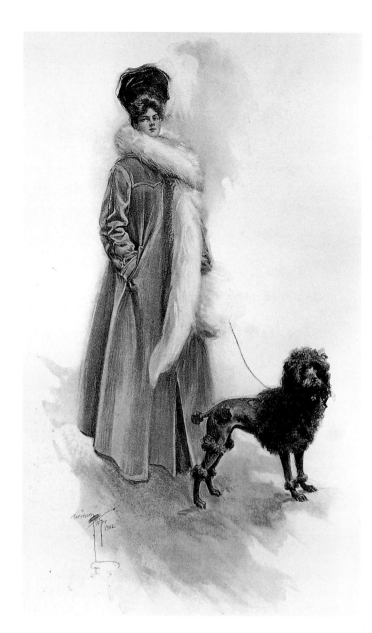

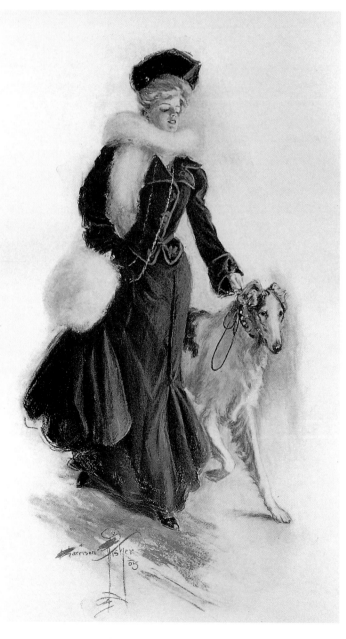

A Winter Promenade

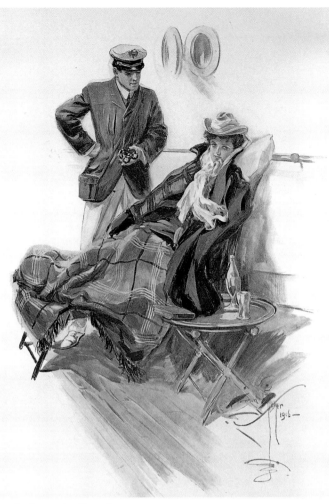

An Interesting Convalescent

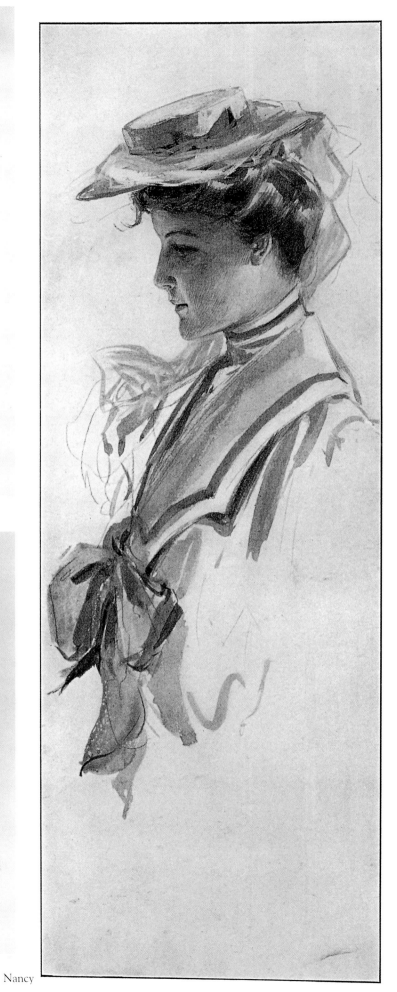

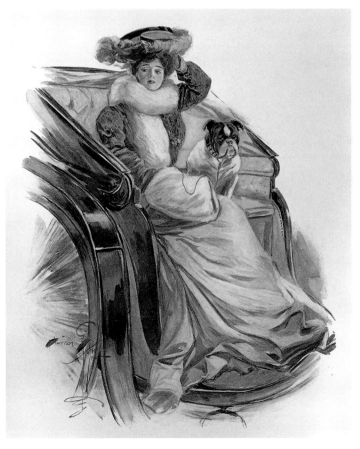

In the Park

Nancy

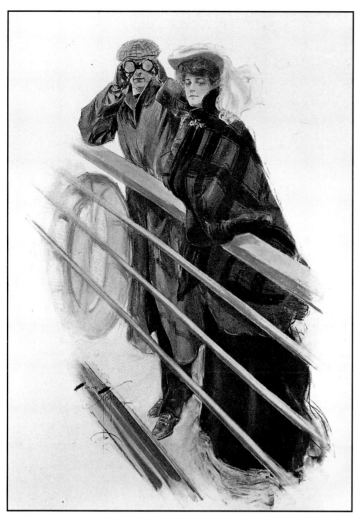

Shipmates

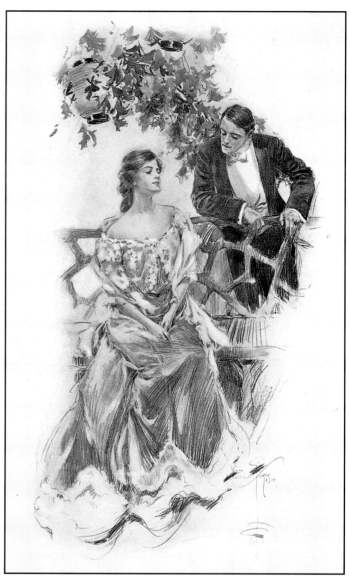

The Vital Question

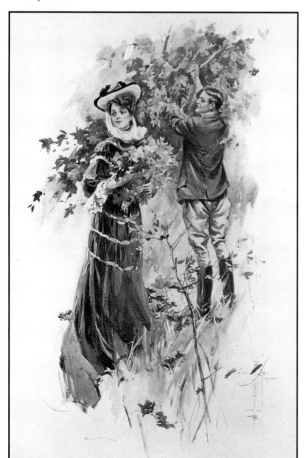

Enslaved

Sylvia, from *The Opened Shutters*

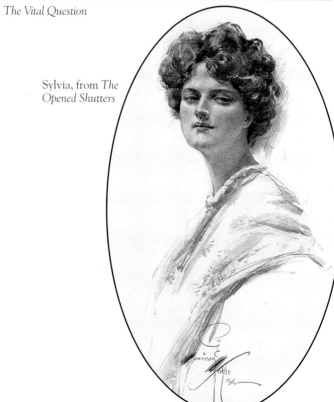

78

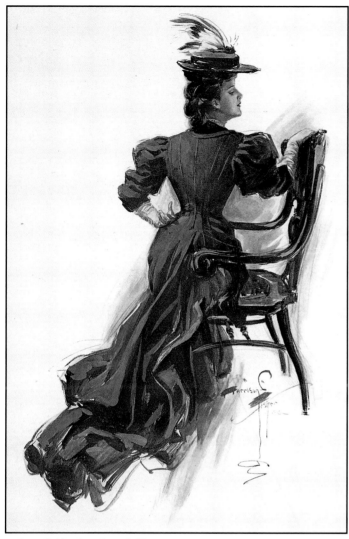

Jane Cable, from *Jane Cable*

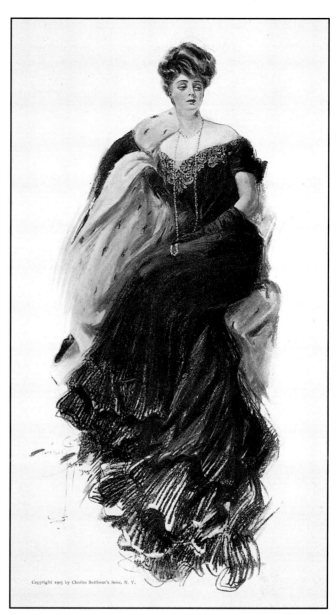

At the Ball

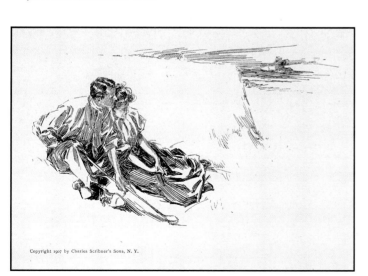

In the Bunker

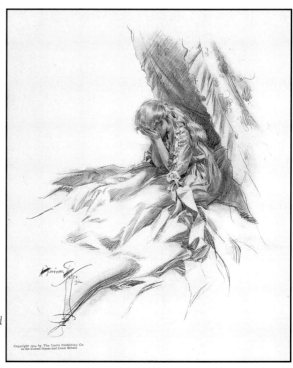

An illustration from *Rose of the World*

A Cross-Country Run

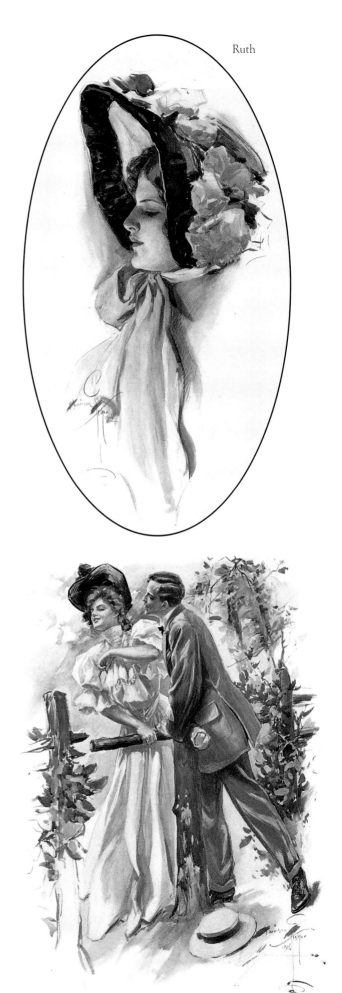

Ruth

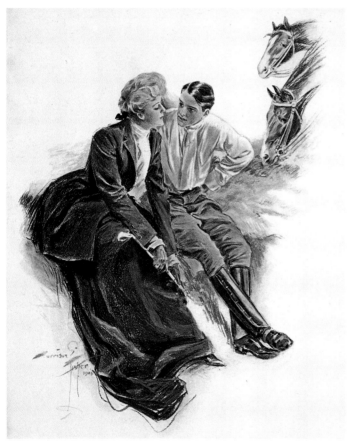

In Clover

Taking Toll

Not Yet But Soon

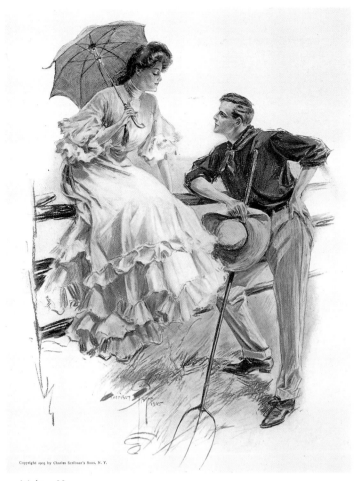

Making Hay

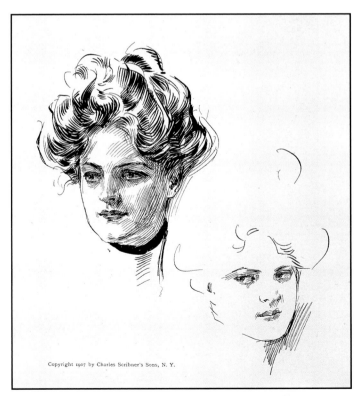

Sketches

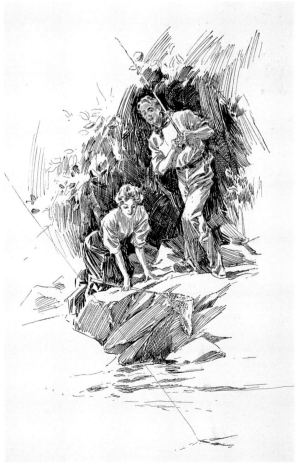

Ready for Him

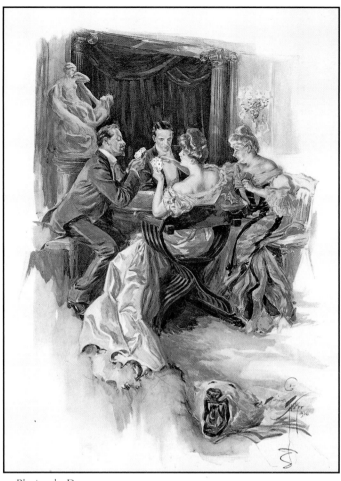

Playing the Dummy

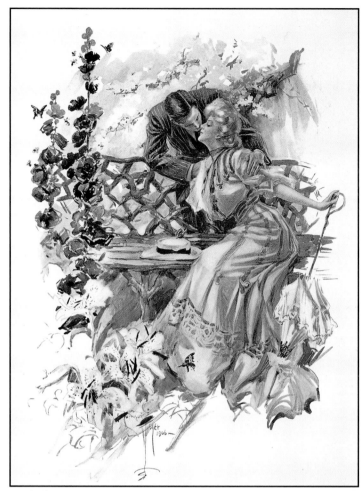

Gathering Honey

The Horsewoman

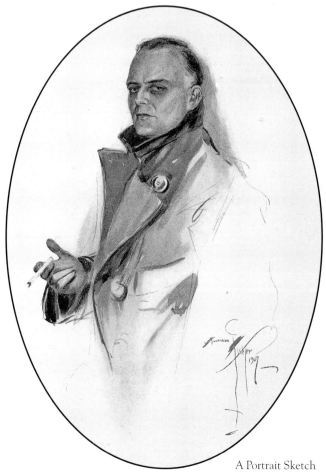

A Portrait Sketch

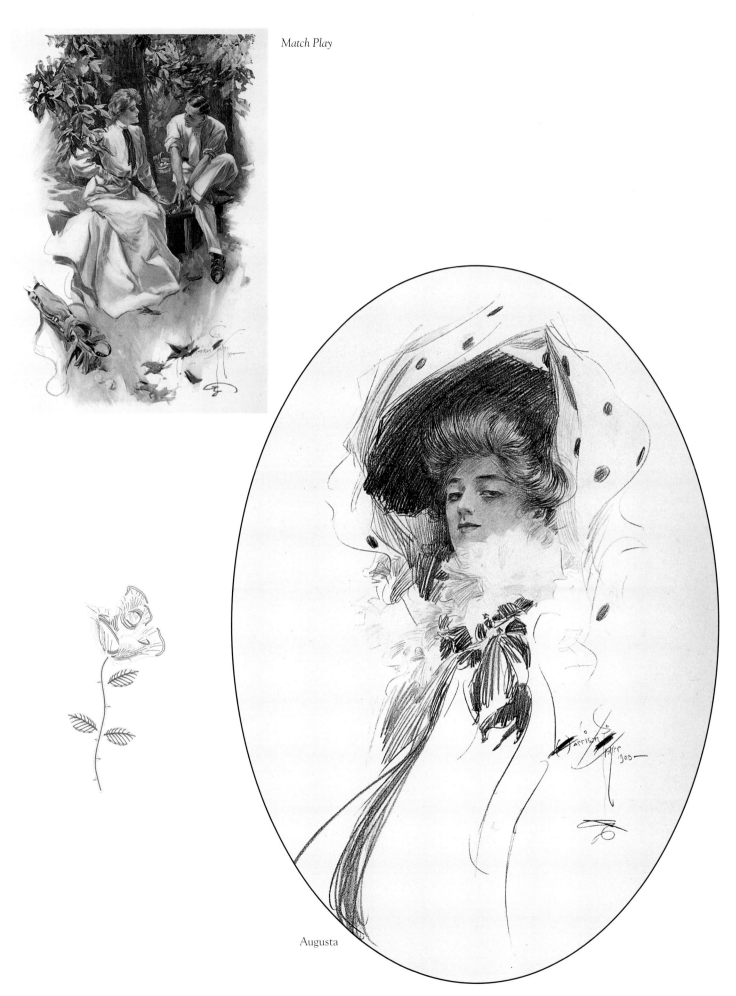

Augusta

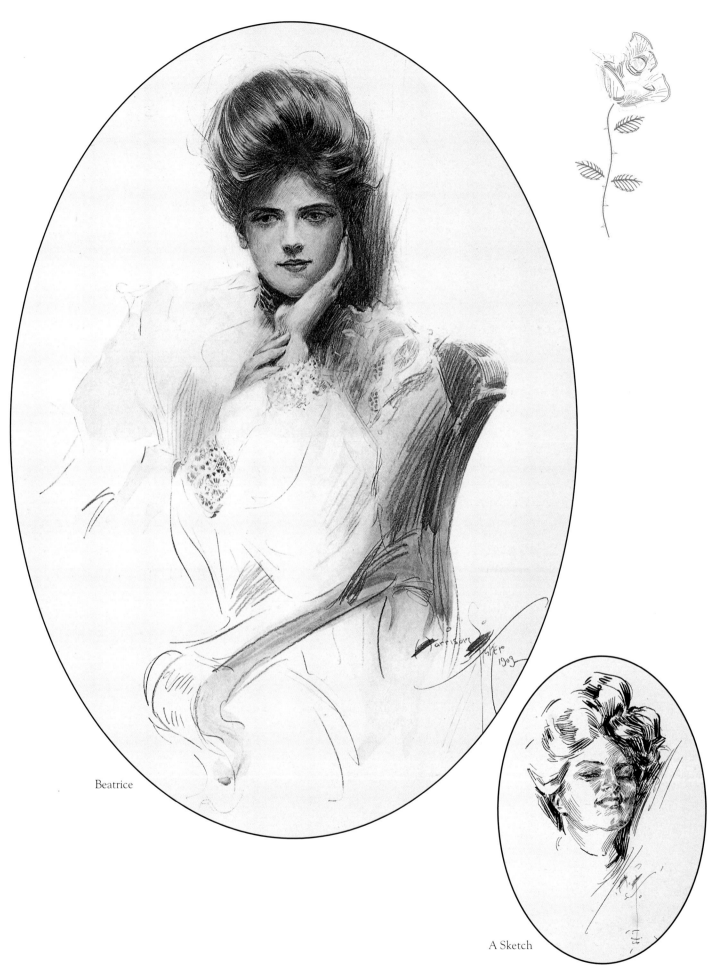

Beatrice

A Sketch

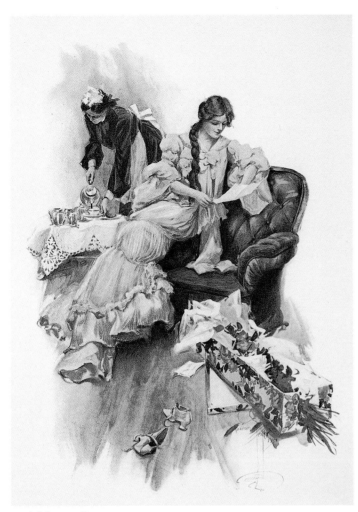

A Morning Greeting

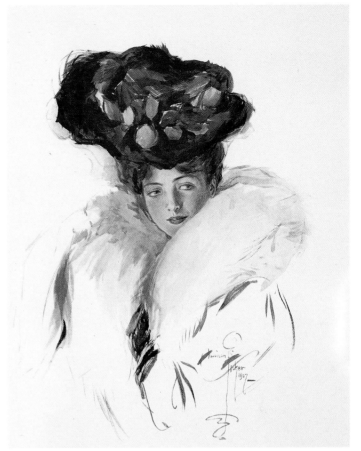

The Winter Girl

A Type

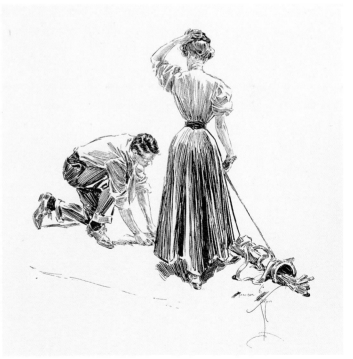

Her Caddy

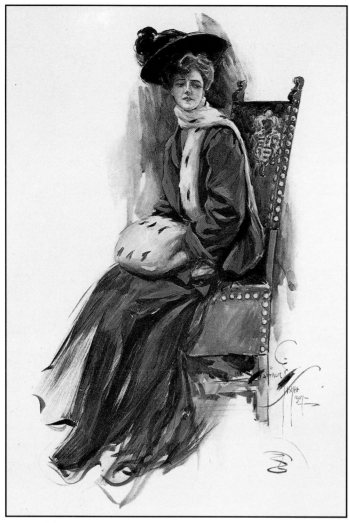

The Adventuress

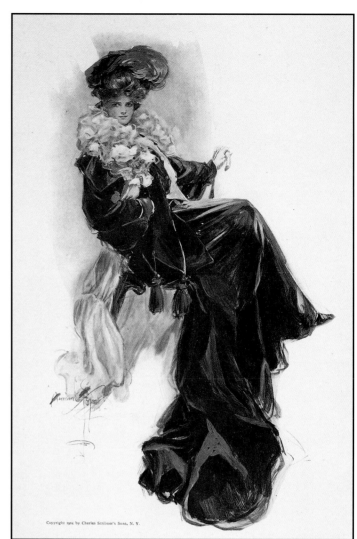

The Matinée Girl

Jane Cable and Graydon, from *Jane Cable*

Jane Cable, from *Jane Cable*; A Study

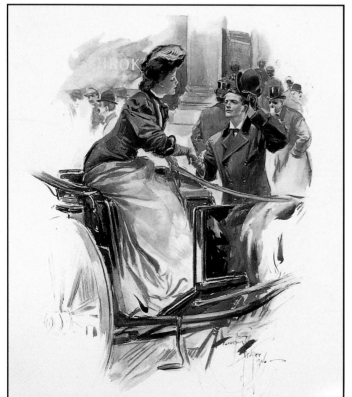

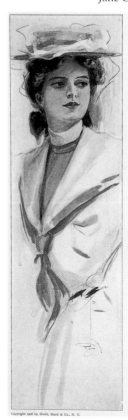
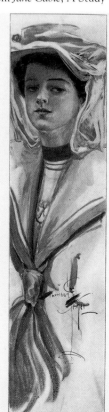

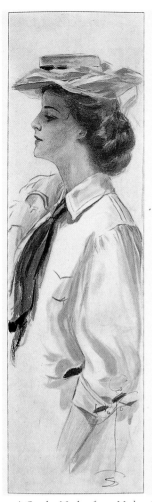
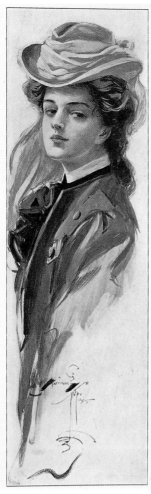

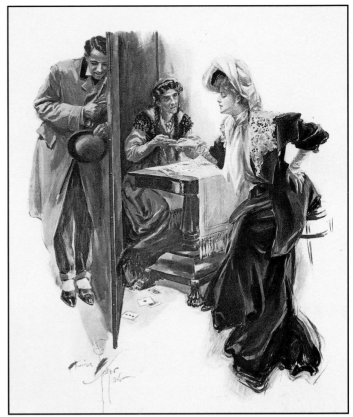

"You Will Marry a Dark Man"

A Study; Nedra from *Nedra*. See also Page 36.

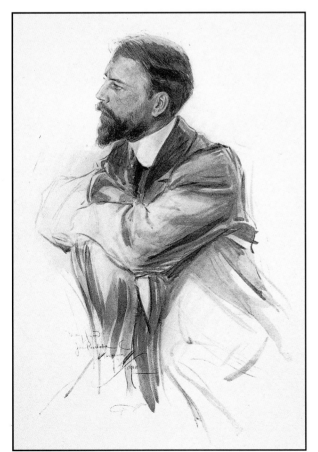

On the Lake

A Portrait Sketch

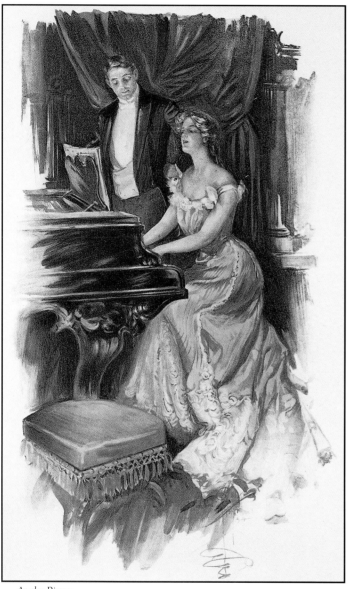

At the Piano

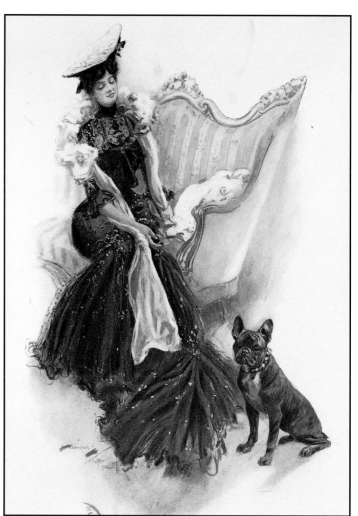

An Afternoon Call

From The One Way Out

Peggy

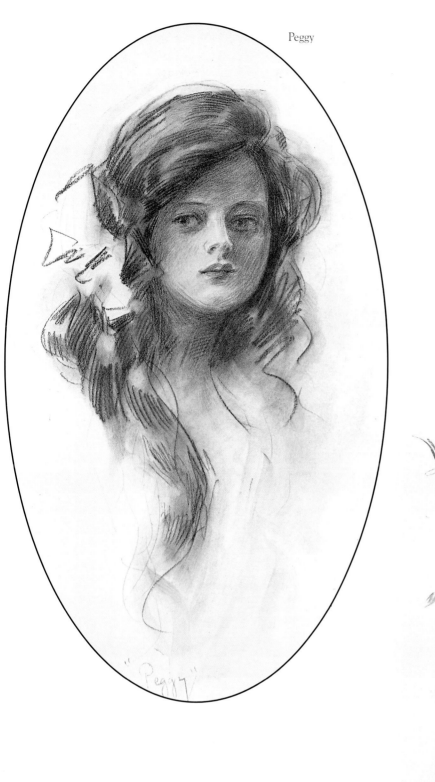

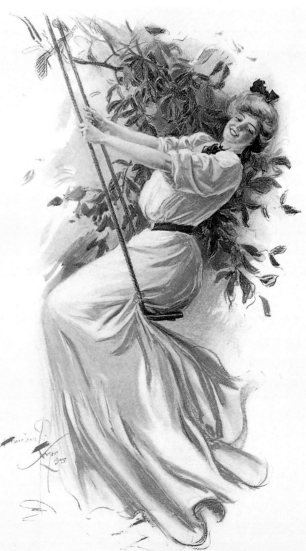

The Summer Girl

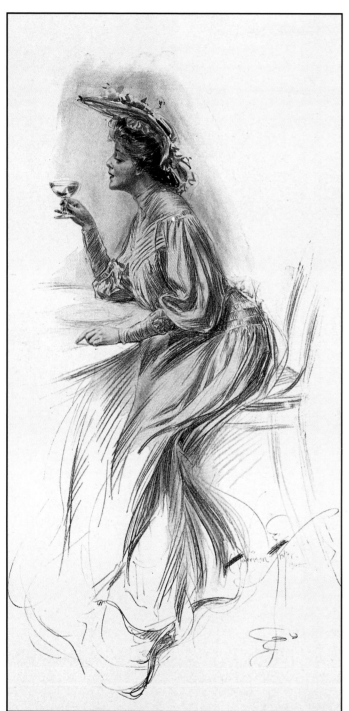

An illustration from *Scribner's Magazine*

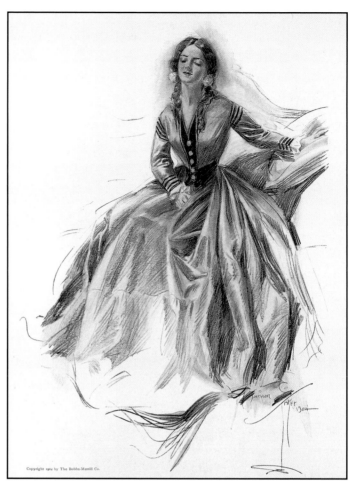

Elinor, from *Black Friday*

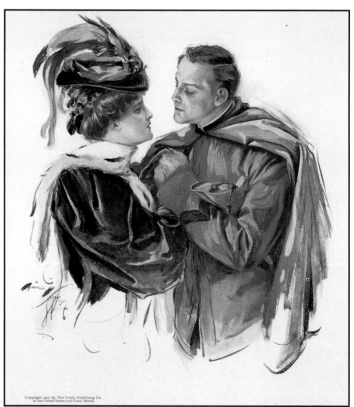

From *The Man Hunt*

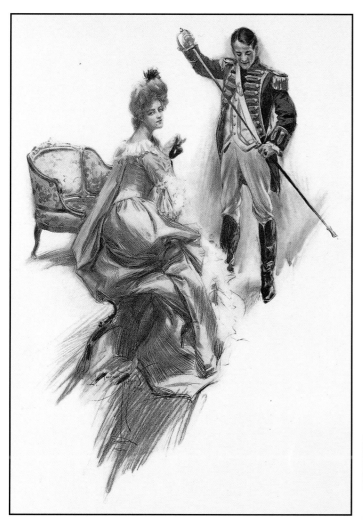

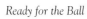
Ready for the Ball

From *Hilma*

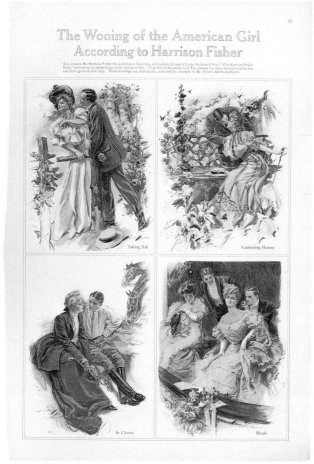

A promotional piece for *The Harrison Fisher*
Book, published in *Ladies' Home Journal* issue
of September 1907.

Following twenty-two photos: *Bachelor Belles*, a compilation of poetry, published by Dodd, Mead & Company, New York, 1908.

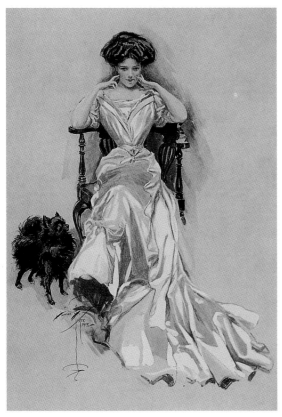

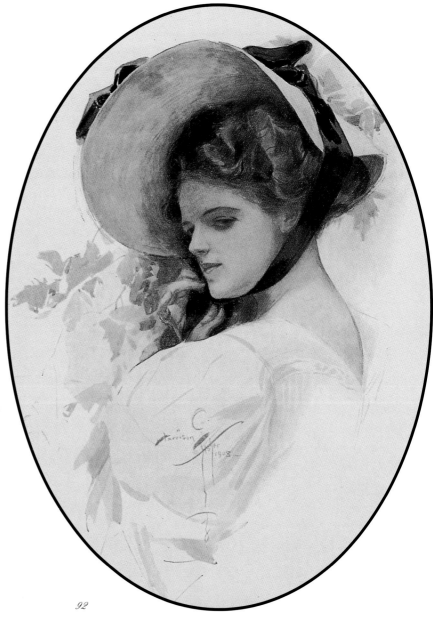

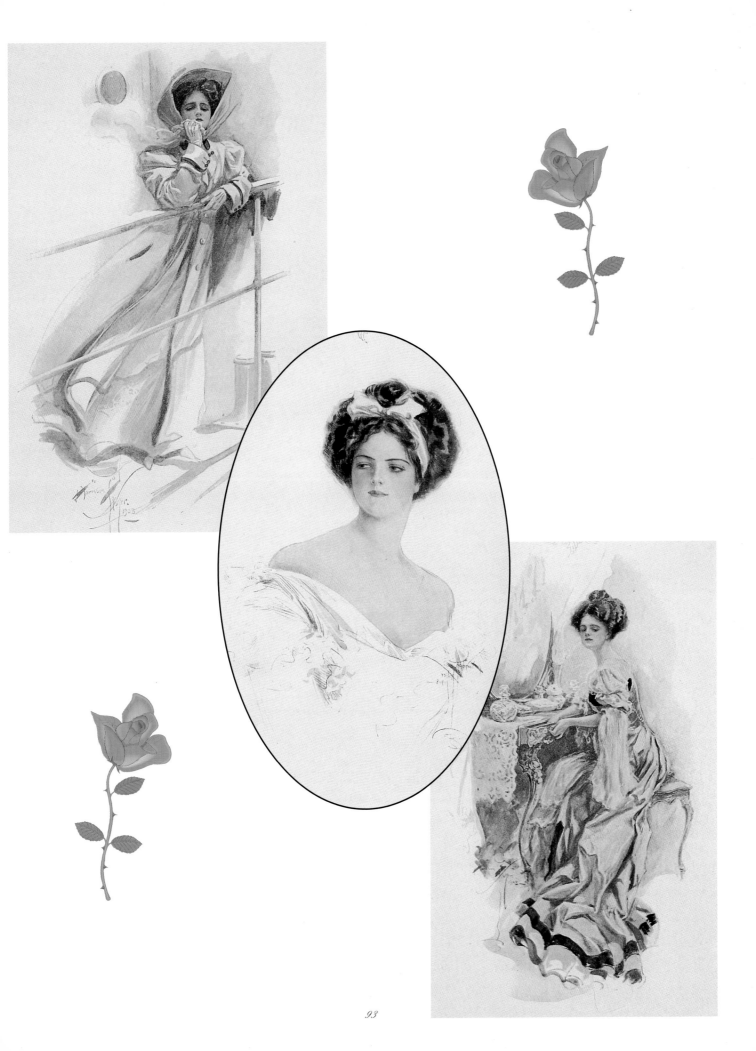

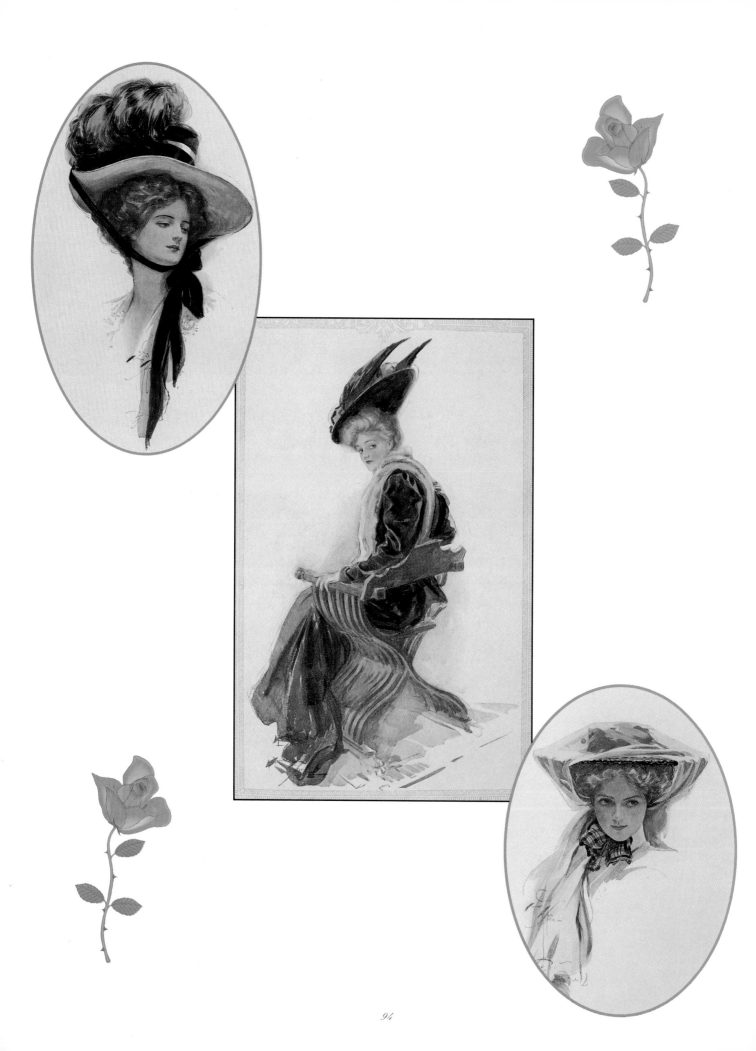

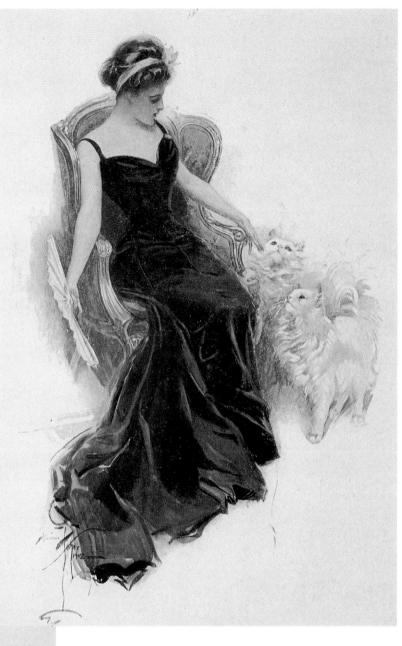

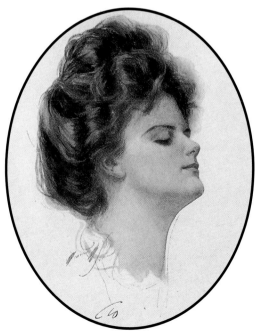

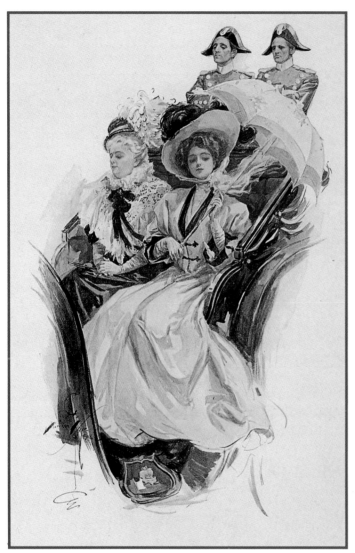

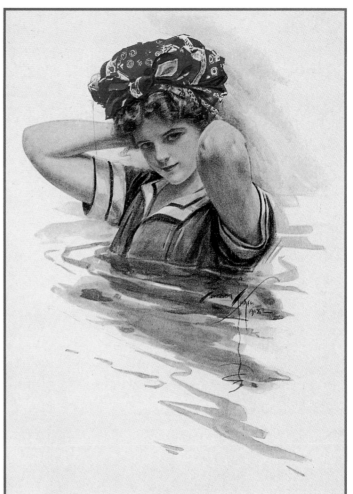

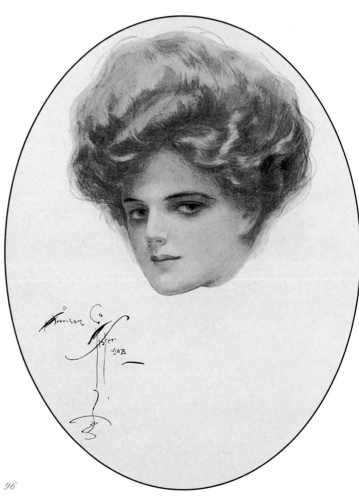

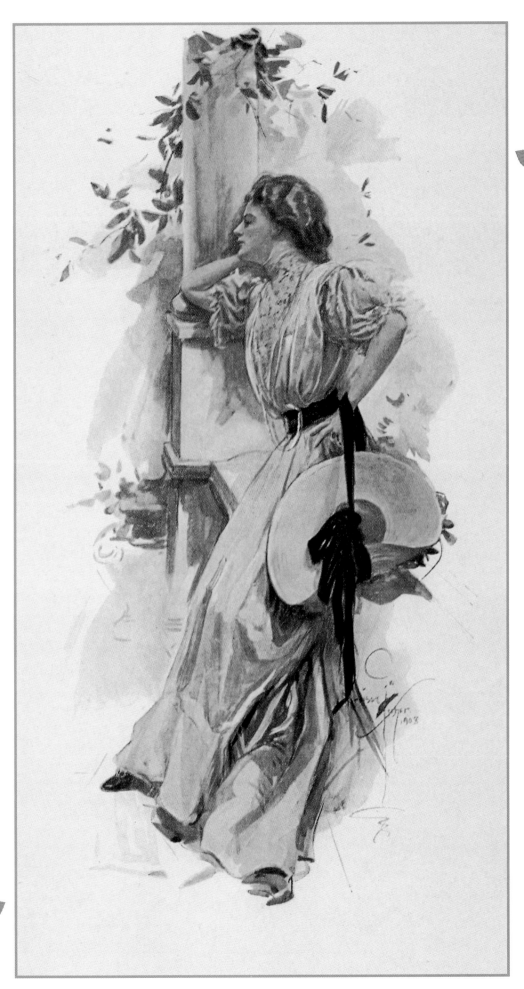

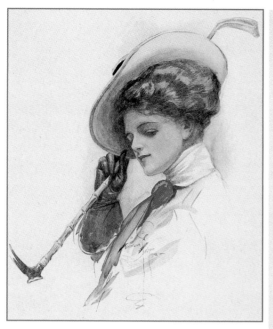

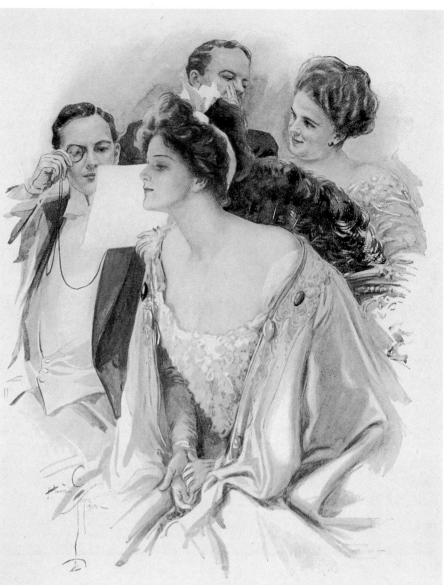

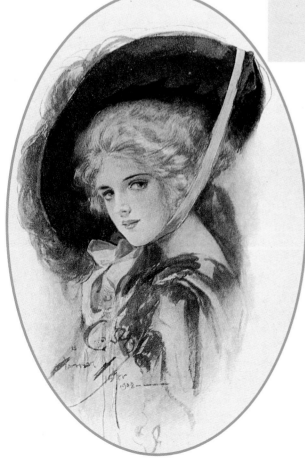

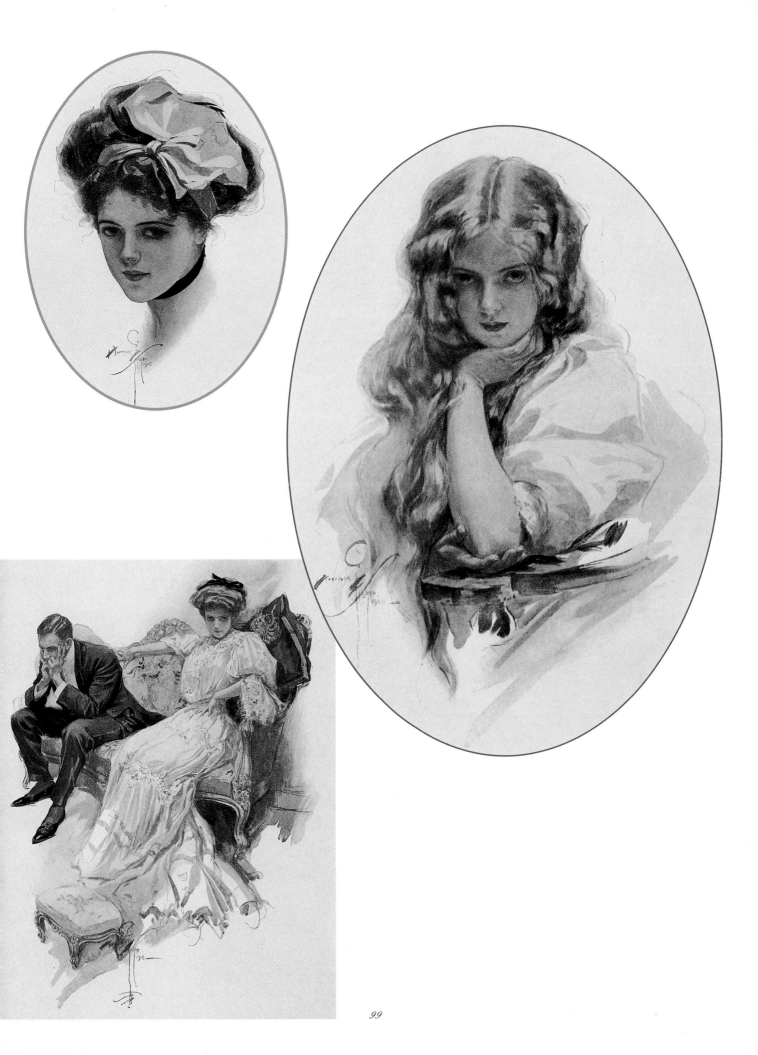

Following twenty-one photos: *Harrison Fisher's American Beauties,* published by Grosset & Dunlap, New York, 1909.

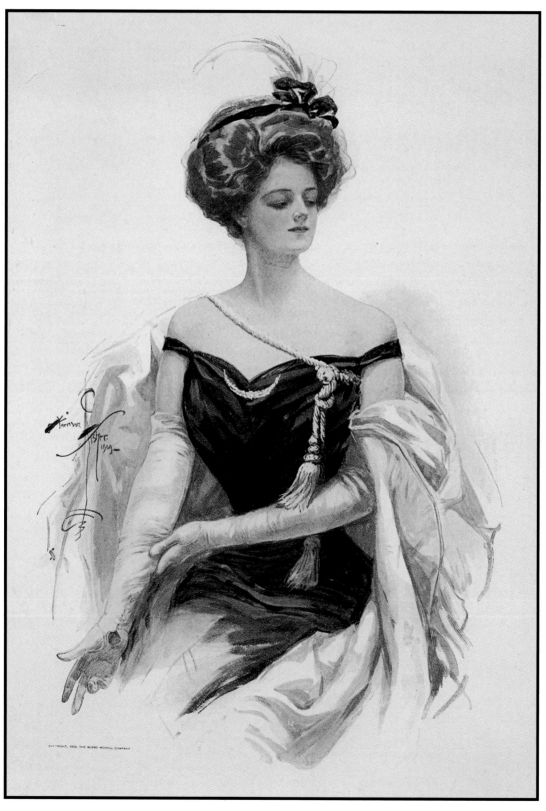

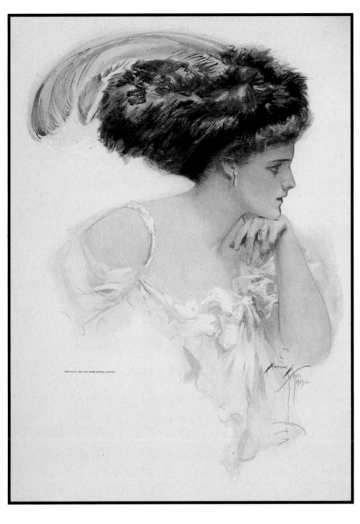

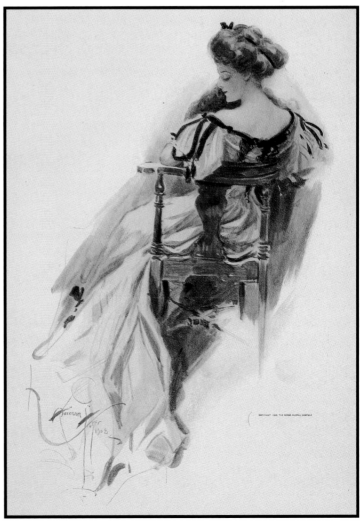

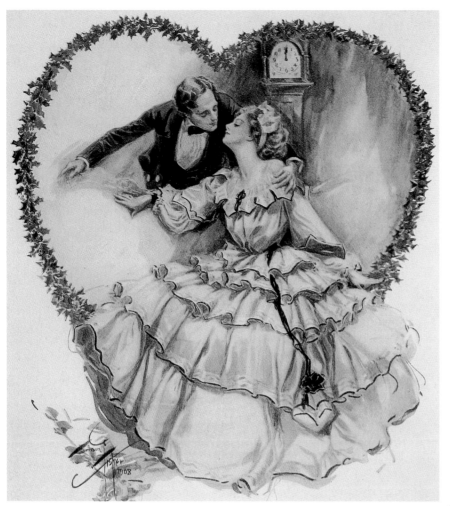

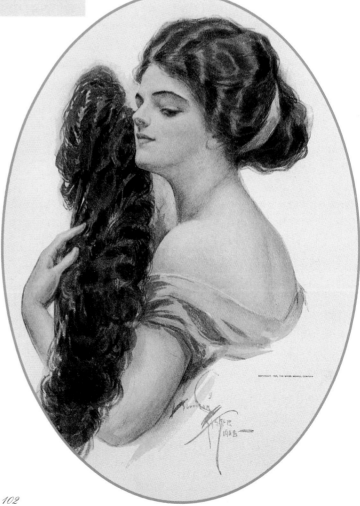

102

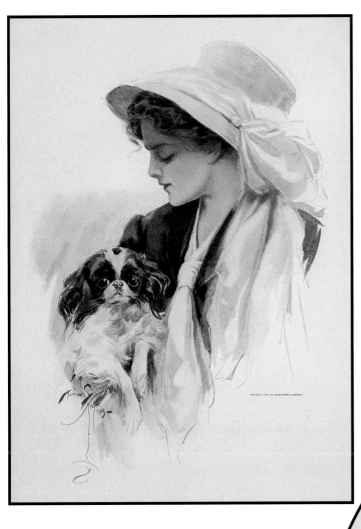

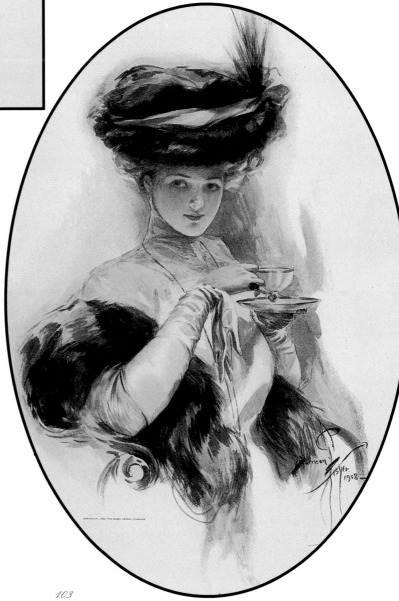

103

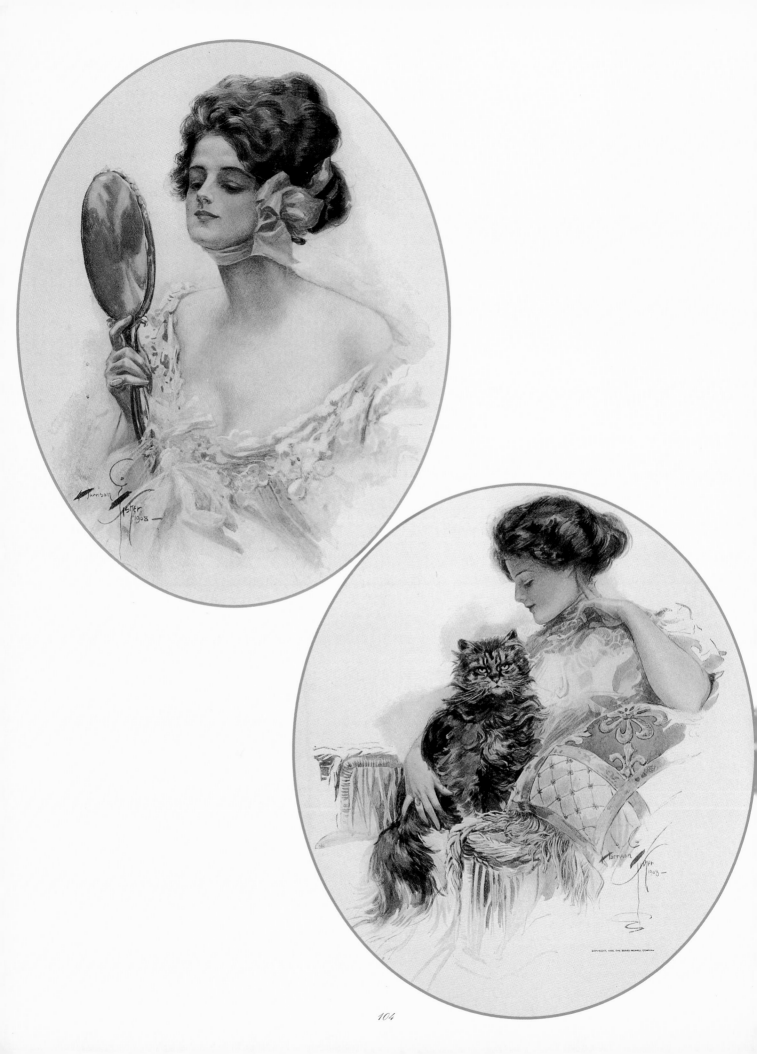

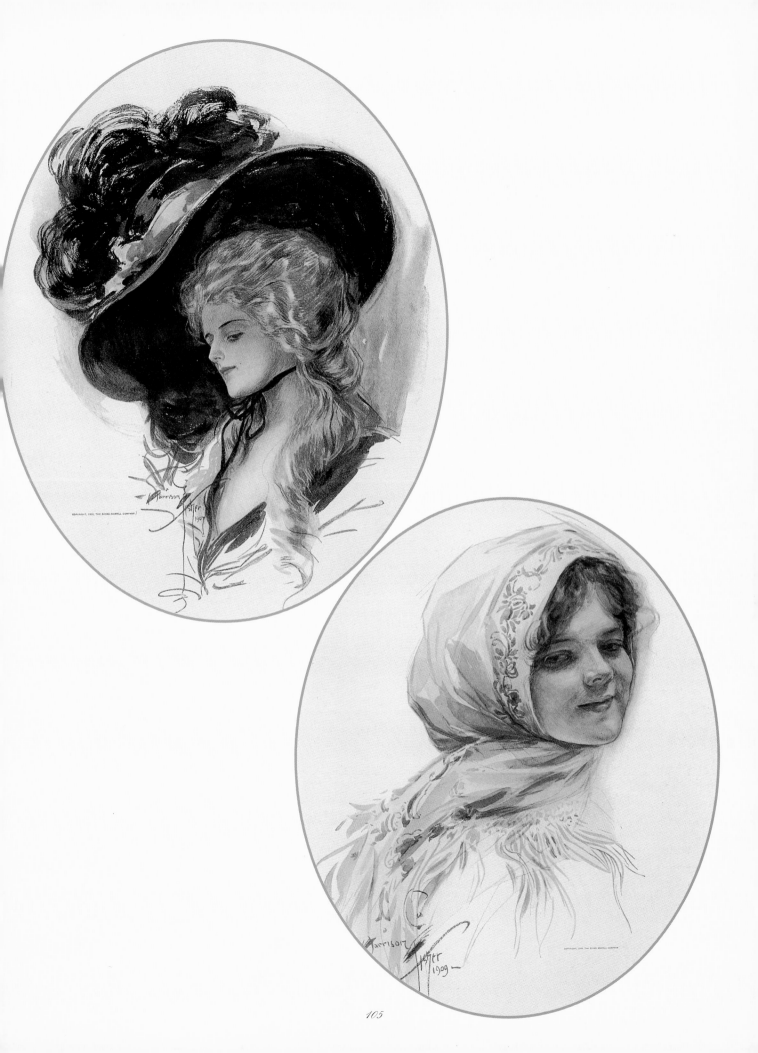

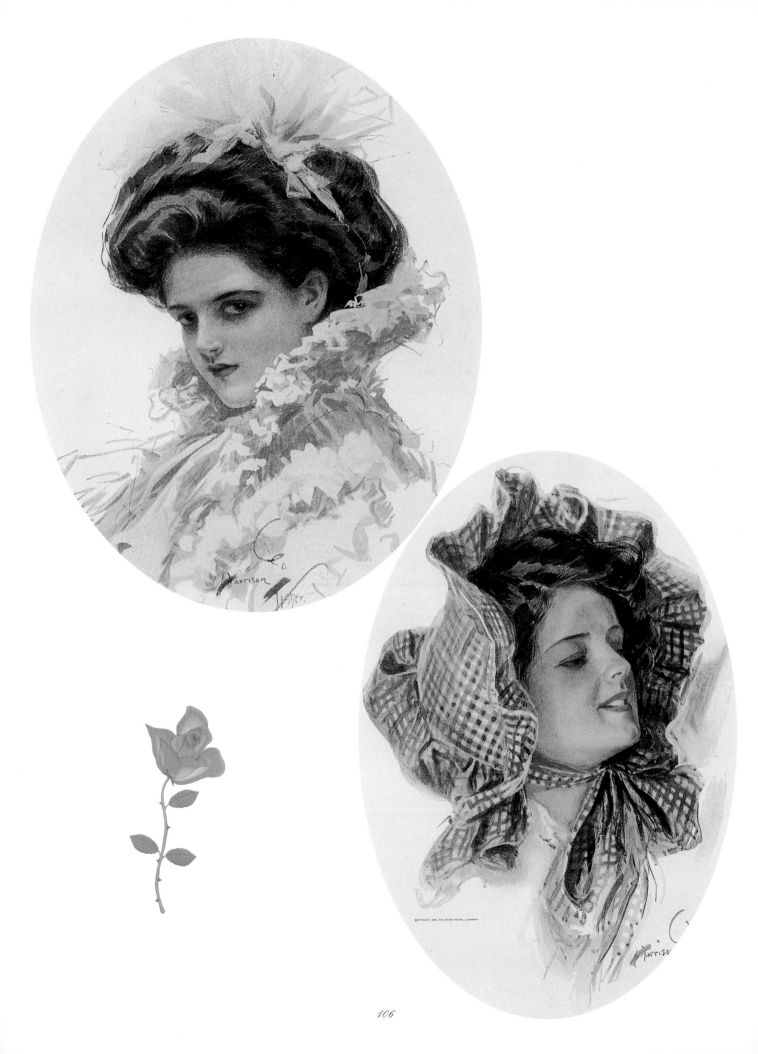

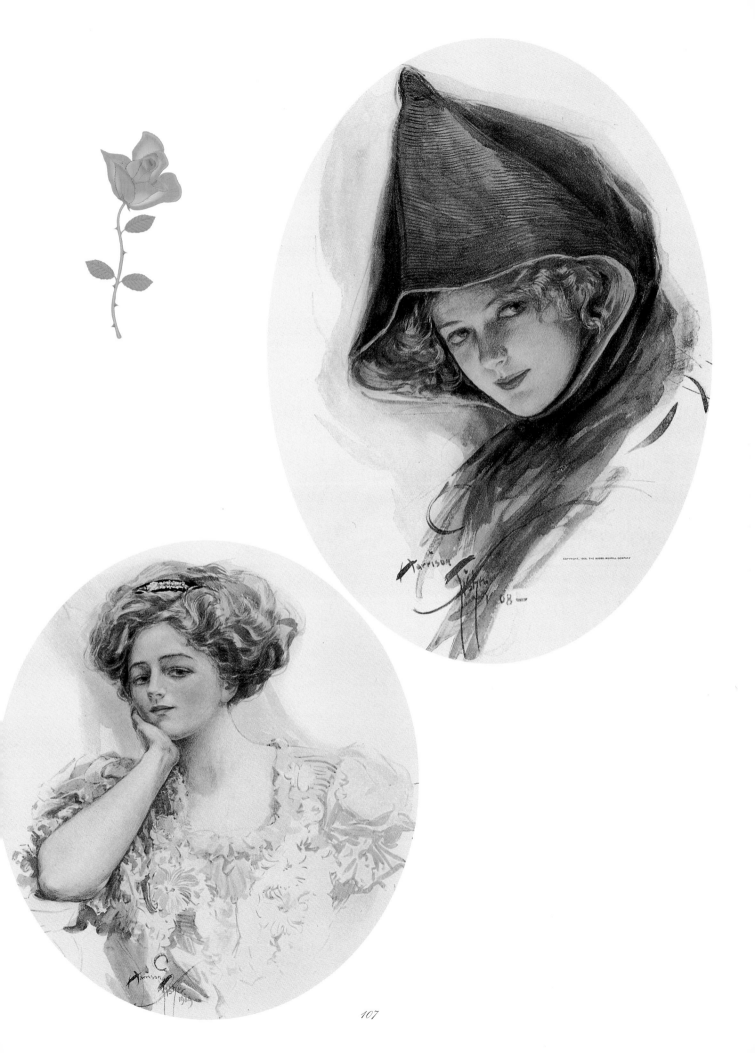

COPYRIGHT, 1909, THE BOBBS-MERRILL COMPANY

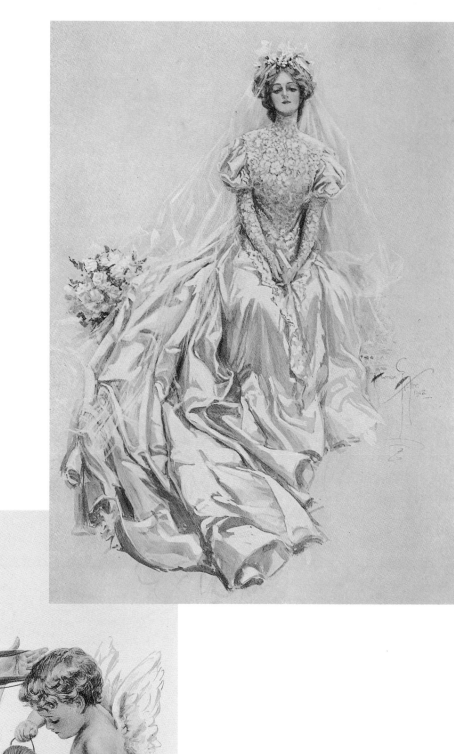

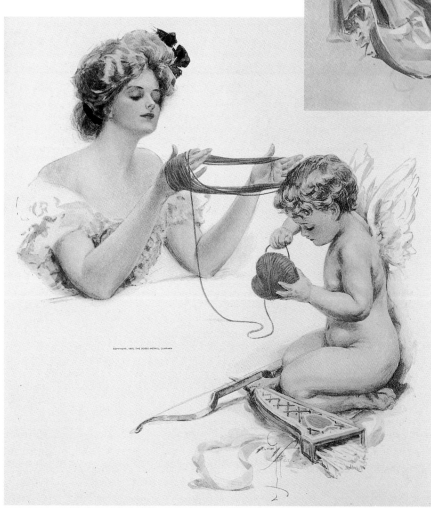

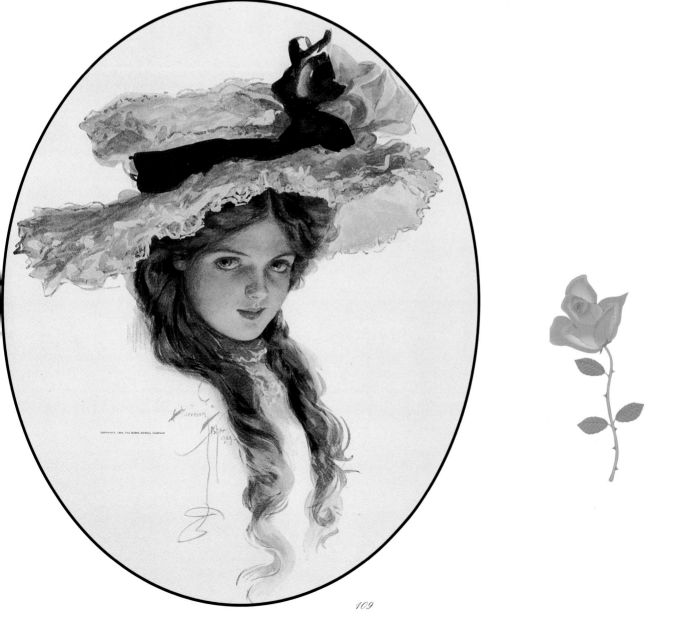

109

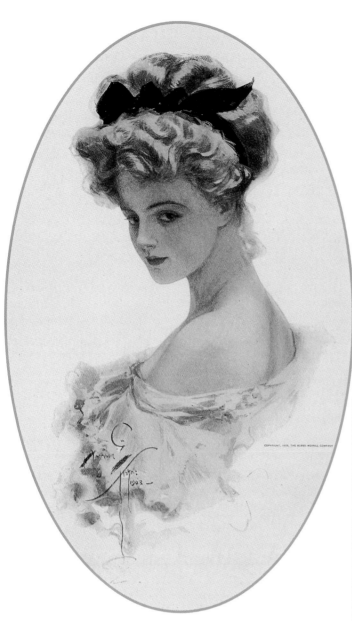

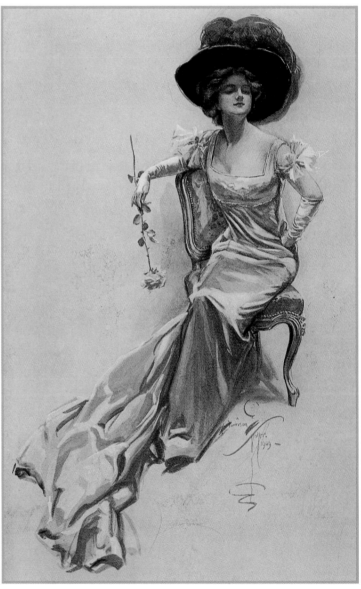

Following sixteen photos: *A Garden of Girls, With Illustrations by Harrison Fisher,* published by Dodd, Mead & Company, New York, 1910.

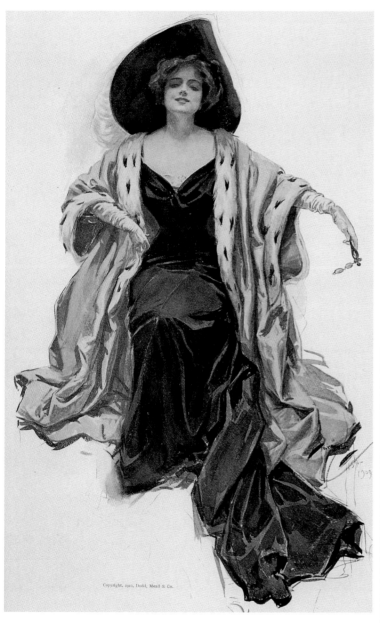

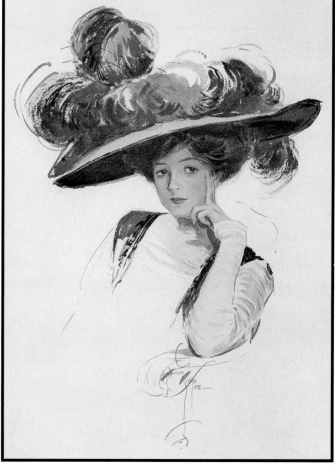

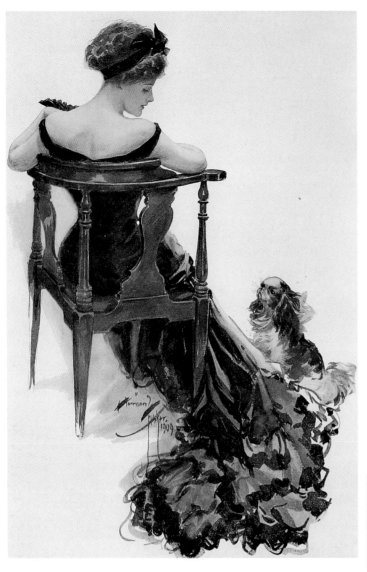

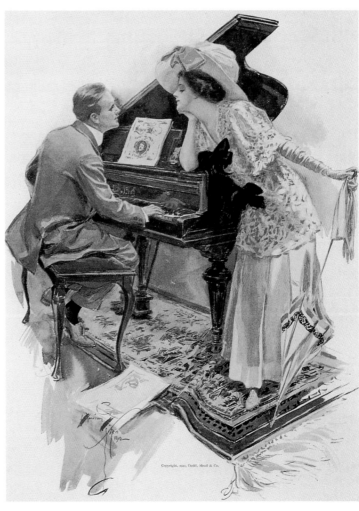

Copyright, 1910, Dodd, Mead & Co.

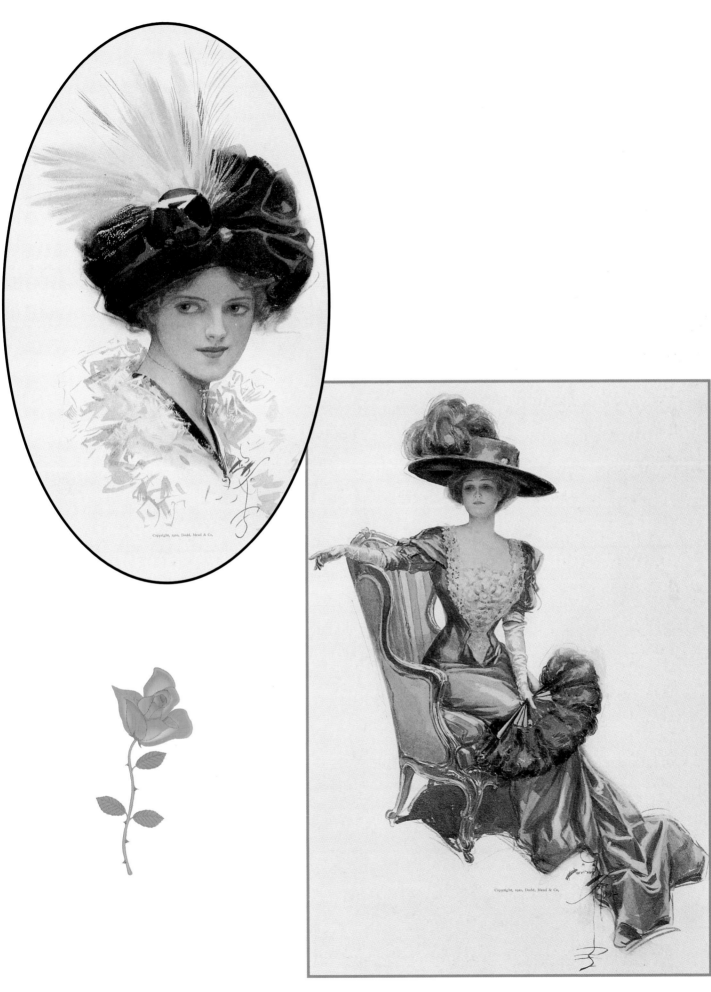

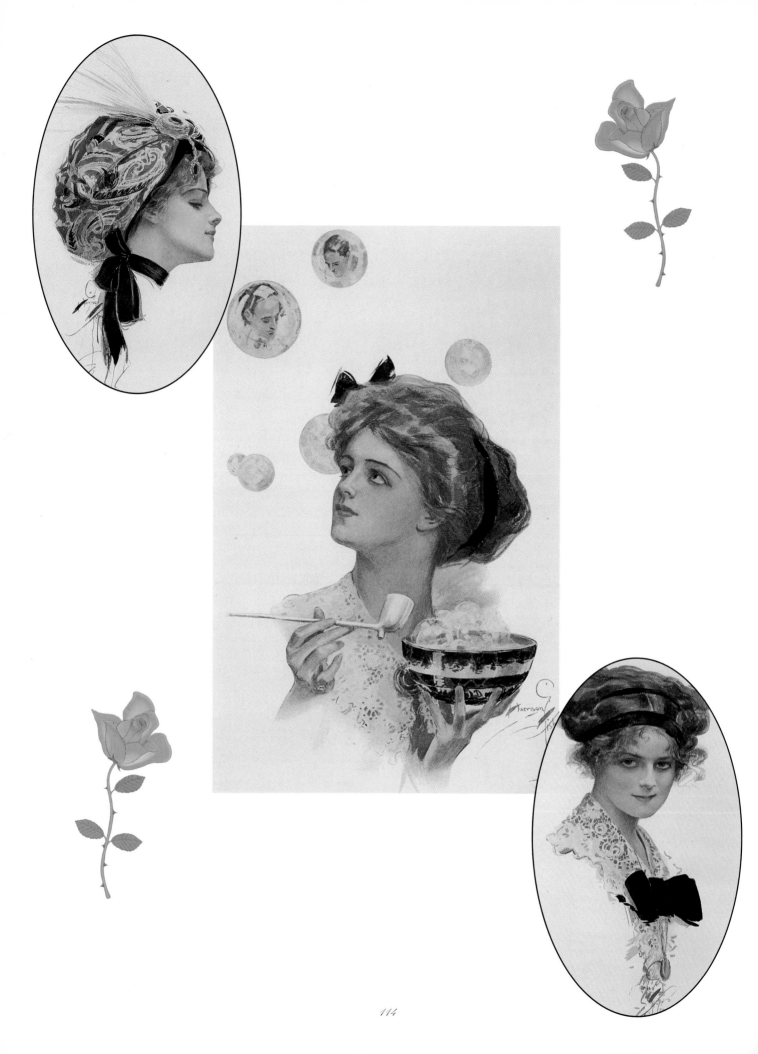

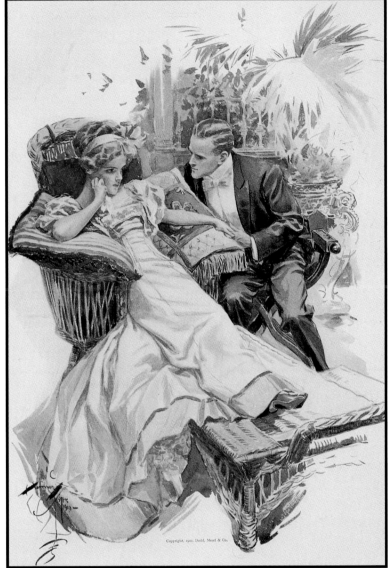

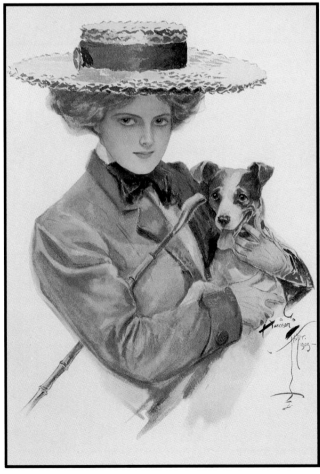

Copyright, 1910, Dodd, Mead & Co.

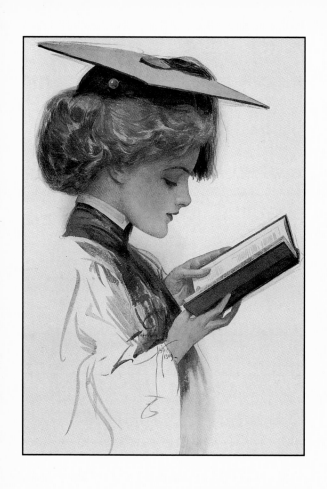

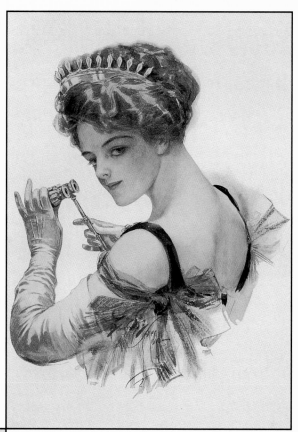

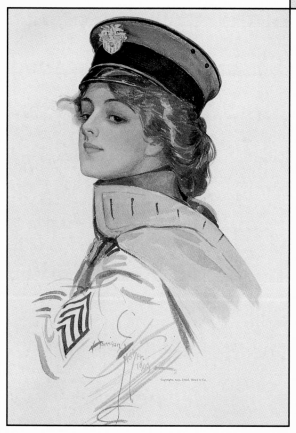

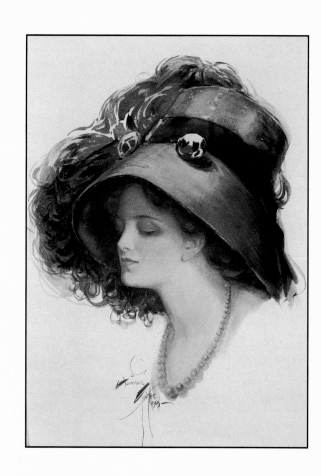

Fair Americans by Harrison Fisher, published by Charles Scribner's Sons, New York, 1911. This book also included several illustrations from the *Harrison Fisher's College Girls* six-part series, shown in the *Serialized Illustrations* section of this book, as well as a black-and-white reproduction of one of his most popular images, *The Kiss*, shown in color on Page 23.

Portait of the Artist

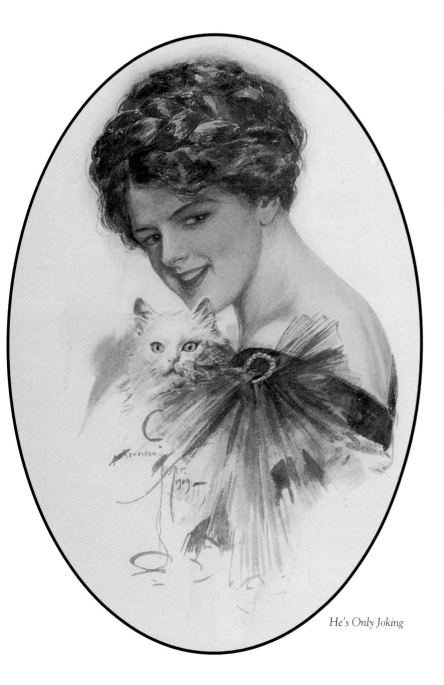

He's Only Joking

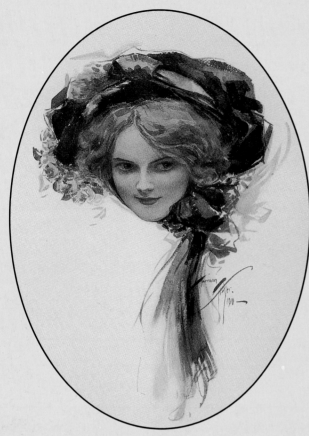

A Study

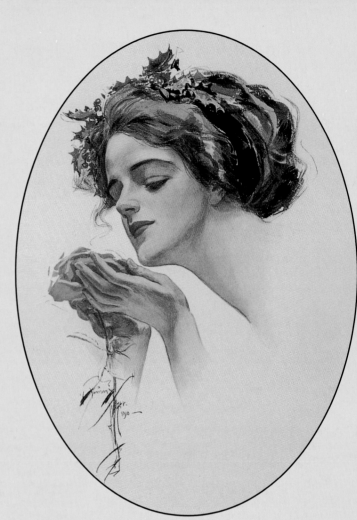

The Christmas Rose

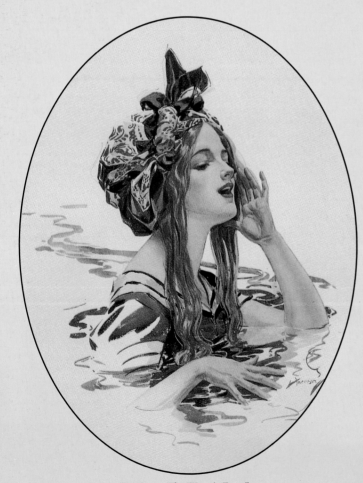

"Come in. The Water's Fine!"

Following the Race

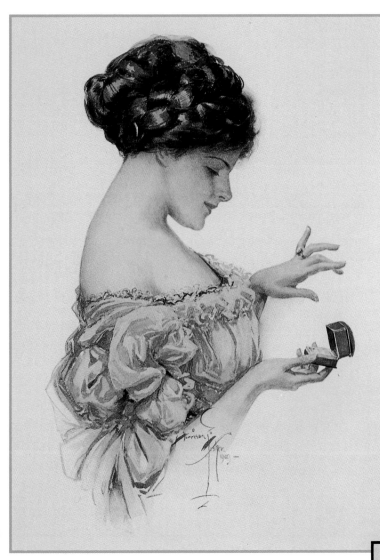

His Gift

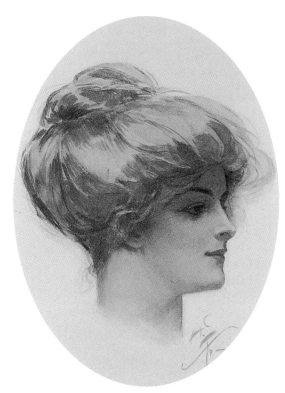

The Lady of the Cover

An Old Song

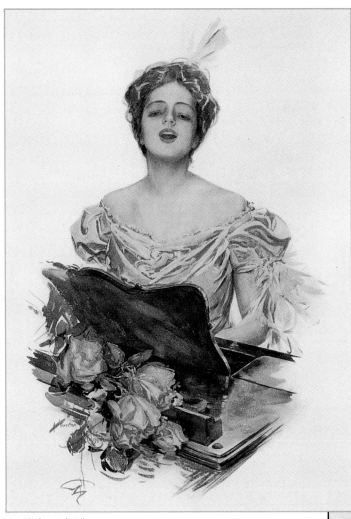

"Robin Adair"

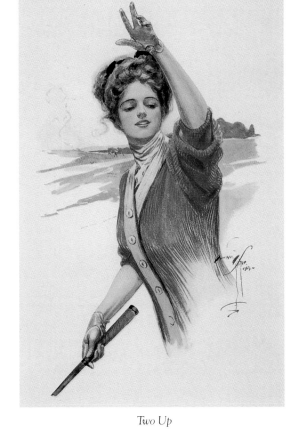

Two Up

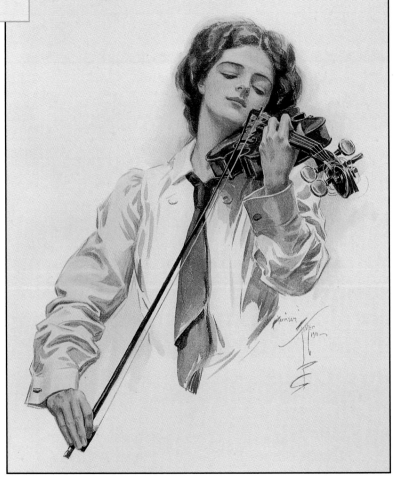

The Artist

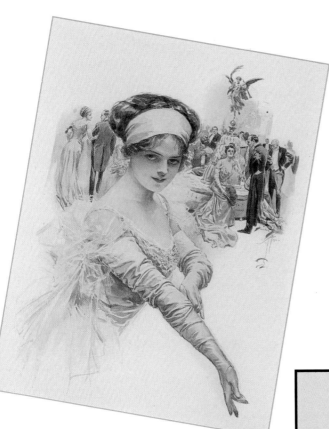

The Débutante

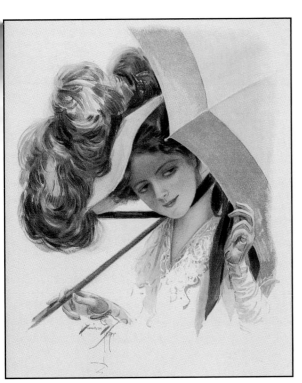

The Ambush

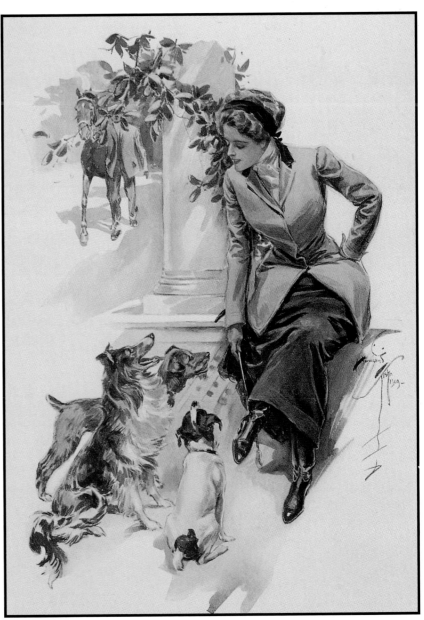

The Sport

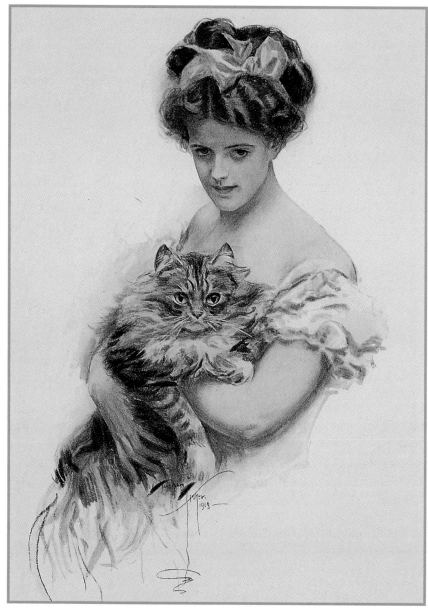

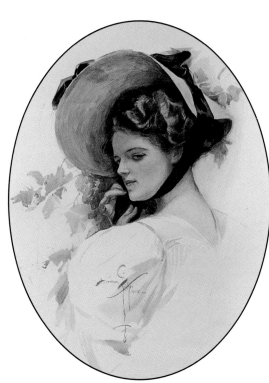

Reflections

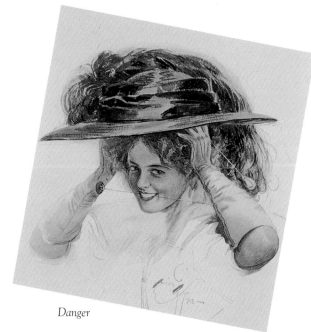

Danger

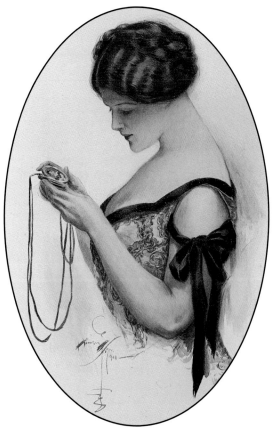

The Old Miniature

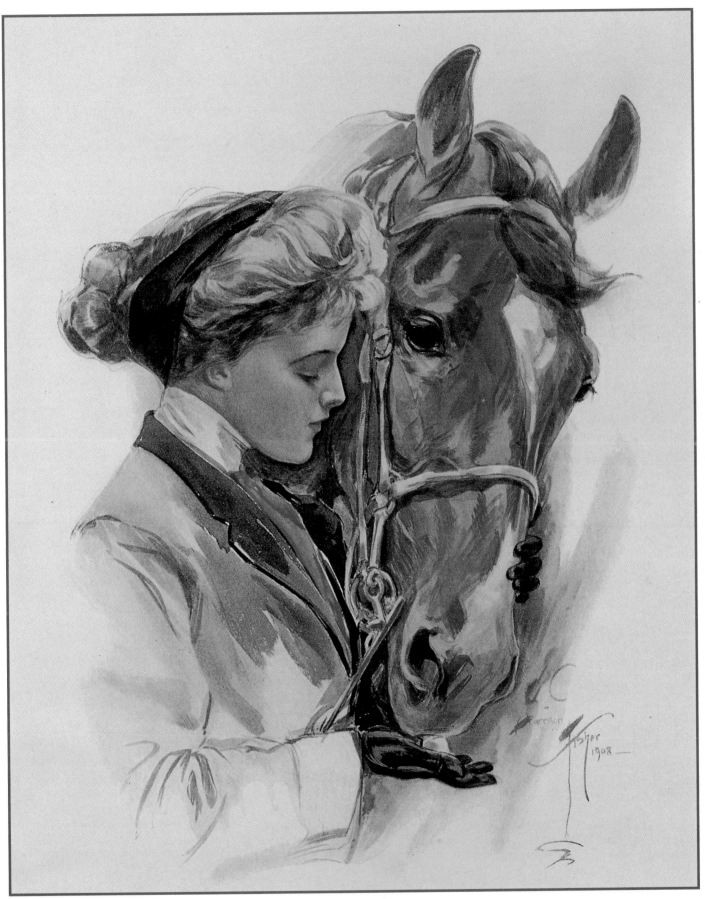

Dumb Luck

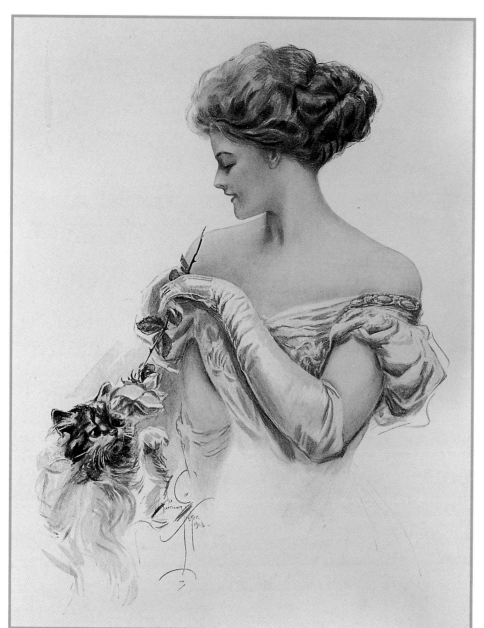

Odd Moments

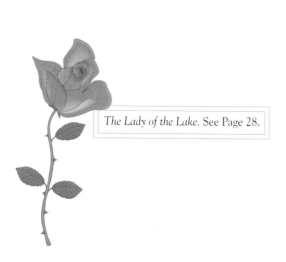

The Lady of the Lake. See Page 28.

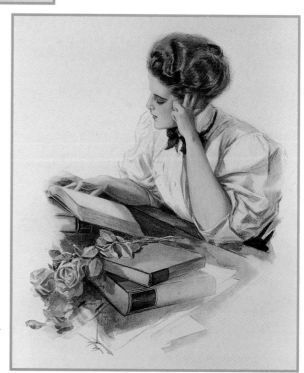

The Study Hour

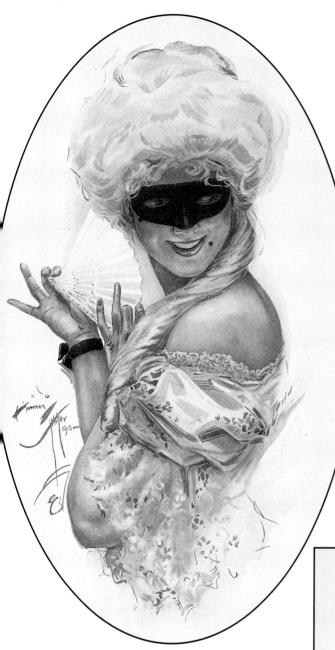

The Masque

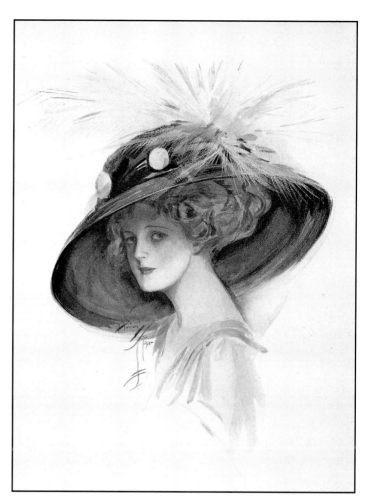

A Study

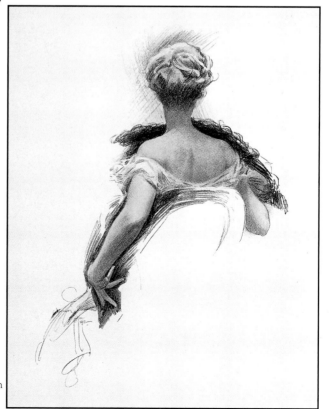

A Sketch

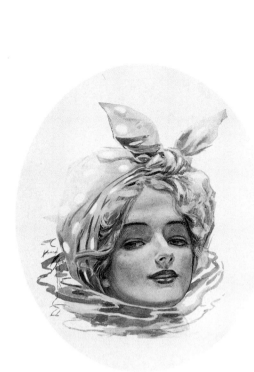

A Study

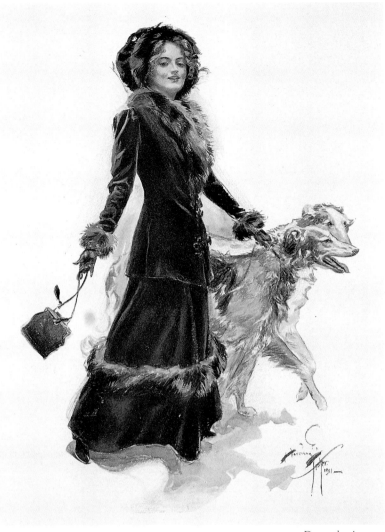

Down the Avenue

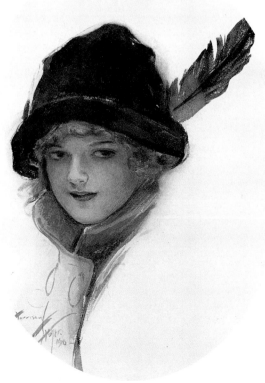

A Study

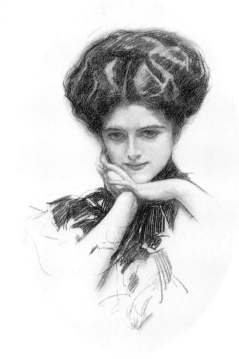

A Study

A Study

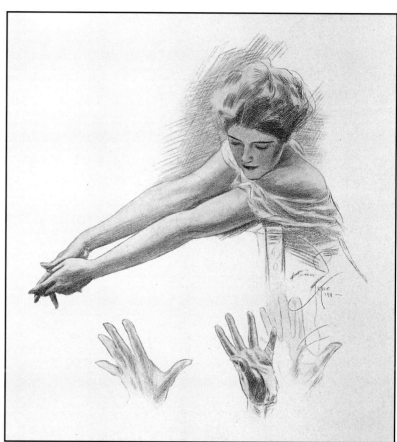

A Sketch

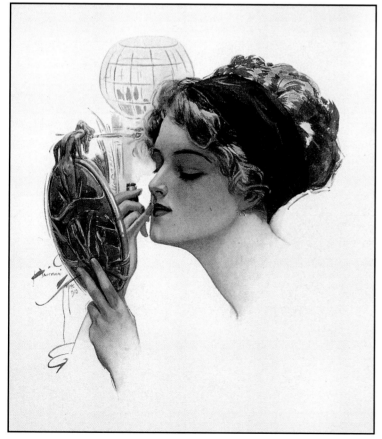

Behind the Scenes

The American Girl in England.
Black and white, see Page 30.

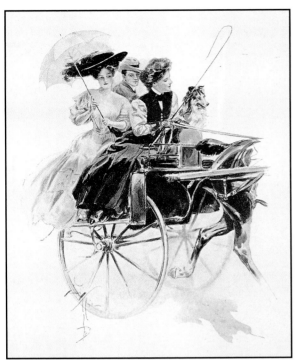

The American Girl in Ireland

The American Girl in France

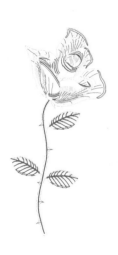

On the Road

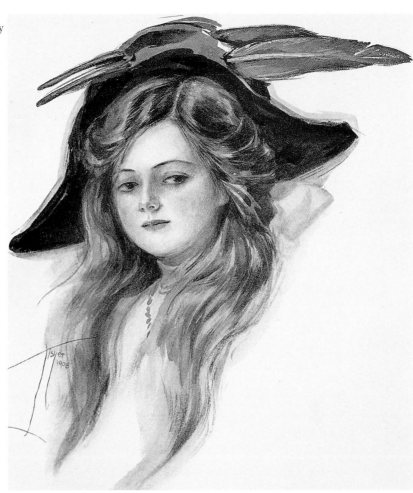

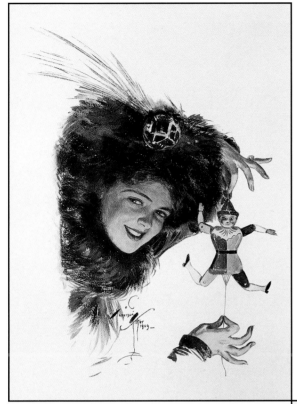

Just Like the Others

The American Girl in Italy.
Black and white, see Page 30.

The American Girl in Holland.
Black and white, see Page 30.

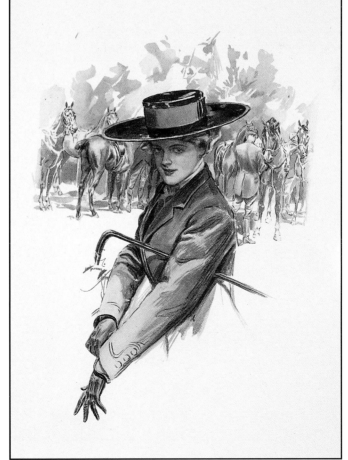

Ready for a Morning in the Park

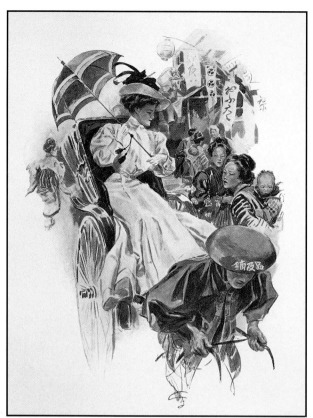

A Study

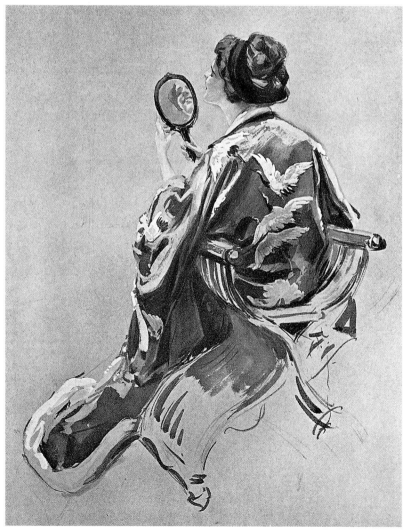

The Bride. See Page 24.

Vanity

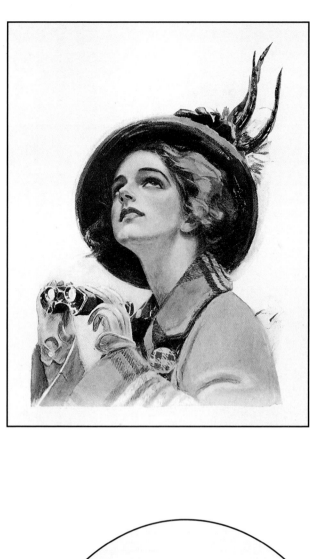

Following the Flight

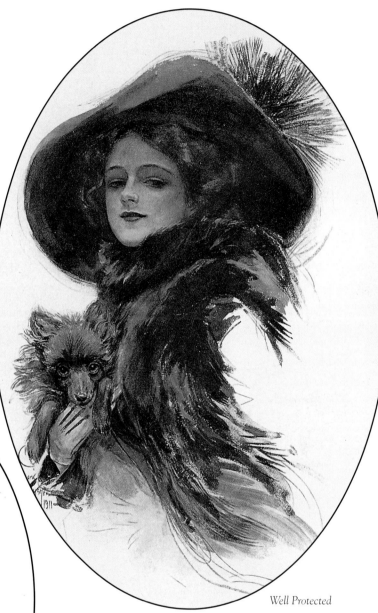

Well Protected

A Study

Rejected

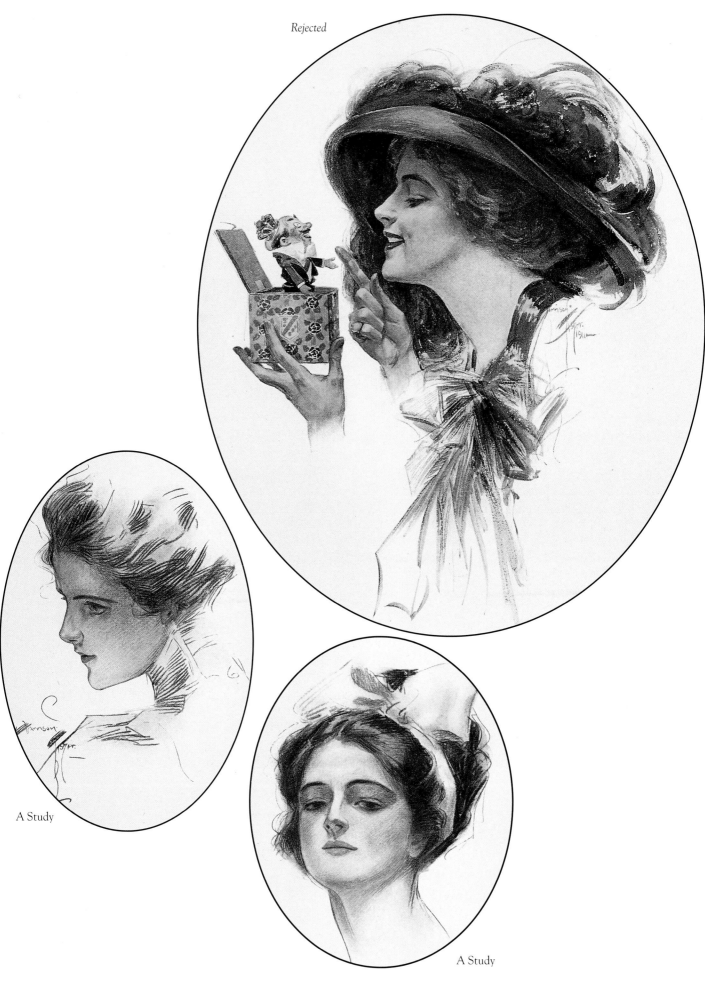

A Study

A Study

Miss Knickerbocker. Black and white, see color version on Page 136.

The Fudge Party. Black and white, see color version on Page 22.

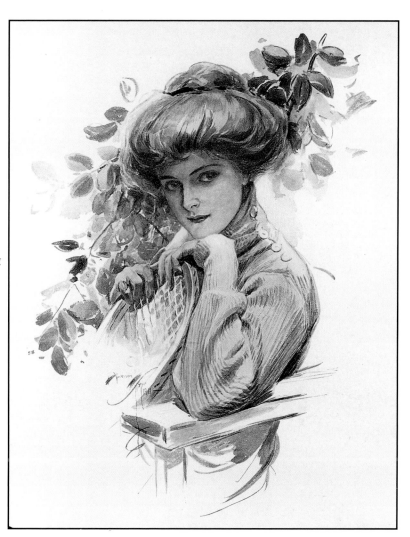

Waiting

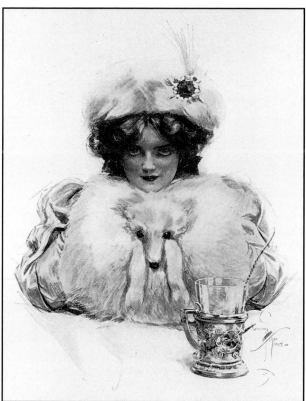

At the Fountain

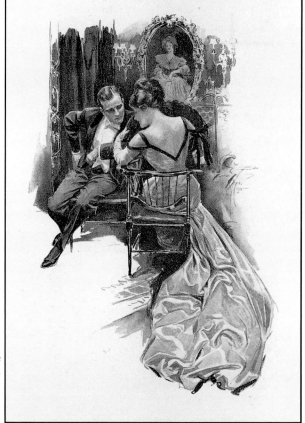

The Butterfly Man. See color version on Page 56.

Miss Santa Claus. Black and white, see color version on Page 137.

Anticipation. See Page 9.

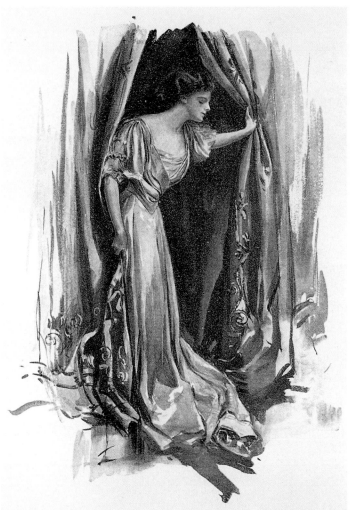

The Alternative

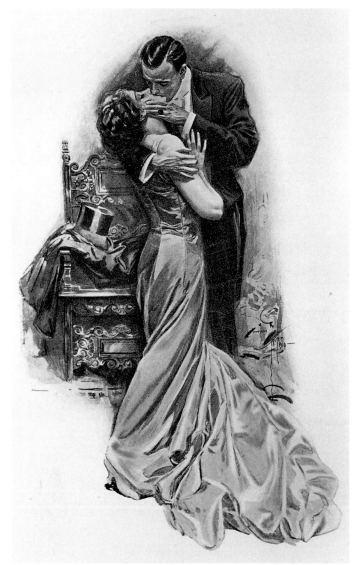

The Kiss. See color version on Page 23.

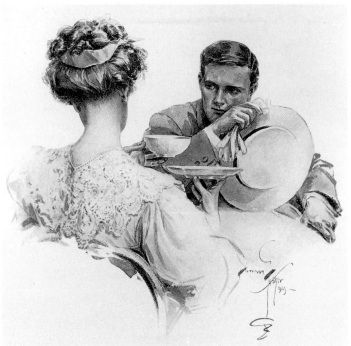

In Suspense

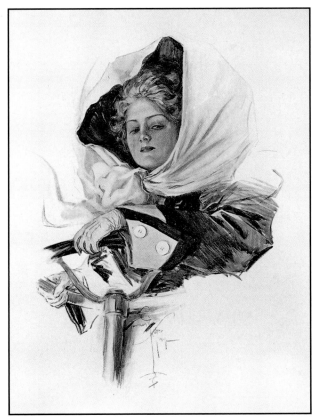

A Fair Driver

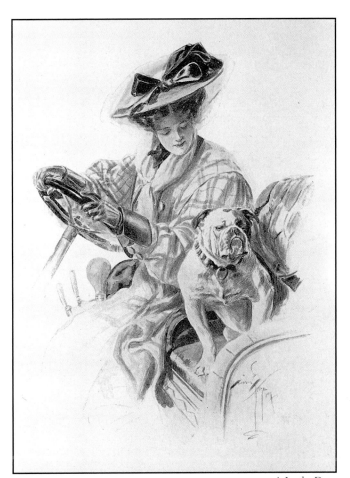

A Lucky Dog

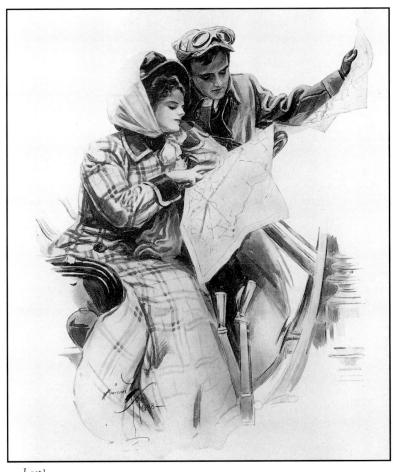

Lost?

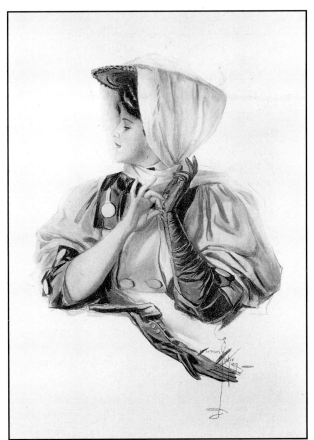

The Motor Girl

135

Harrison Fisher's American Girls in Miniature, published by Charles Scribner's Sons 1912. This book contained many reprints of Fisher's magazine work, including color versions of his *American Girls Abroad* and *The Greatest Moments of a Girl's Life* series, as well as numerous pictures printed in earlier artist folios. Most of these have been removed from this book in order to avoid redundancy.

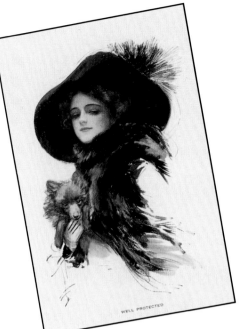

WELL PROTECTED

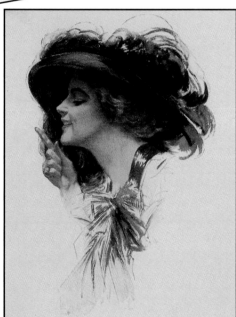

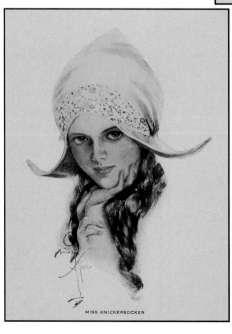

MISS KNICKERBOCKER

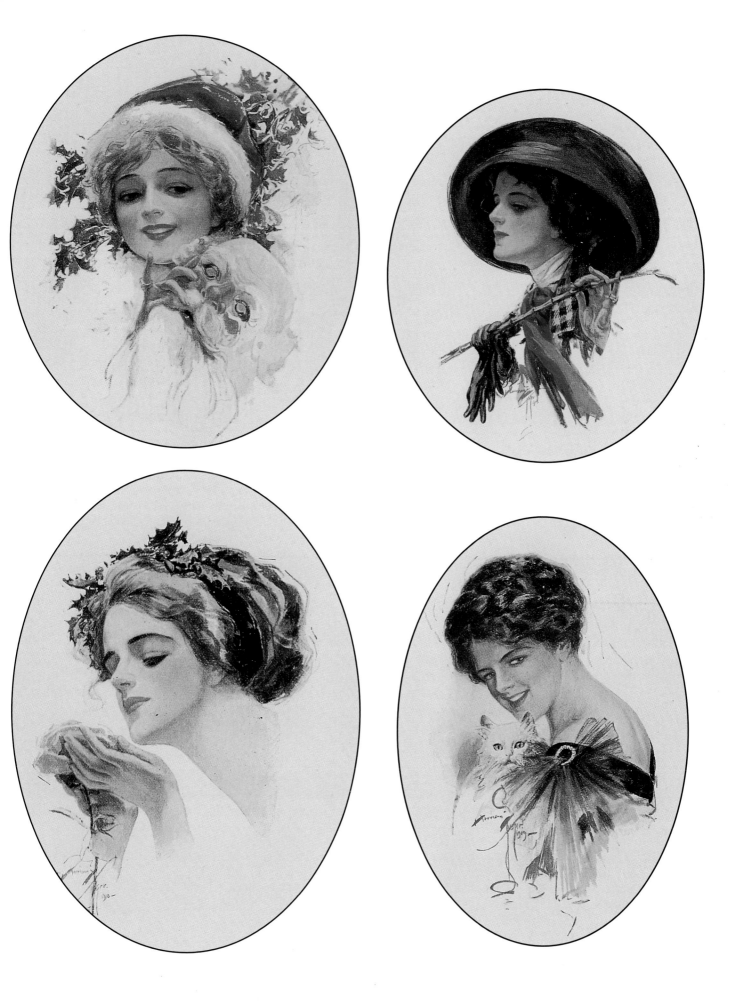

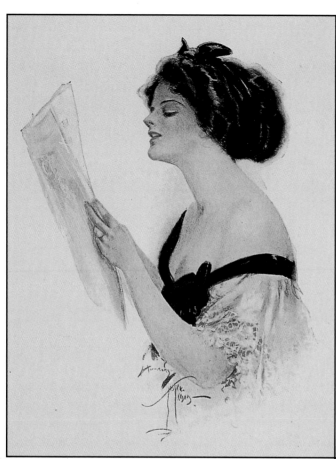

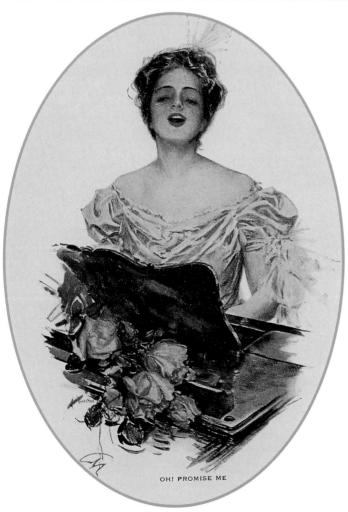

OH! PROMISE ME

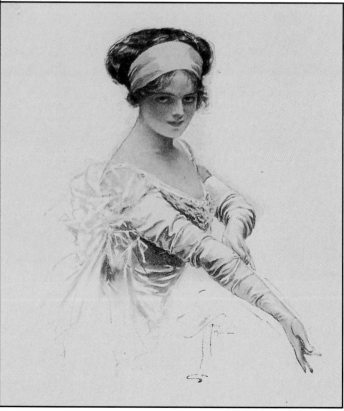

138

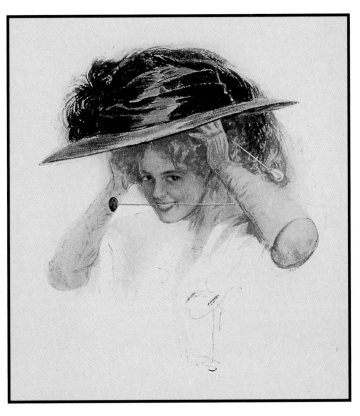

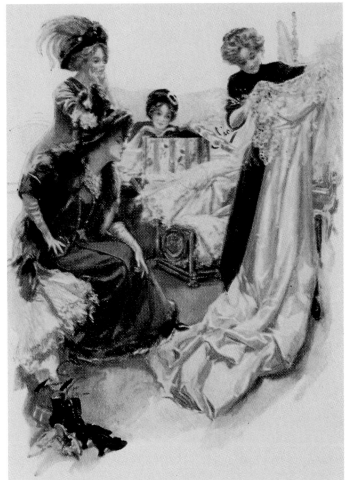

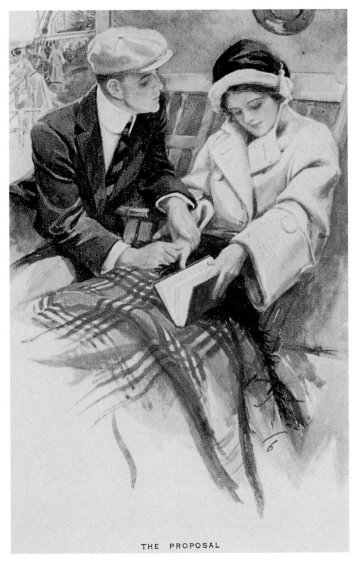

THE PROPOSAL

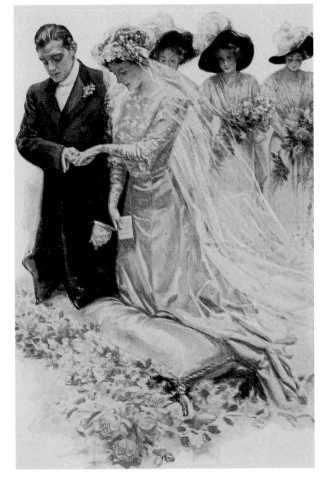

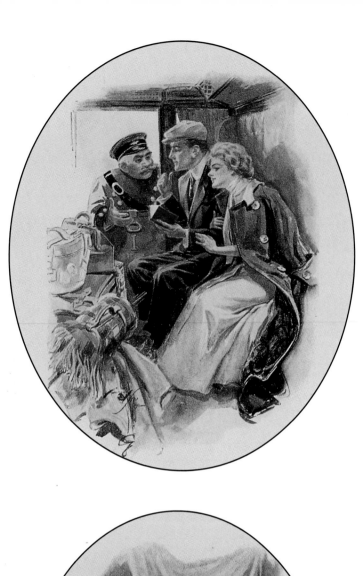

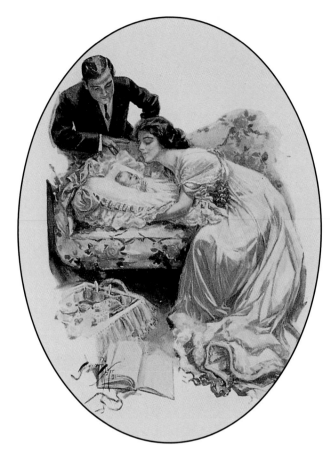

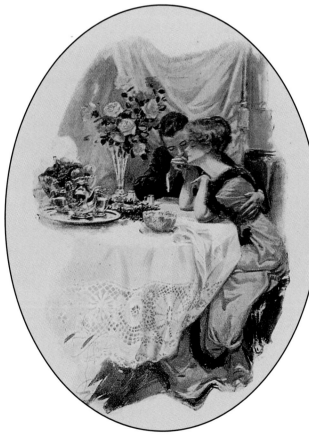

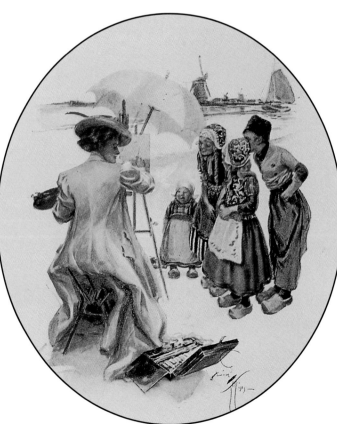

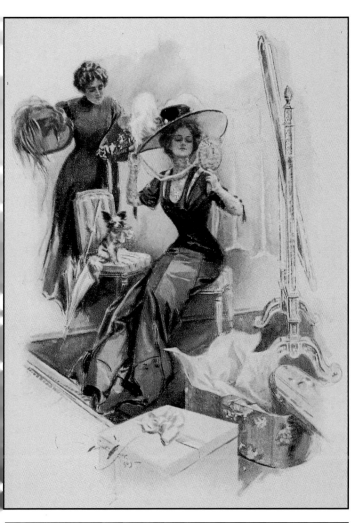

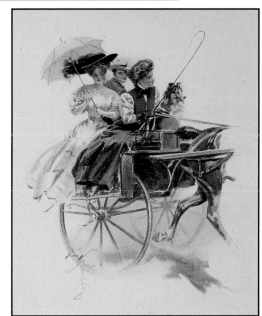

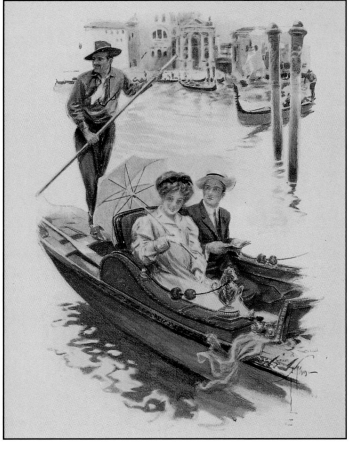

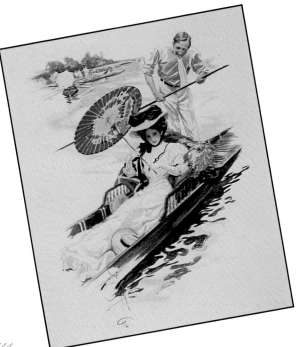

Maidens Fair, published by Dodd, Mead & Company, New York, 1912. Harrison Fisher was finding an outlet for the pictures he so publicly claimed he wanted to do—men and children, anything other than fair maidens. But the quality was slipping, too, as the hasty sketches compiled for this book attest.

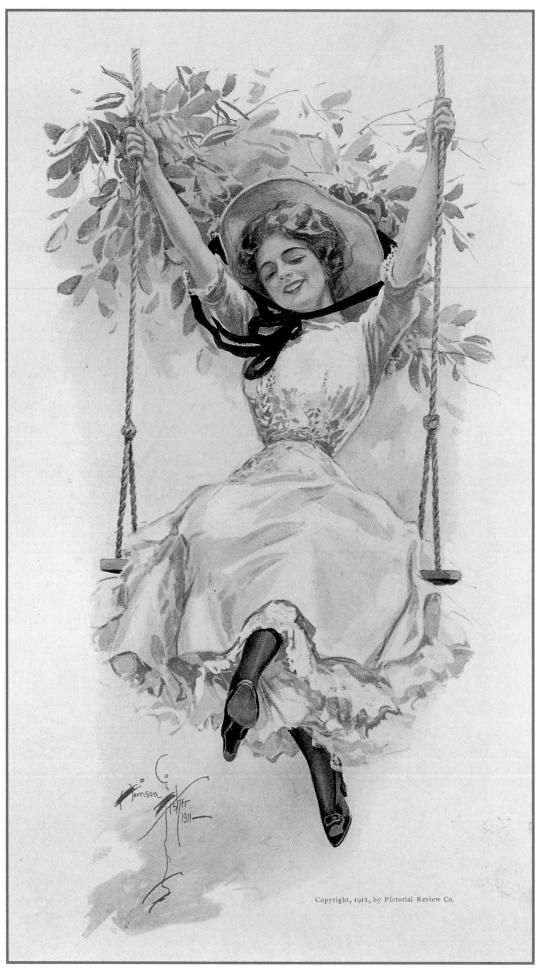

Copyright, 1911, by Pictorial Review Co.

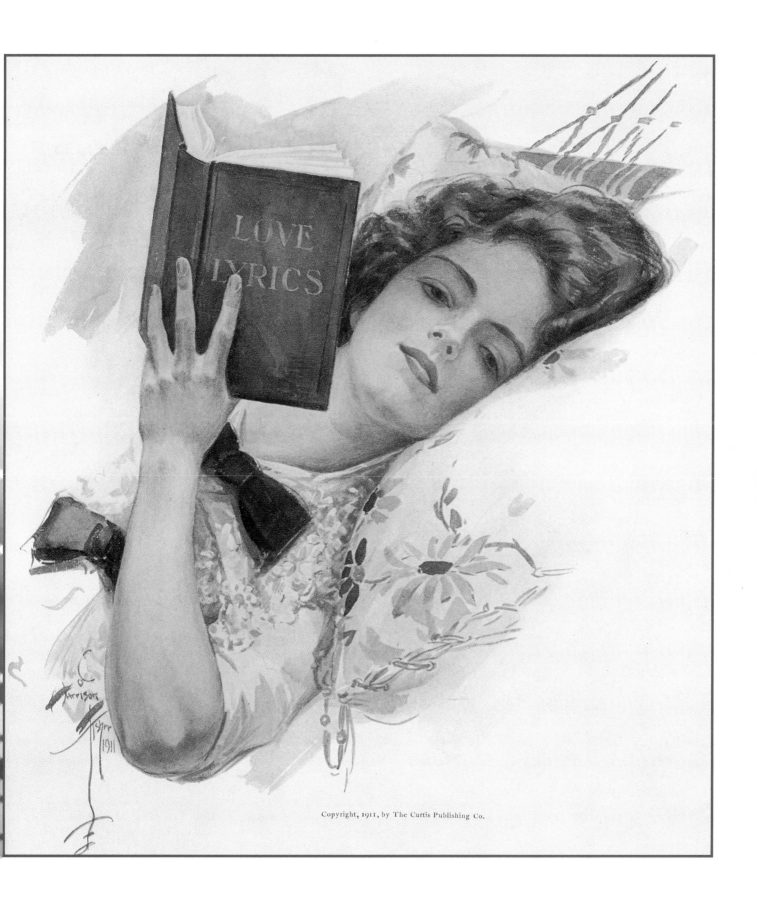

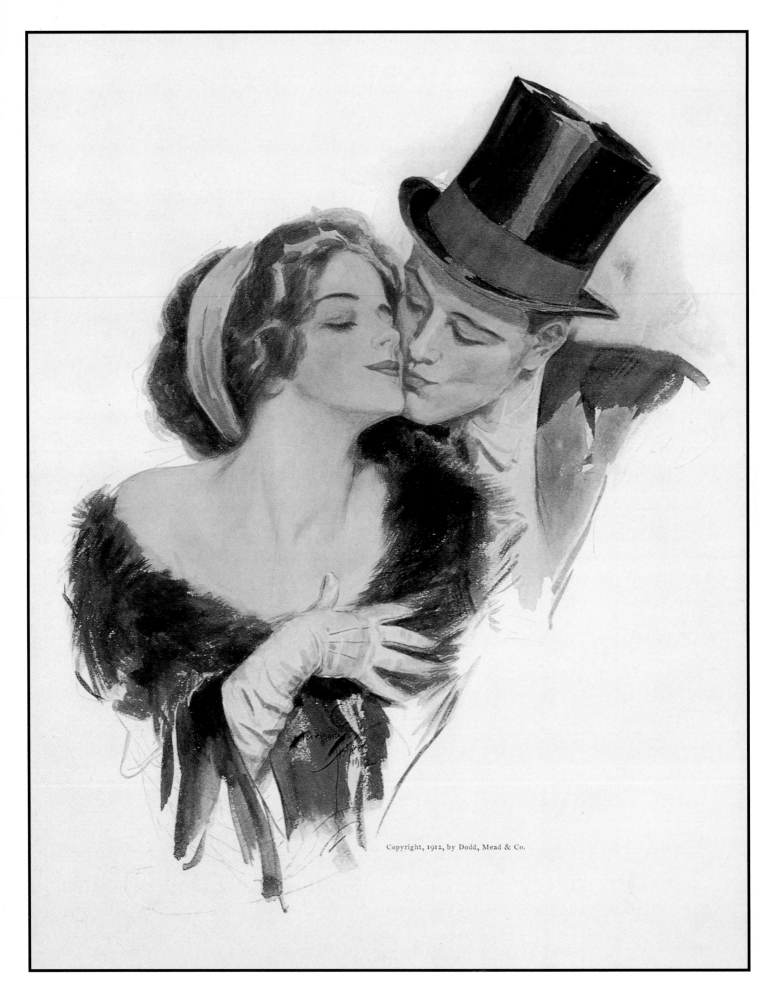

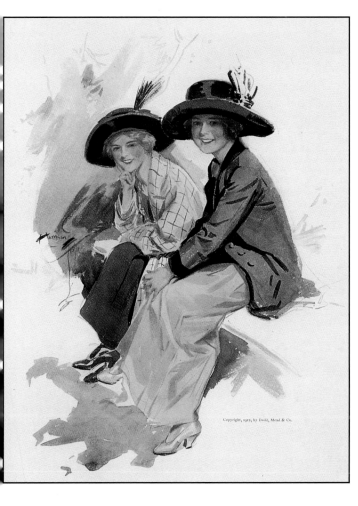

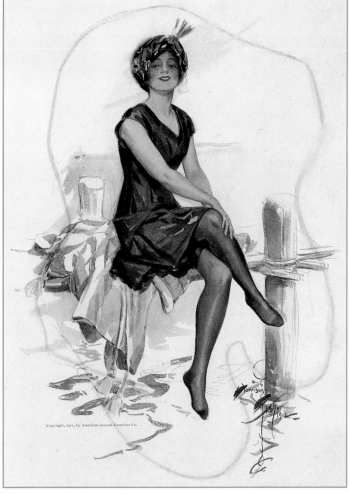

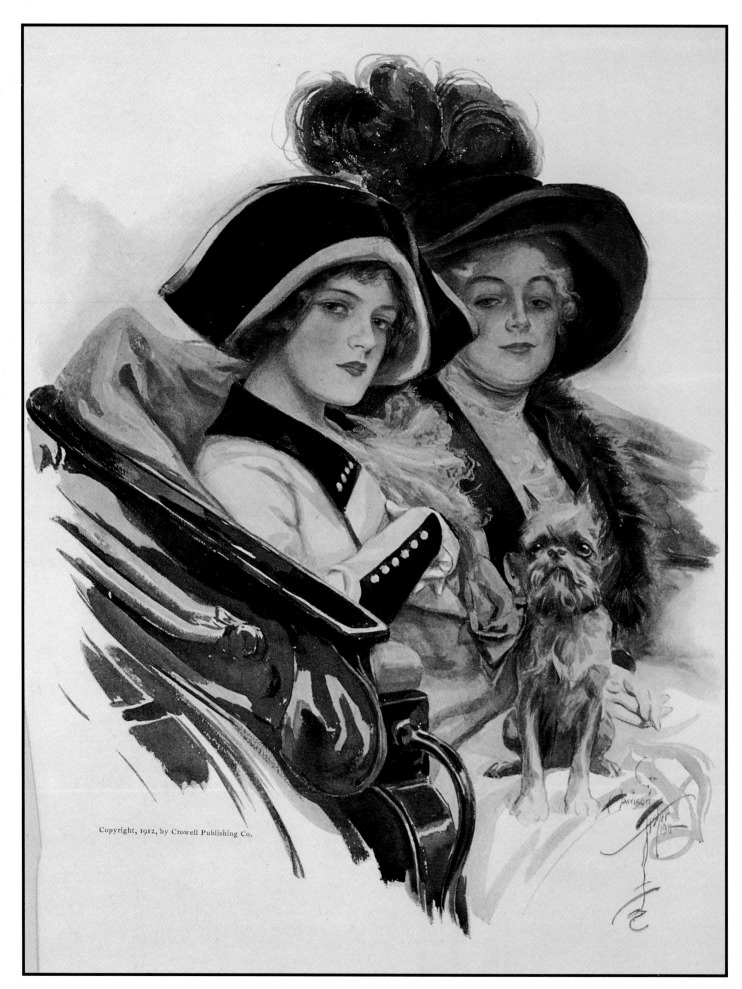

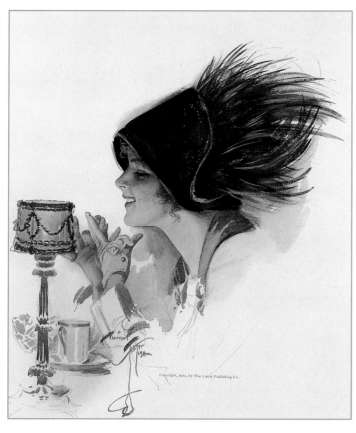

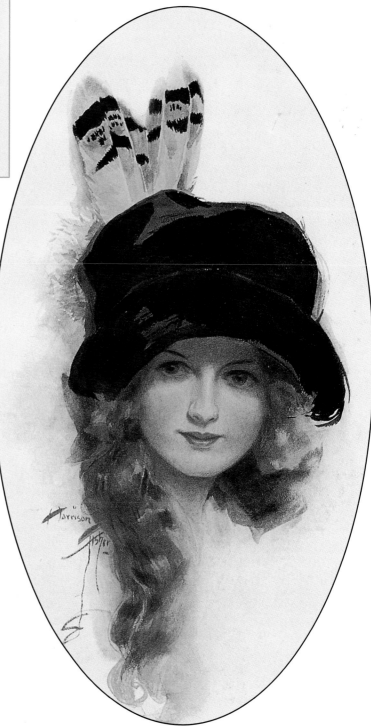

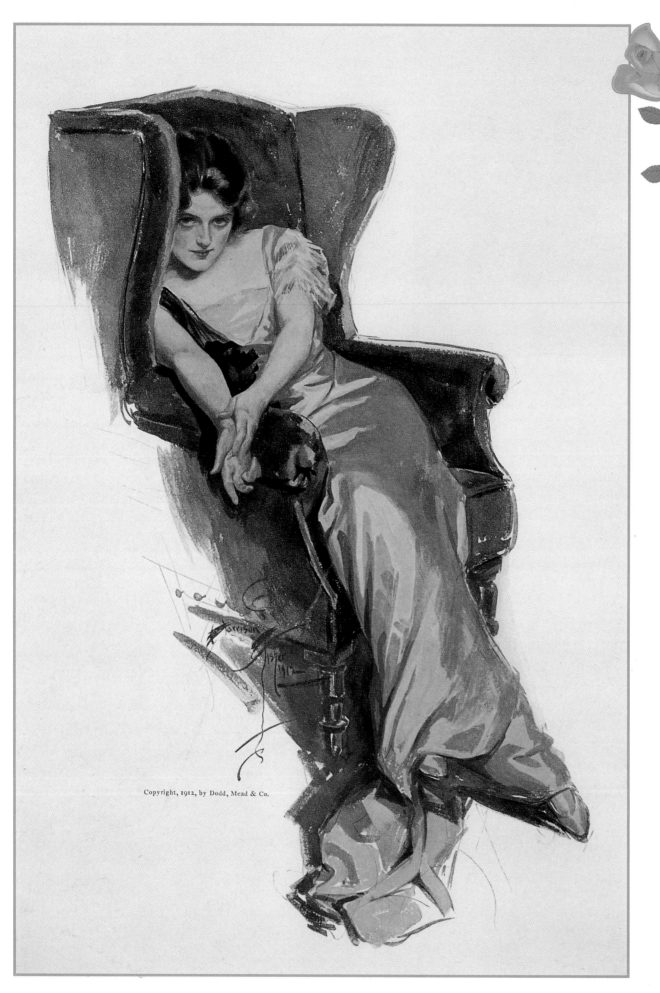

Copyright, 1912, by Dodd, Mead & Co.

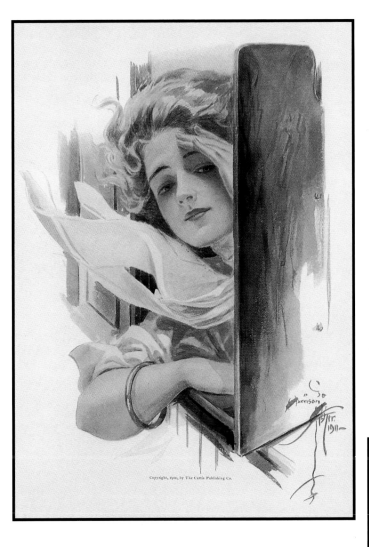

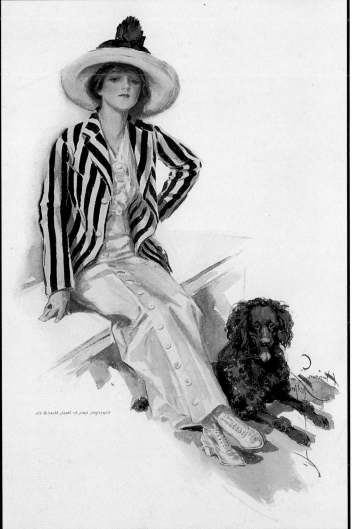

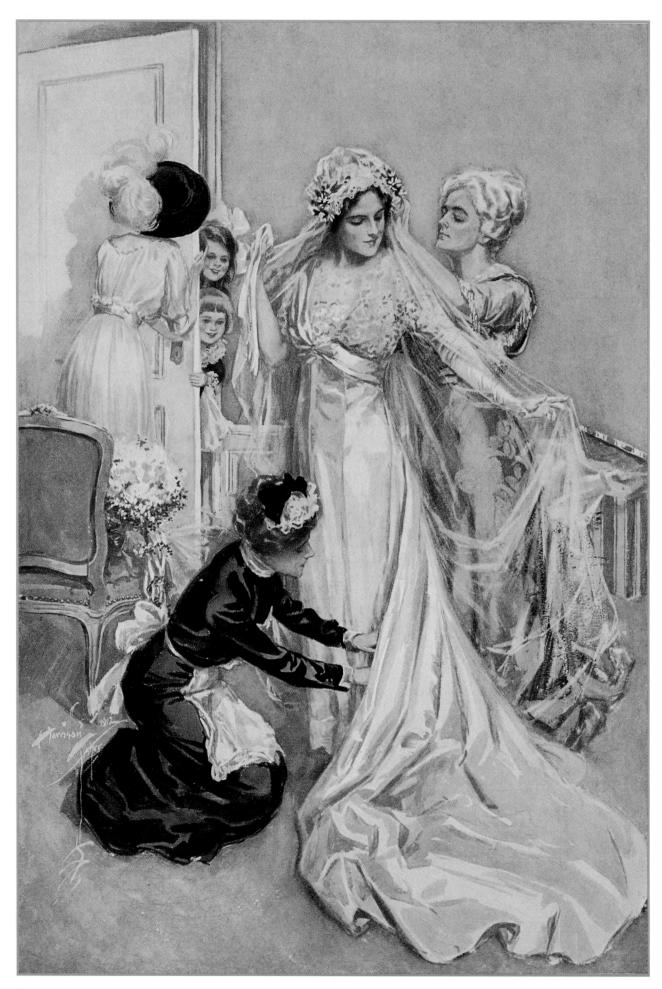

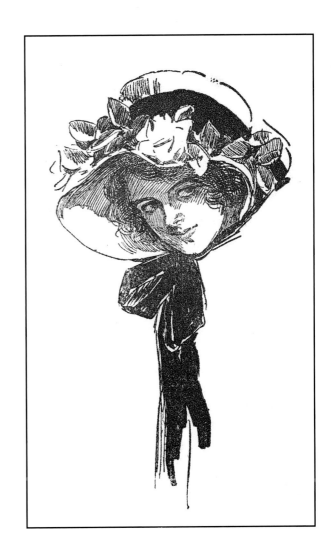

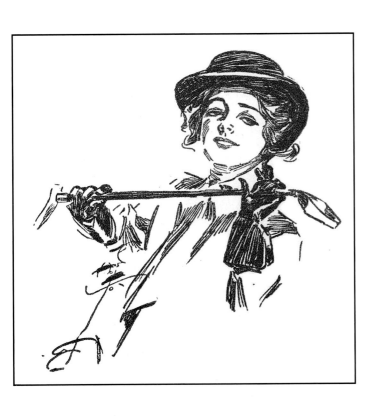

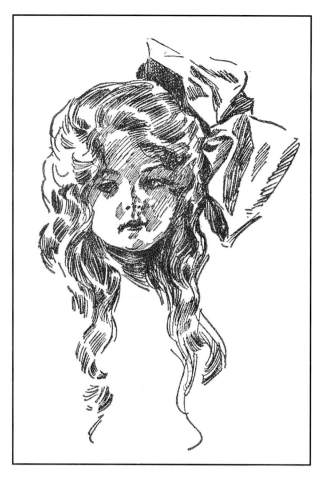

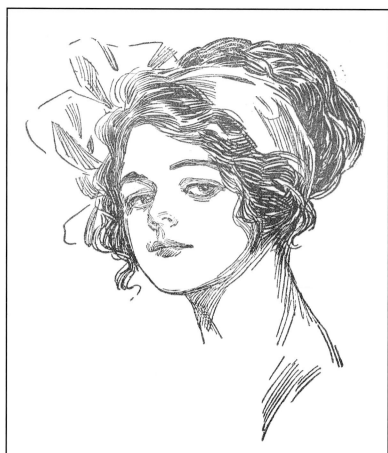

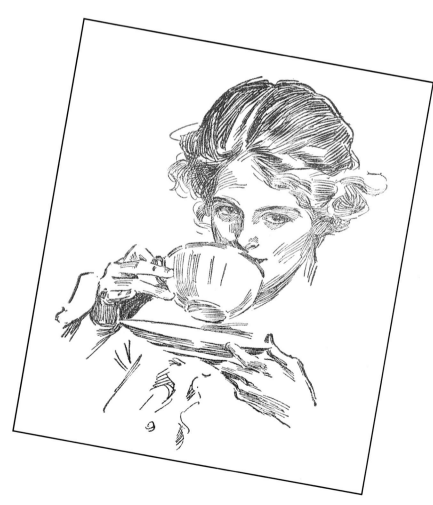

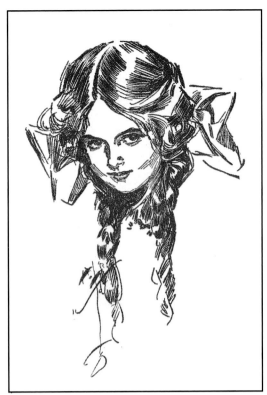

Beauties by Harrison Fisher, Verse by Carolyn Wells, published by Dodd, Mead & Company, New York, 1913. This book contains many reproductions of magazine cover work as well as color versions from some of his serialized magazine illustrations.

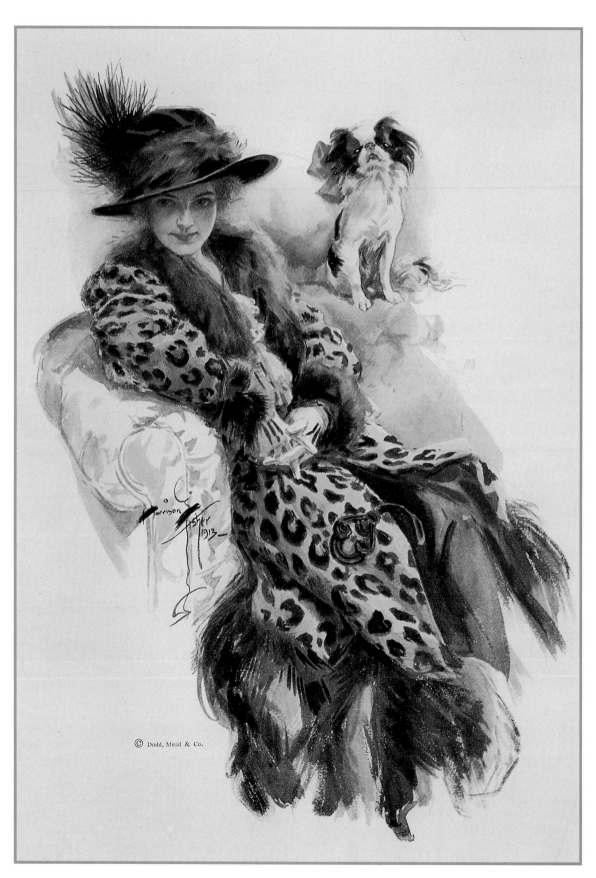

© Dodd, Mead & Co.

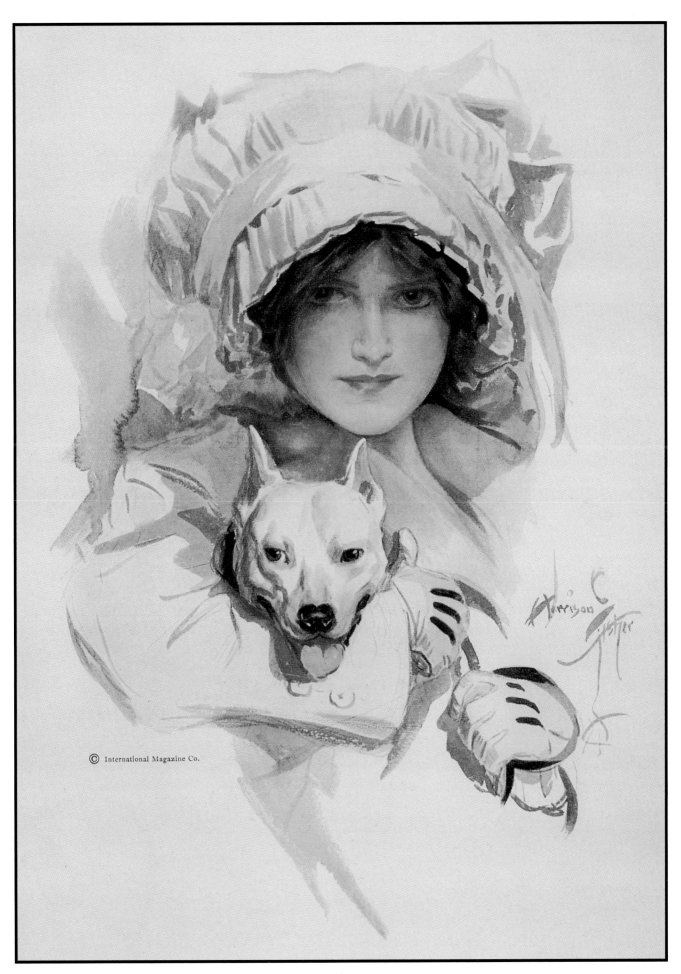

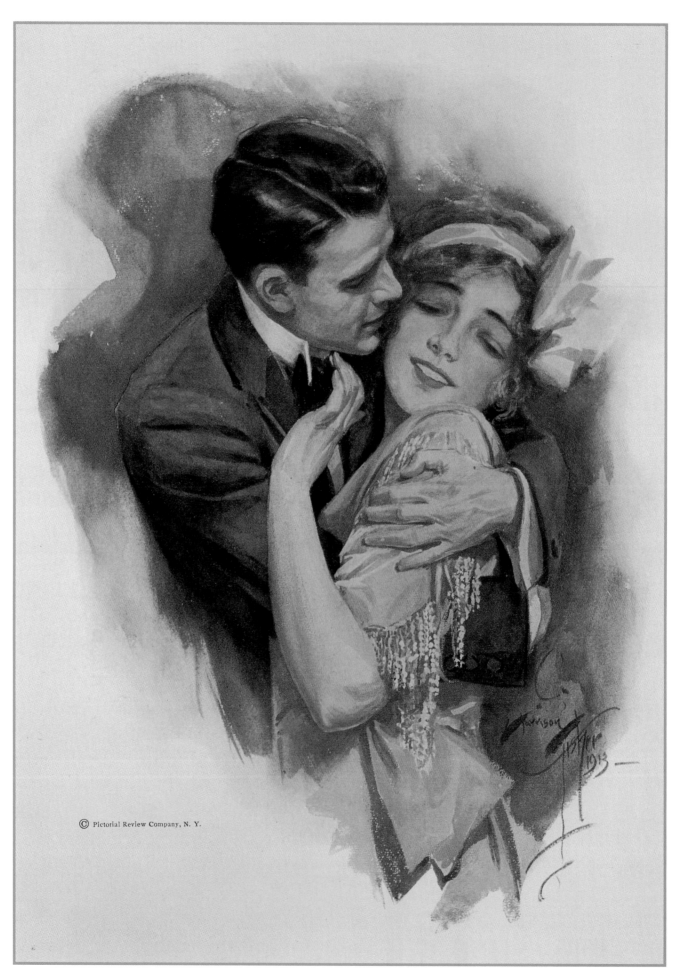

© Pictorial Review Company, N. Y.

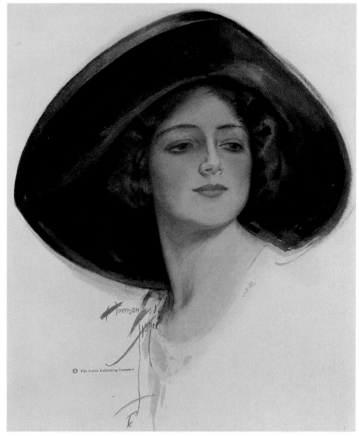

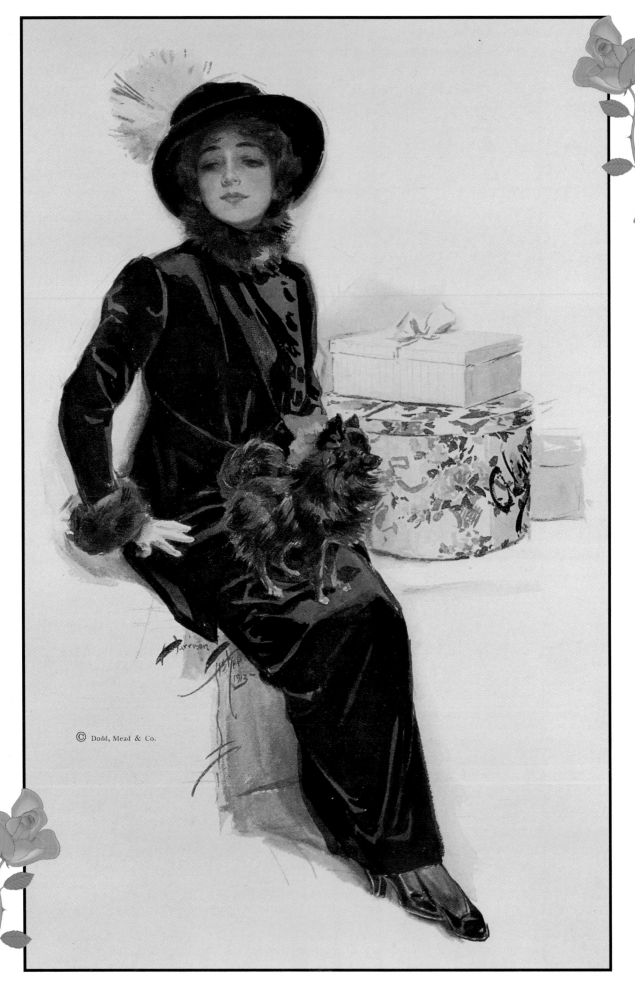

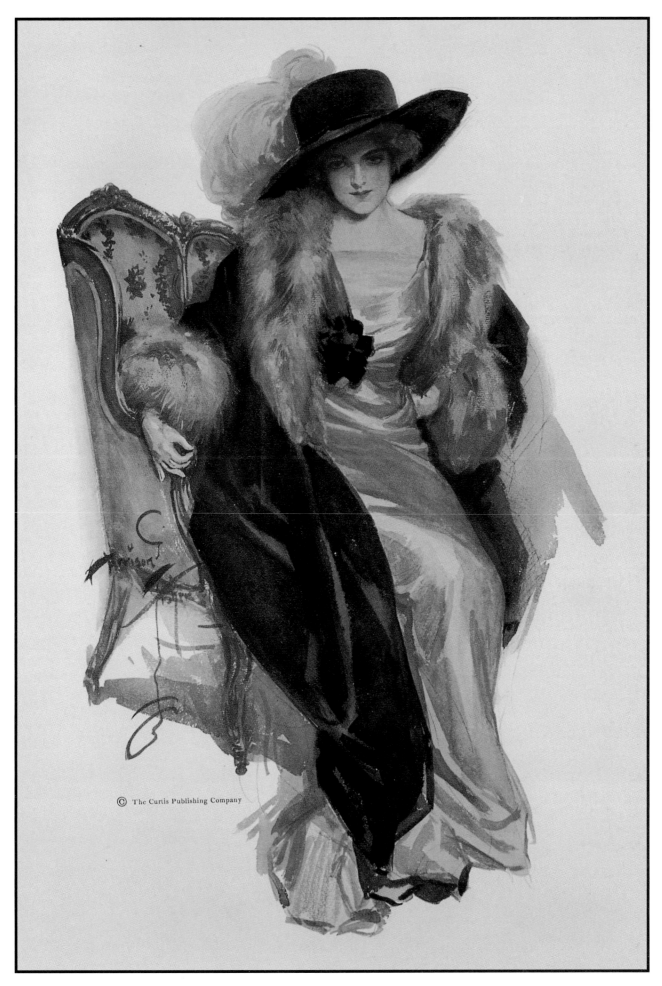

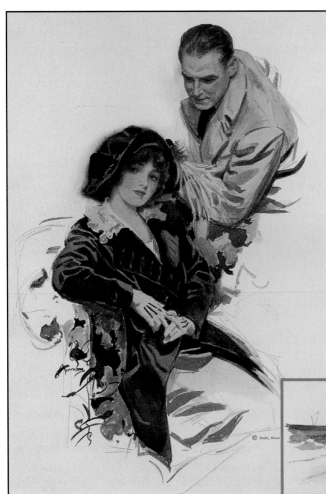

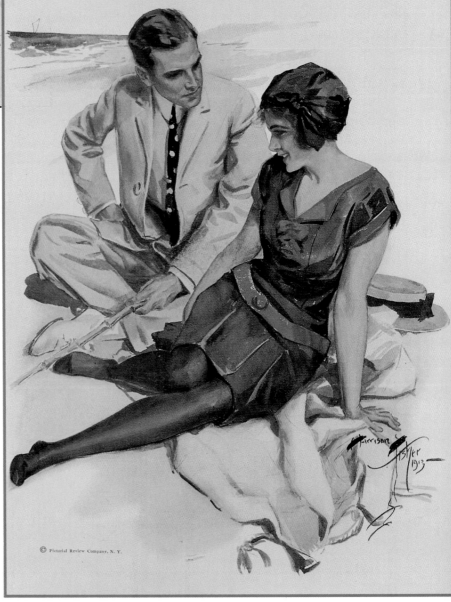

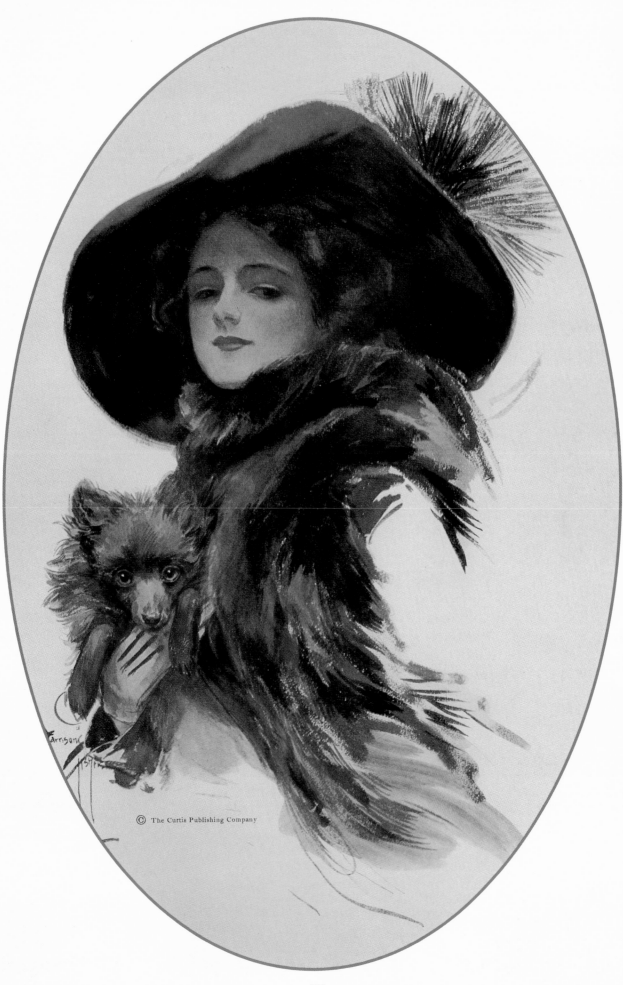

163

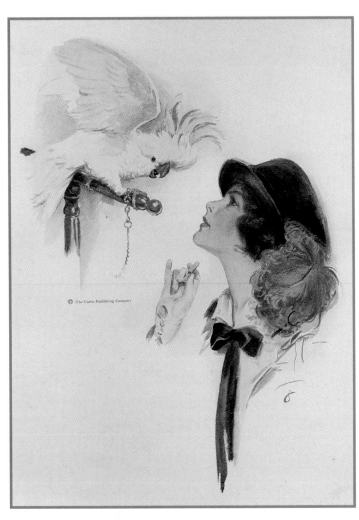

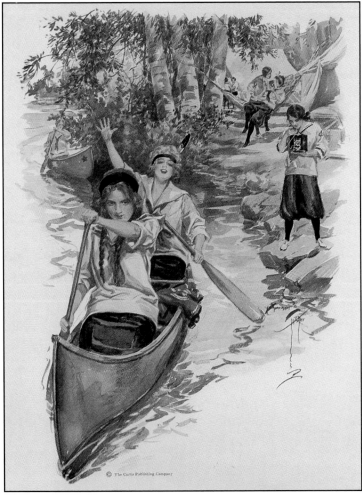

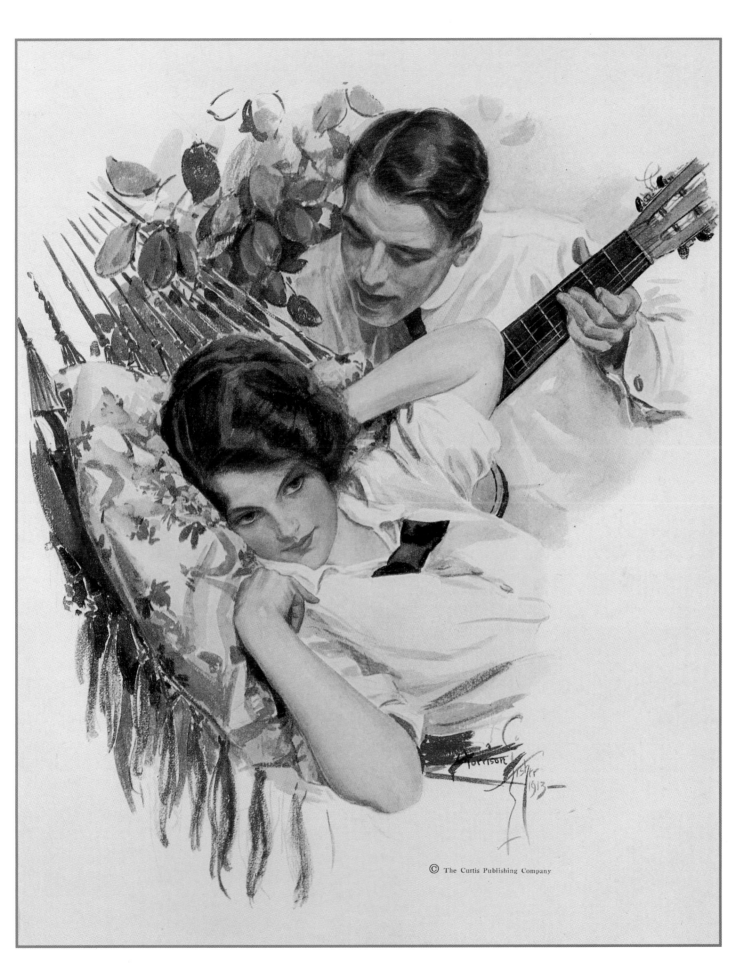

© The Curtis Publishing Company

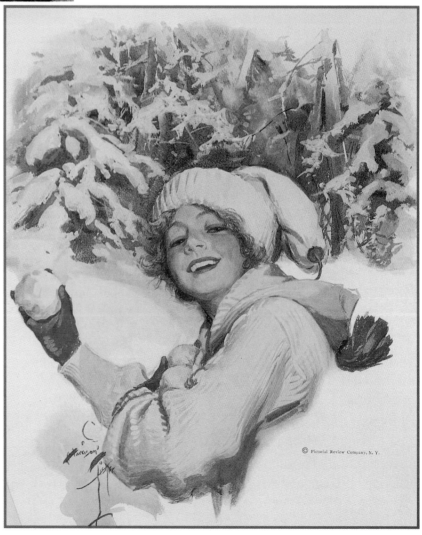

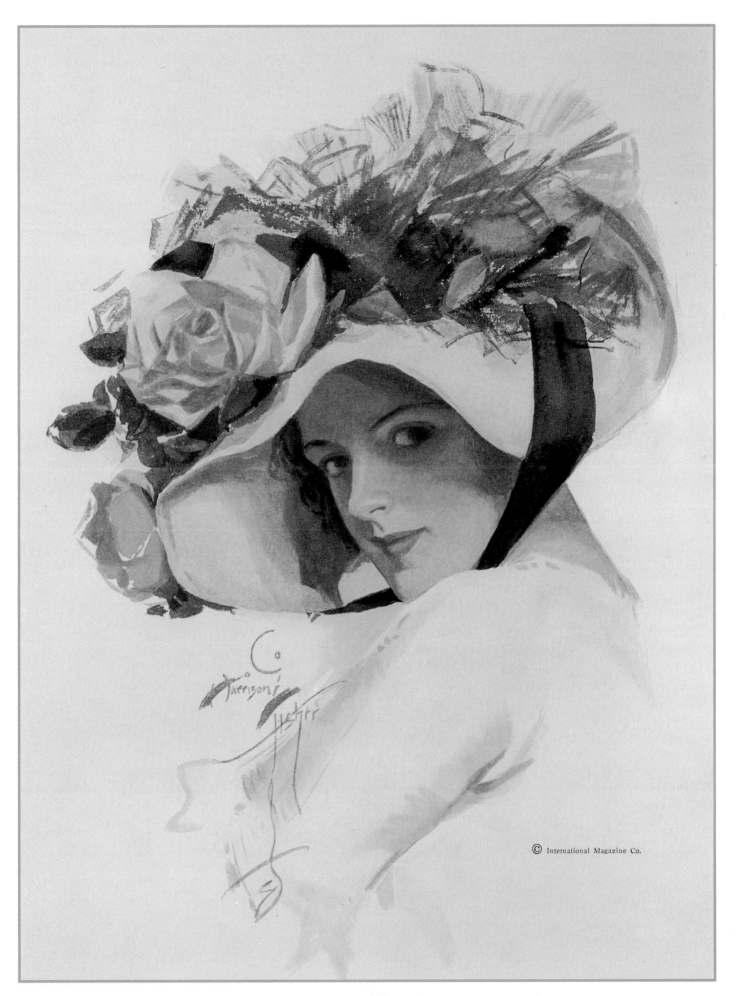

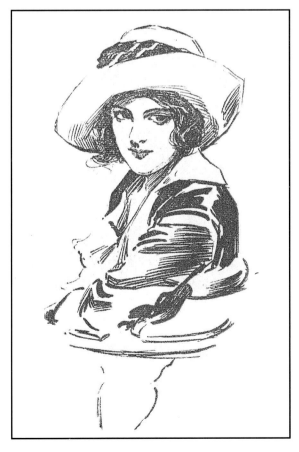

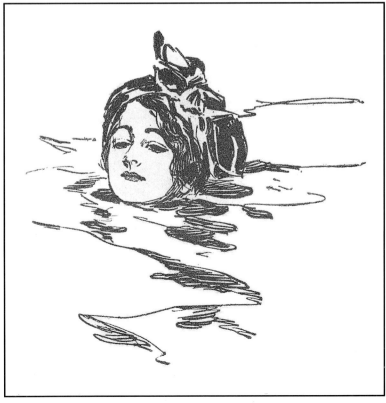

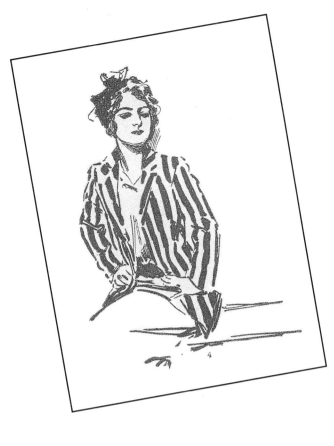

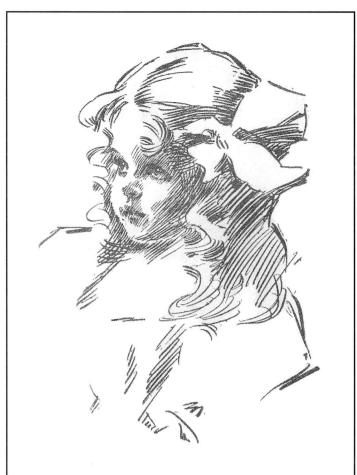

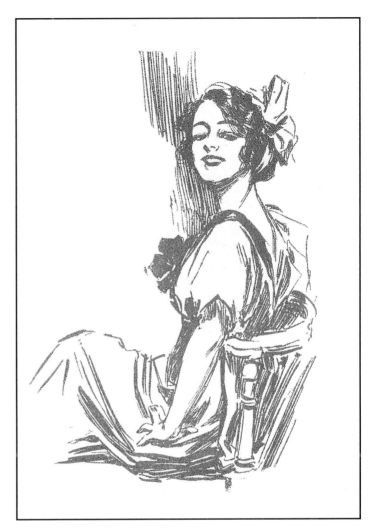

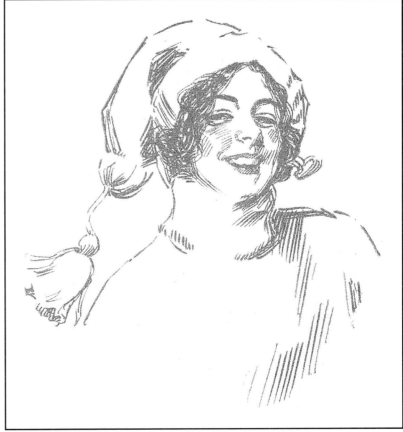

By Bruce Magnotti

I first became acquainted with the work of Harrison Fisher in 1986, while on my way to appraise an estate in Baltimore, Maryland. After a long drive from Pittsburgh, I fortuitously exited the highway into the historic village of Hagerstown, Maryland. I located a telephone book and the number of a quaint B&B. Luckily, the proprietor answered the phone at the late hour.

After checking in, I ran a warm bath and stepped into a deep claw-foot tub. As I rested my head on a comfortable towel, my eyes fell on a framed lithograph of an enchanting woman wearing a blue-green bathing dress and cap. Her hand was cupped to her mouth and the caption read, "Come in! The Water's Fine." The lithograph had a printed signature and date: "Harrison Fisher 1910" and "Copyright by the Curtis Publishing Company."

I was struck by the lifelike detail and cameo appearance of the character. I then noticed that the walls of the bathroom were covered with similar images. Some were playfully exotic, others hauntingly beautiful, still others tauntingly erotic. Later that evening, in the library, I asked the proprietor if he was interested in selling any of the prints and, of course, he replied, "No, thank you."

As an antiques and art collector and dealer, I could see the quality and value inherent in these prints; as an anthropologist, I could appreciate Harrison Fisher's portrayal of the romantic culture of the turn of the century.

I must preface this price guide with a note that the values associated with the works of Harrison Fisher parallel the rapid rise we have seen in the works of Maxfield Parrish and R. Atkinson Fox. These values have risen substantially in the last ten years and it is my opinion that they will continue to rise. Harrison Fisher artist portfolios that I purchased in 1990 for $75-100 are now selling for $350-400. Postcards that could be purchased for $3-5 are now selling for $25-50.

The following values are derived from Internet auction records available from the thirty day period August 1, 1998 - September 1, 1998, as well as listings from other online book stores, antique shops, and malls. The individual dealers offering these prints vary in their ability to present the art works, e.g. quality fast-loading images and accurate descriptions, so some of the prices have a wide range of value.

Postcard Collections
(six matted and framed postcards in series)

Smiles and Kisses	$167.50
The Greatest Moment In A Girl's Life	$131.50
The Six Important Events in a Girl's Life	$171.00
The Six Senses	$165.00

Individual Postcards
(#'s provided when available)

#844 Compensation	$18.50
#971 Cynthia	$43.00
#869 I'm Ready	$24.50
#183 Miss Knickerbocker	$16.50
#256 Preparing to Conquer	$20.50
#108 The Bride	$15.50

Magazine Covers
(often with the complete magazine)

1928 *Cosmopolitan*	$16.50
1929 *Cosmopolitan*	$26.00
1932 *Cosmopolitan*	$17.00
1933 *Cosmopolitan*	$20.00
1907 *Ladies' Home Journal*	$25.50
1911 *Ladies' Home Journal*	$30.00
1911 *Ladies' Home Journal* (January 1)	$140.00
1913 *Pictorial Review*	$35.00
1898 *Puck*	$31.00

Illustrated Novels

A Checked Love Affair (New York, 1903)	$25.00
A Six Cylinder Courtship (New York, 1907)	$24.00-55.00
Beverly of Graustark (New York, 1904)	$45.00
Cowardice Court (New York, 1906)	$20.00-35.00
Hiawatha (Indianapolis, 1906)	$125.00-248.00
Man on the Box (New York, 1904)	$25.00
Market Place (New York, 1899)	$12.50-22.00
Nedra	$15.50 - 20.00
Princess Maritza (New York, 1906)	$30.00

Salomy Jane (Boston, 1910)	$40.00-55.00
The Butterfly Man (New York, 1910)	$15.00-20.00
The Day of the Dog (New York, 1904)	$40.00
The Lure of the Mask (Indianapolis, 1908)	$26.00-40.00
The Purple Parasol (New York, 1905)	$25.00-75.00
Three Men on Wheels (New York, 1905)	$25.00-44.00

Artist Portfolios

A Dream of Fair Women (auction)	$225.00
A Dream of Fair Women (bookseller)	$400.00
A Garden of Girls	$414.00
American Beauties (auction)	$255.00
American Beauties (bookseller)	$400.00
American Girls in Miniature	$250.00
Bachelor Belles	$227.50
Fair Americans	$225.00
Maiden's Fair	$250.00
The Harrison Fisher Book	$326.50

Prints

A Prairie Belle	$35.00
An Old Song	$39.00
Anticipation	$42.00
Art and Beauty	$35.00
Best Friends	$47.00
Can't You Speak?	$35.00
Danger	$55.00
Fine Feathers	$37.00
He's Only Joking	$35.00
His Gift	$62.00

Mary	$40.00
My Lady Drives	$45.00
Oh! Promise Me	$37.00
Opera Night	$39.00
Phoebe	$39.00
Pink of Perfection	$42.00
Ready and Waiting	$47.00
Reflections	$55.00
Refreshments	$45.00
Song of the Soul	$55.00
Tempting Lips	$37.00
Vanity	$37.00

Miscellaneous

1906 Ansco Camera & Supplies Catalog	$125.00
Candy Tin "Reflections" (Tindeco)	$61.50
Candy Tin "Yachting Girl" (Tindeco)	$73.00
Sheet Music ("Rose of Washington Square")	$24.50
World War I Poster	$152.50

Bruce A. Magnotti has been collecting, appraising and dealing in antiques on the West Coast since 1972. He has a degree in Anthropology from Central Washington University and is co-founder and CEO of the Internet company **www.aesops.net**. AESOPS.NET encourages and assists antique stores to sell antiques on the world wide web. Bruce works closely with another internet company, **www.oldcities.com**, and can be reached there via e-mail at **anchor@oldcities.com**, or at his "snail mail" address of AESOPS.NET, P.O. Box 558, Ellensburg, WA 98926.

Bibliography

Andrews, Barbara. "Harrison Fisher: A Cynic About Women?", *Antique Trader Weekly*, 11 May 1976.

Bowers, Q. David, Ellen H. Budd, and George M. Budd. *Harrison Fisher*. Wolfeboro, N.H.: Bowers, 1985.

Carrington, James B. *The Harrison Fisher Book*. New York: Charles Scribner's Sons, 1907.

Christie, Dr. Victor J. W. "Harrison Fisher: An Admirer of Beauty," *Antiques & The Arts Weekly*, 15 Octorber 1982.

Fair Americans by Harrison Fisher. New York: Charles Scribner's Sons, 1911.

"Famed Calif. Art Leader Succumbs," *Los Angeles Evening Herald and Express*, 19 January 1934.

Jerome, Lucy B. "Personalities of Star Illustrators," *Holland's Magazine*, January 1914.

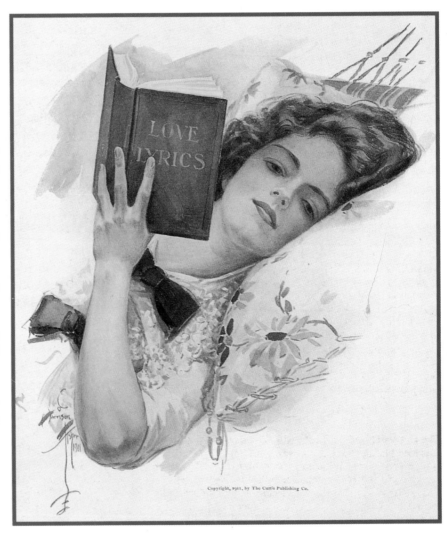

Copyright, 1911, by The Curtis Publishing Co.